Duchamp & Co.

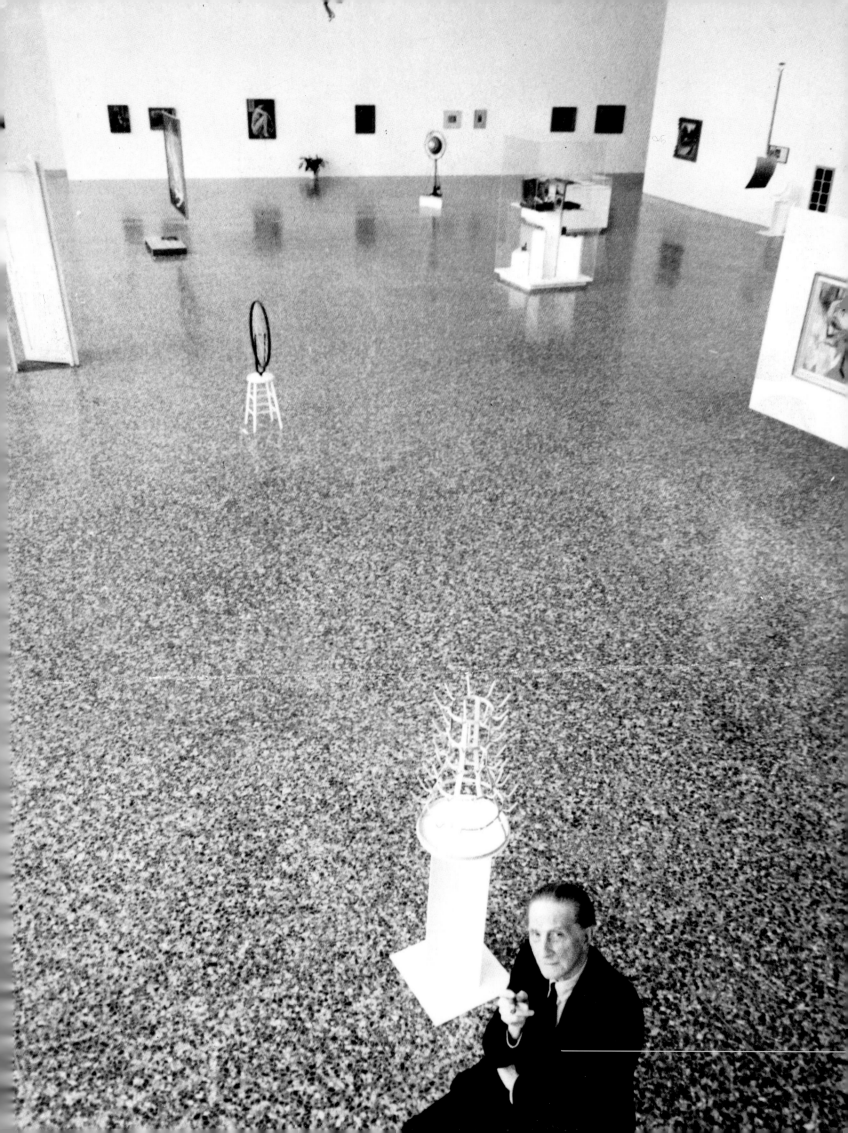

Duchamp
& Co

PIERRE CABANNE

·TERRAIL·

COVER ILLUSTRATION

Marcel Duchamp smoking a cigar at the retrospective exhibition
of his work held at the Pasadena Museum of Art, Los Angeles, in 1963.

PREVIOUS PAGE

Marcel Duchamp at the exhibition "Not seen and/or less seen
of/by Marcel Duchamp/Rrose Sélavy", New York, 1965.

OPPOSITE

1931, Marcel Duchamp playing chess.

FOLLOWING PAGE

Marcel Duchamp

L.H.O.O.Q.

1919, replica made in 1930,

rectified readymade, pencil on a reproduction of *Mona Lisa*,

19.7 x 12.4 cm (7 3/4 x 4 7/8 in).

Parti communiste français, Paris.

Editor: Jean-Claude Dubost
English translation: Peter Snowdon
Cover design: Gérard Lo Monaco and Laurent Gudin
Desk editor: Aude Simon
Graphic design: Marthe Lauffray
Editorial assistant: Malina Stachurska
Iconography: Nils Warolin
Typesetting and filmsetting: Einsatz Goar Engeländer, Paderborn
Lithography: Litho Service T. Zamboni, Verona

English edition, copyright © 1997
World copyright © FINEST SA/EDITIONS PIERRE TERRAIL, PARIS 199
The Art Book Subsidiary of BAYARD PRESSE SA
Copy number: 140
ISBN 2-87939-135-0
Printed in Italy.

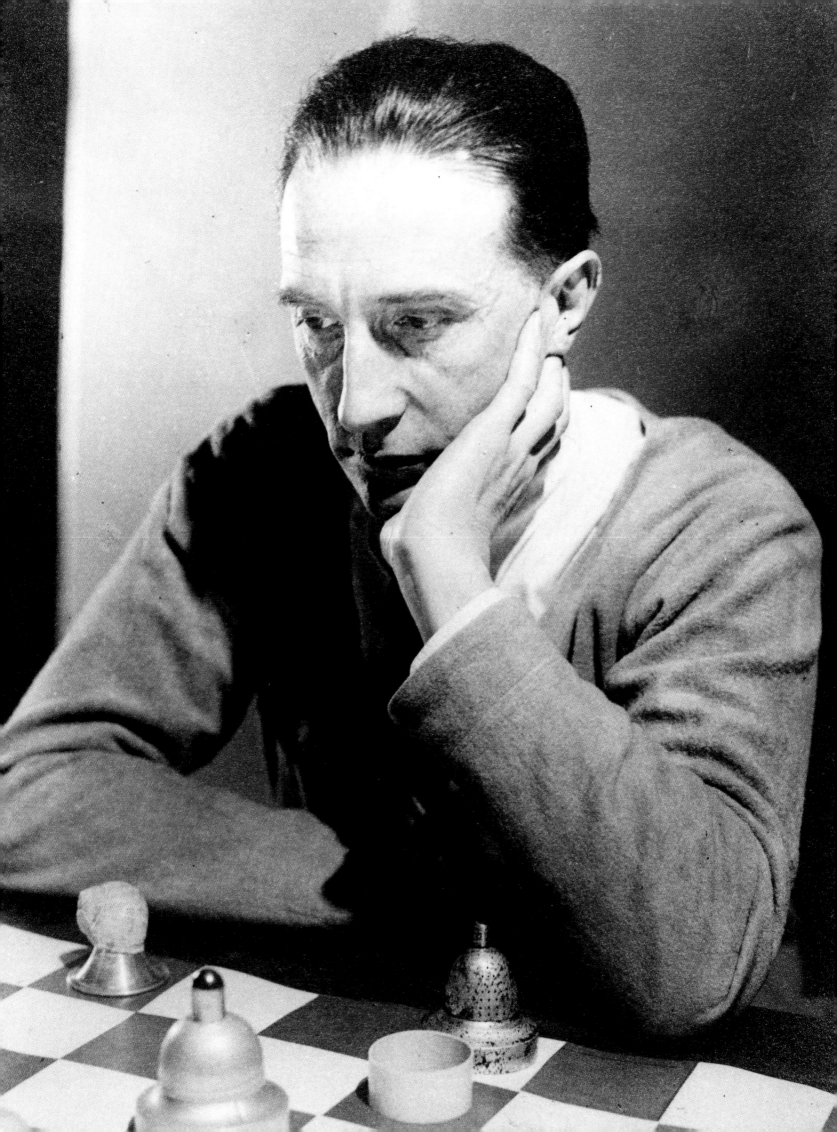

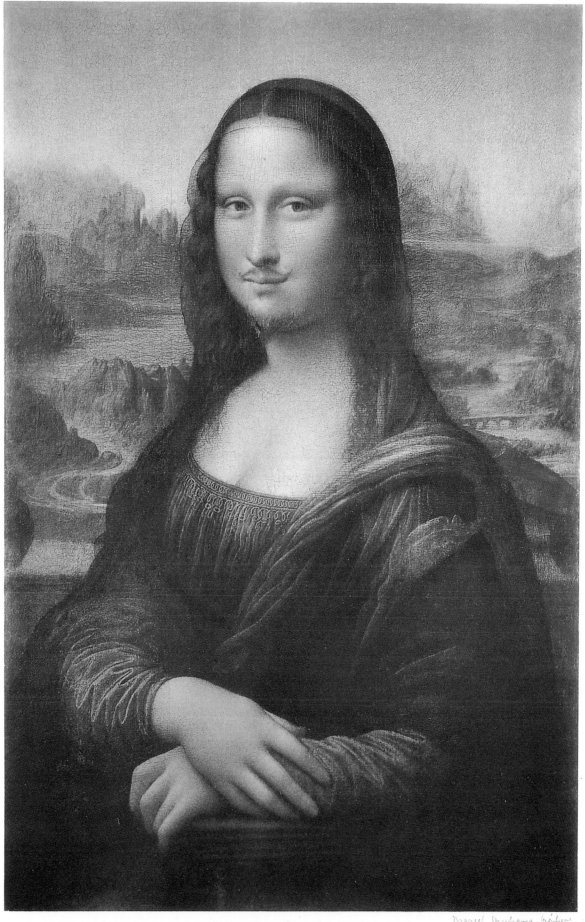

L.H.O.O.Q.

Marcel Duchamp réplique 1930

CONTENTS

INTRODUCTION

OPPOSITE
Marcel Duchamp
*Given: 1. The Waterfall,
2. The Illuminating Gas.*
(exterior)
1946-1966, mixed-media assemblage
including old wooden door in brick
surround, interior visible through
two small peepholes,
242.5 x 177.8 x 124.5 cm
(95 1/2 x 70 x 49 in).
Donation of the Cassandra Foundation,
Philadelphia Museum of Art.

King from the set of chess pieces carved
by Marcel Duchamp in Buenos Aires.

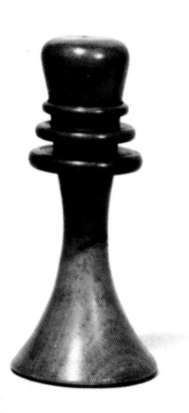

Some saw him as an artist, others as an engineer (a term he liked). For some he was a subversive, for others merely ludic. What can one say about a man who spent his entire life evading definition? A critic approaching the life and work of Marcel Duchamp needs to cultivate an elegance of his own, a sense of humour and even a hint of condescension. Evasion exists to establish a distance between subject and pursuer. It reflects the desire to live, perhaps even to act, without justifying oneself. It implies that opportunities and emotions can be treated with suspicion, money with indifference, and reputation (others will see to that) with circumspection. There remains the reductive pleasure of puns and epigrams with which to deflate anyone taking seriously the repertory of behaviour listed above.

Duchamp did not take things too seriously. "I prefer breathing to working", he once said. He asserted his own right to indolence and considered incompletion the prerogative of his works – his "things", as he called them. Despite his apparent indifference, these "things" have come to occupy a central place in contemporary art. Their maker is now regarded, rightly or wrongly, as the exemplary guru of the avant-garde, and the progenitor of a posterity as heteroclite as it is controversial.

André Breton declared that Duchamp was "the most intelligent man of the 20th century", to which Duchamp replied that the word "intelligence" was "the most elastic term imaginable". Contrary to what has often been supposed, he did not deliberately cultivate an aura of mystery. He would politely answer any question he was asked, though his answers were not always relevant. Indeed, he took politeness so far as to agree with the opinions of whoever he happened to be talking to, thus demonstrating what Aragon once called "the Olympian detachment that was his lesson to us all".

He made no attempt to hide the generally unexceptional course of his life from public view. He produced few "things", and exhibited fewer. During the last twenty years of his existence, he secretly worked on a single extraordinary "installation". At his own request, it was revealed to the public only after his death, when it went on show at the Philadelphia Museum. Even then, in a final act of evasion, what was "shown" was only partially visible. And the notebook that he produced while working on this unusual project contained few, if any, explanations. Indeed, there is no rational explanation for any aspect of Marcel Duchamp's life and work. From an early age, he learnt to distance himself from all inquiry, and never once faltered in this policy. He never commented on attempts to analyse, interpret and explain his work. He ignored those who sought to situate it in the labyrinthine history of 20th-century art. This volume constitutes precisely the variety of enterprises that he ignored.

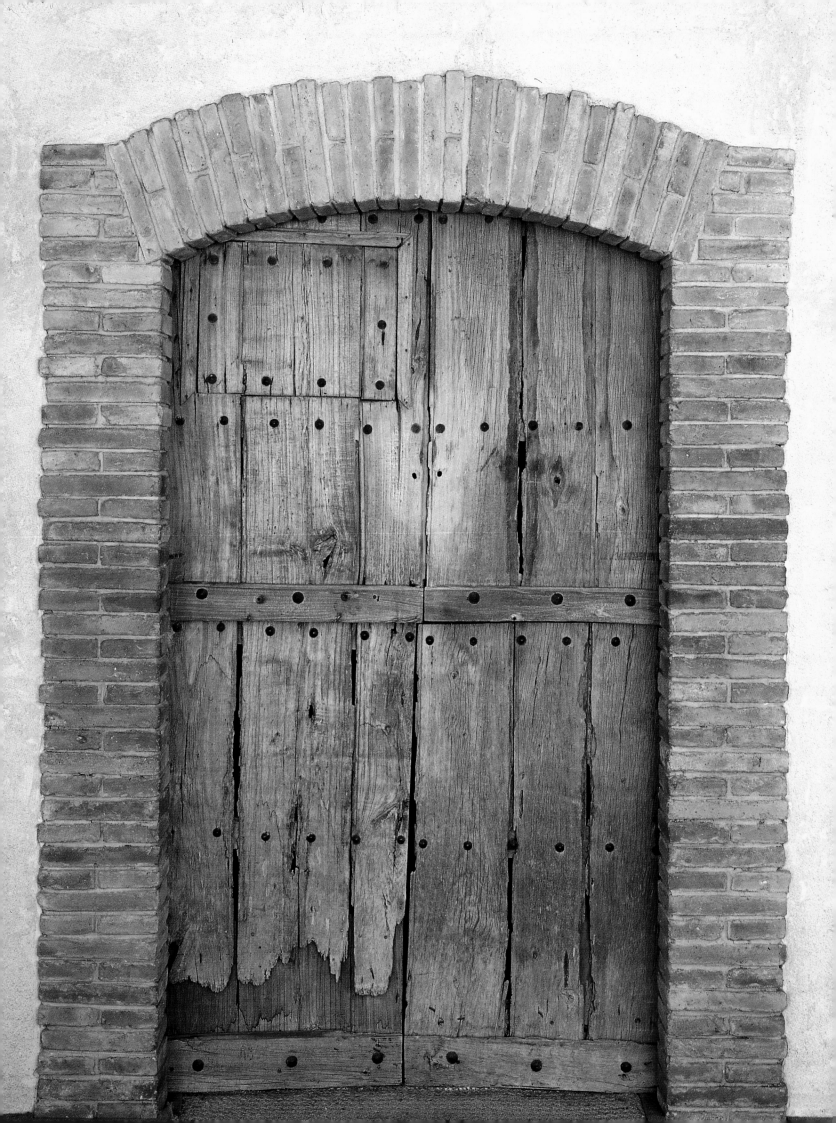

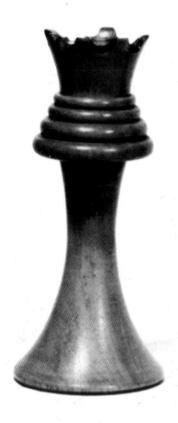

Queen from the set of chess pieces carved
by Marcel Duchamp in Buenos Aires.

OPPOSITE
Marcel Duchamp
**Given: 1. The Waterfall,
2. The Illuminating Gas**
(interior)
1946-1966, velvet, wood, leather
stretched over an armature of metal,
twigs, aluminium, glass, Plexiglas,
linoleum, cotton, gas lamp
(Welsbach burner type), motor, etc.,
242.5 x 177.8 x 124.5 cm
(95 1/2 x 70 x 49 in).

Donation of the Cassandra Foundation,
Philadelphia Museum of Art.

First, a few facts. Marcel Duchamp was born at Blainville in the Seine-Maritime in 1887, and died at Neuilly, a suburb of Paris, in 1968. He was the younger brother of the painter Jacques Villon (born 1875) and the sculptor Raymond Duchamp-Villon (born 1876). He had three sisters, one of whom, Suzanne, was born two years after Marcel; she too became a painter.

Duchamp never gave the impression that his "creative activities" were very important to him. Indeed, he loathed the very word: "creation". He scarcely glanced at studies of his work; it is quite possible he never read a word of them. He himself seemed to have little belief in what he did, and no particular vision of art. So he had no reason to be interested in what people said about him. Interpretation of his work seemed to him futile. But he did take great pleasure in words.

To discourage the inquiries his behaviour inevitably elicited, he decreed that he did not believe in "the creative function of the artist", explaining that "everyone does something, and people who do things on a canvas, with a frame, are called artists"[1]. To dispel any misunderstanding about his early work as a painter, and his decision to give up painting in 1912 (when he was twenty-five years old), he made the following statement: "I considered painting as a means of expression, not an end in itself. One means of expression among others, and not a complete end for life at all; in the same way, I consider that colour is only a means of expression in painting and not an end. In other words, painting should not be exclusively retinal or visual; it should have to do with the grey matter, with our urge for understanding.[2]"

Having thus renounced his "intoxication with turpentine" at an early age, Duchamp went on to astonish, disturb and repel his contemporaries with projects untoward, inscrutable, or merely scandalous. For many years, France made little or no effort to "understand" this very un-Cartesian artist. But things were different in America. There he arrived in 1915, in the middle of the war, a young man apparently austere as a Quaker, but with a penchant for women and the wild parties then fashionable in New York society and artistic circles. For Americans, Duchamp was a diabolical emissary of the European avant-garde. The European avant-garde had never heard of him.

Thus, somewhat to his surprise, he found himself instigating a revolution in the New World. There he was able to make a career as a permanent trouble-maker and iconoclast. He divided his time between the two continents, according to mood and financial opportunity, and consequently belonged to neither. Instead, he created a third continent, a fictive land, where he worked to render the banal constraints of common reality inoperative. There, he constructed what can legitimately be called his *œuvre*. The tortuous path that his imagination followed and the diversity of the forms in which it expressed

1 Marcel Duchamp, *Ingénieur du temps perdu*, interviews with Pierre Cabanne, Paris, 1967/1977. (Eng. tr.: Pierre Cabanne, *Dialogues with Marcel Duchamp*, London, 1971; 2nd ed., NY, 1987. The published English translation is unduly literal and sometimes misleading. I have therefore made my own translations from the French text throughout. – Translator's note).
2 "Regions which are not ruled by time and space…": edited transcript of "A Conversation with Marcel Duchamp", television interview conducted by J. J. Sweeney and recorded at the Philadelphia Museum of Art, Philadelphia, NBC, January 1955; in Michel Sanouillet & Elmer Peterson (eds.), *The Essential Writings of Marcel Duchamp*, London, 1975.

Marcel Duchamp
**Given the Illuminating Gas
and the Waterfall**
1948-1949, painted leather over
plaster relief, mounted on velvet,
50 x 31 cm (9 11/16 x 12 3/16 in).
Moderna Museet, Stockholm.

OPPOSITE

Marcel Duchamp at the retro-
spective exhibition at the
Pasadena Museum of Art in 1963.
To his left, *The Brawl at Austerlitz*,
to his right, *Fountain*,
the scandalous readymade of 1917.

itself might suggest that it was constantly at the mercy of the artist's volatile
moods. But we know that, though he eschewed logic, Marcel Duchamp was
nonetheless a thinker, an inventor whose creation was a mode of existence
unique to himself.

"Art is an outlet towards regions which are not ruled by time and space", he
once said. He later modified this statement, declaring that: "The artist appar-
ently acts like a medium, who is looking for a way out of the labyrinth into a
clearing beyond time and space…"

Duchamp knew that he was such a medium. His apparently erratic activity was
meant to lead, by a series of successive, sometimes unrelated approximations,
towards a definite goal. That goal was not immediately apprehensible, because
it lay outside the conventional and elementary forms of reality that are acces-
sible to critical reason and analytical method. Through this activity Duchamp
achieved a total freedom, the freedom to act without having the need to jus-
tify himself to anyone, indeed, without even appearing to be at work. Much to
André Breton's dismay, he spent most of his time playing chess.

This freedom was the "clearing" that he had sought. There were few works
along the way. Either Duchamp was indifferent to such matters, or he simply
chose to economize his thought and energy. After he had abandoned painting,
he continued to work for another fifty-six years, but produced only thirty or so
works.

A cult figure of the 20th century

It is easy to understand how Duchamp was able to surprise and shock his con-
temporaries. It is more difficult to understand how he became one of the cult
figures of the century while producing only a small number of rather singular
works. Yet as early as 1955-1960, he was at the centre of the most important
transformation in artistic values of the second half of the 20th century. This
was Neo-Dada, which led directly to the emergence of Pop art. Only then did
the full significance of Duchamp's work emerge, in the priority of ethics over
aesthetics implicit in his conception of the artist's moral responsibility. This
reversal of perspective undermined the comfortable *status quo* of the prevailing
visual culture. It called into question received wisdom about the artist's func-
tion, and about the content, meaning and purpose of art. What was art? "That
little game which men have always played with one another", was Duchamp's
verdict. From this point on, throughout the 1960s, his influence spread ever
more widely, spawning countless disciples both in the USA and Europe.
Duchamp himself remained unimpressed by his reputation. "I am a proto-
type", he remarked: "Every age has to have one."

Duchamp had been an object of curiosity for his contemporaries ever since the
first "scandals" that he had committed. It comes as a surprise, then, to find that
the first important essay on his work, if we leave to one side a few scattered
articles by his Dadaist friends, dates from 1922. It was written by André Breton
and first appeared in the fifth number of the review *Littérature*, before being

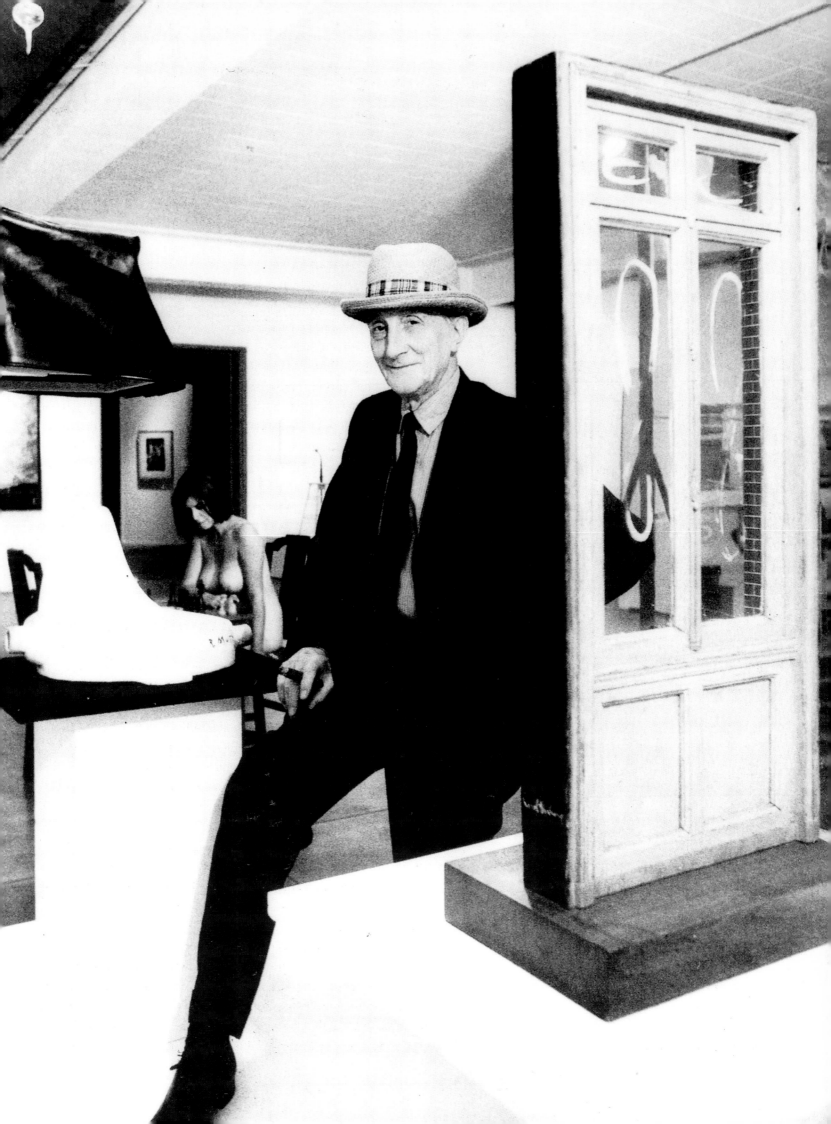

Rook from the set of chess pieces
carved by Marcel Duchamp
in Buenos Aires.

reprinted two years later in Breton's book, *Les Pas perdus*. For an in-depth study of Duchamp's œuvre, we had to wait until 1959, when Robert Lebel's monograph was published simultaneously in Paris and New York. Lebel made no secret of the difficulties that he had encountered in writing his book. At first it was read by a narrow circle only, but it later played a crucial role in introducing Duchamp to a new generation.

The first retrospective exhibition of Duchamp's work took place in 1963, when the artist was seventy-six years old. It was held, moreover, at the Pasadena Museum in California, which is not a major venue. Other retrospectives soon followed in the great museums of Europe and the USA, each show bigger and more warmly received than its predecessors. Duchamp did not much care for such occasions, but attended the openings with his customary detachment. At some of these exhibitions, his work was shown alongside that of his brothers and his sister Suzanne.

Duchamp is unique among artists in another way: virtually his entire œuvre is on permanent display in a single museum. Most of his work belonged to his principal patron, Arensberg, whose collection has been exhibited at the Philadelphia Museum of Art since 1953. After Duchamp's death, his final installation completed this extraordinary collection.

1 - A young man of good provincial family

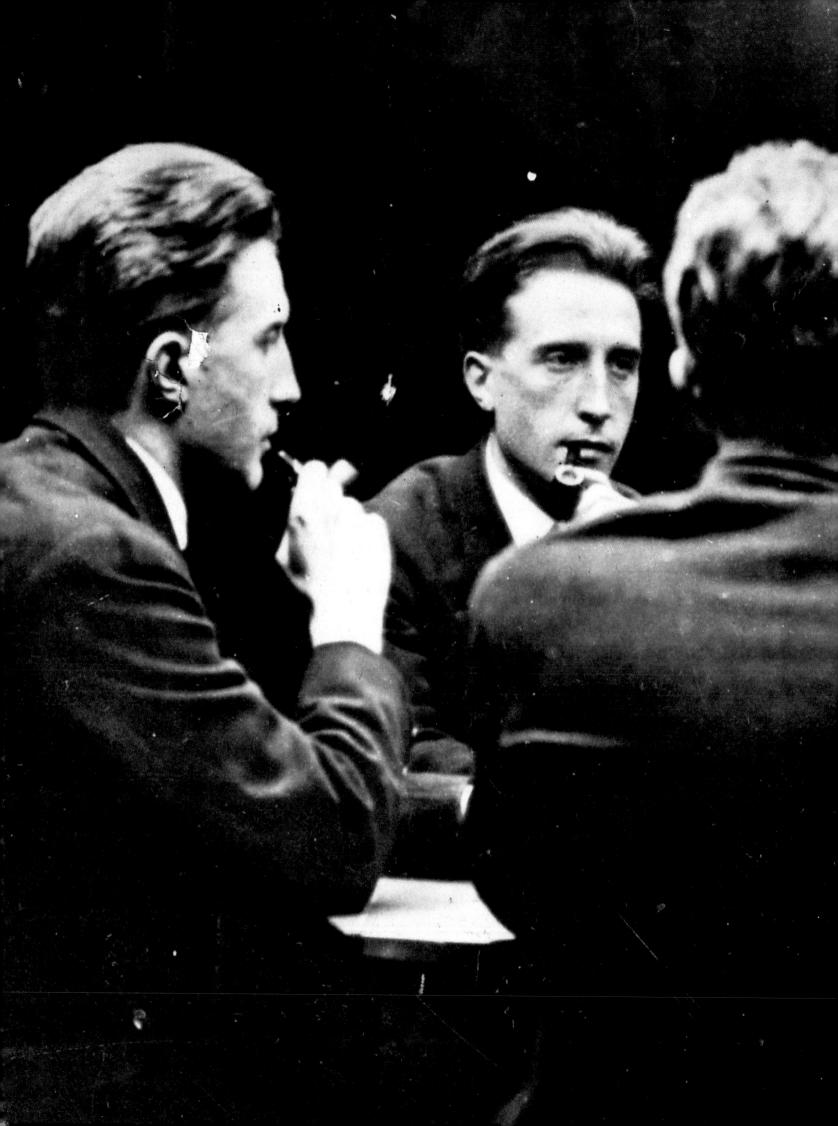

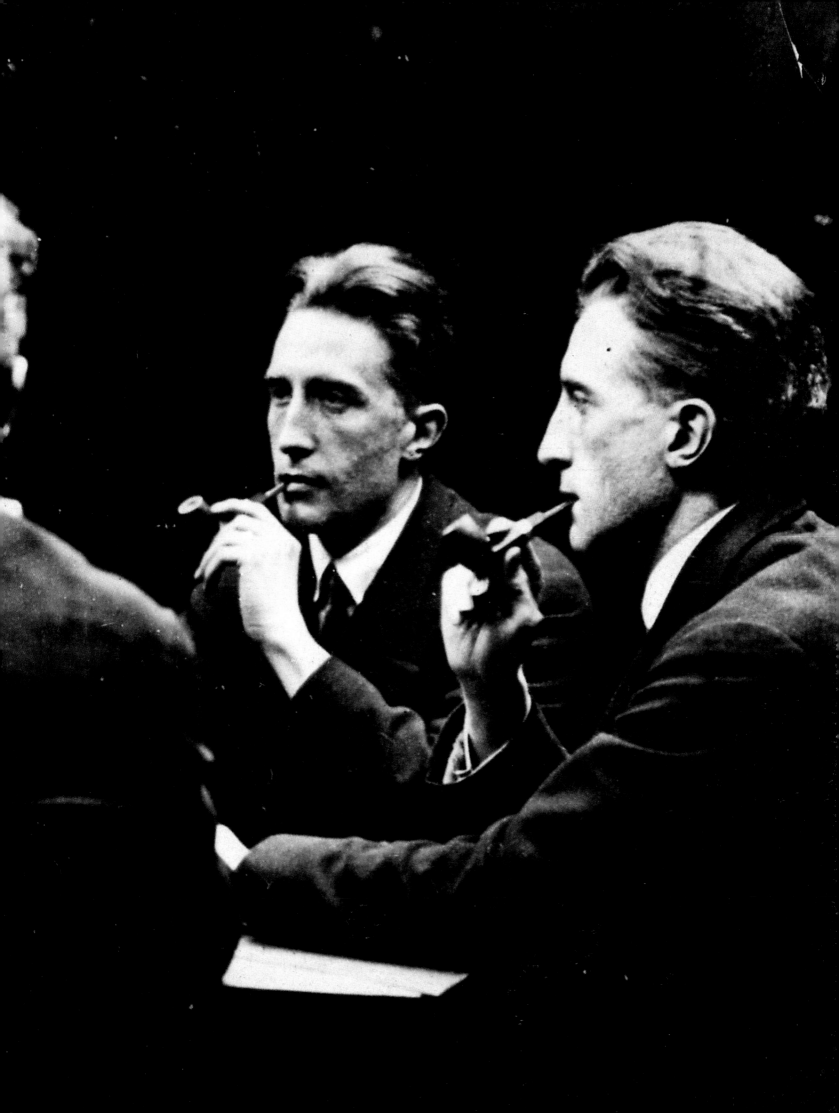

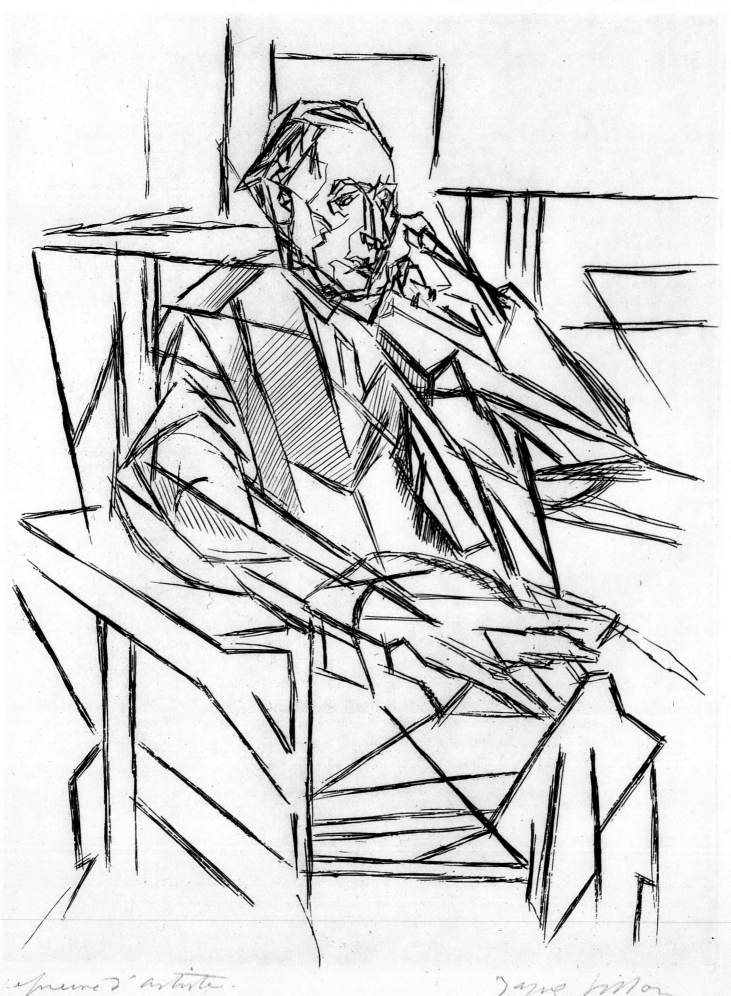

épreuve d'artiste. Jacques Villon

Mademoiselle
Voulez vous doubler?
Nouvelles paroles
d'une vieille chanson

Respectment
marcel Duchamp
09

Both Jacques Villon and his younger brother Marcel Duchamp started their artistic careers as cartoonists. They were very close to one another, as were all the Duchamp children throughout their lives. Later, however, they took different directions both in their art and in their lives. Villon used a pseudonym so as not to offend his family's provincial sense of propriety, and under his new name he came to symbolize "the painter" devoted to his brushes and easel – in short, exactly the kind of artist that Marcel was later to satirize.

Raymond, too, chose an artistic career. He was eleven years older than Marcel, and began to sculpt while his younger brother was still at high school.

Villon was then living in Montmartre, the famous Bohemian quarter, home to painters, poets and cartoonists. The differences in age between the three brothers prevented any jealousy between them. Marcel's later attitudes and behaviour must have been difficult for Villon to accept (Raymond, who died in 1918, at the age of forty-two, did not live to see them). Villon was a very private man with gentle manners. He did not understand his brother, whose way of life was as alien to him as the "things" with which Marcel astonished avant-garde circles. Yet there is no evidence that he ever criticized Marcel or poked fun at his work, at least in public.

The nearest the two brothers ever came to a clash was over the catalogue of the Société Anonyme. The Société Anonyme was a contemporary art collection founded in 1920 by Katherine Dreier. As one of the team who worked on the catalogue between 1943 and 1949, Duchamp inserted an ironically ambiguous article about his elder brother. A few years later, Villon took his revenge. While Duchamp was staying in Paris in 1951, Villon painted his portrait, using his habitual method of decomposing the model through a grid of subtly coloured geometrical planes. Commenting on his intentions, Villon said: "I wanted the plastic interpretation used to remind the viewer of the role which Marcel Duchamp played in the development of the Cubist aesthetic.[1]" The irony was lost on no one, least of all Duchamp himself; his role in the development of the Cubist aesthetic had been minimal, to say the least.

The birth of a vocation

The Duchamps were an archetypal late 19th-century provincial family, respectable and respected. Maître Justin Isidore (known as Eugène) Duchamp was a notary. His house was the most comfortable in Blainville, a rural town nestling in the valley of the Crevon. (This is the area of Normandy in which

ABOVE
Cartoon by Marcel Duchamp, 1909.

PREVIOUS PAGES
Photograph of Marcel Duchamp
taken in New York in 1917.

OPPOSITE
Jacques Villon
Portrait of Marcel Duchamp
1951, engraving,
24.4 x 31.5 cm (9 1/2 x 12 1/2 in).
Private collection, Paris.

1 René Barotte: "Jacques Villon à la galerie Charpentier", *Plaisir de France*, July 1961.

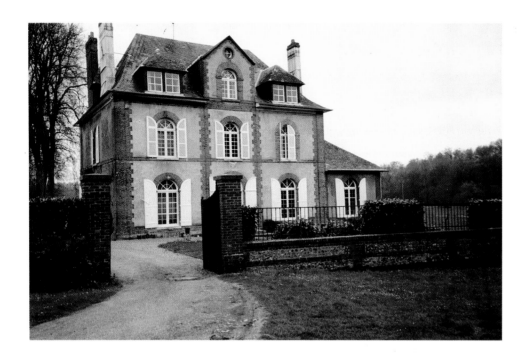

Mme Bovary was set.) The traditional copper plate bearing Justice and her scales was an emblem of respectability in itself. The house has survived virtually unaltered to this day amid extensive gardens surrounded by iron railings. Maître Duchamp and his family took up residence there in 1883, four years before Marcel was born. Gaston (later Jacques Villon) and Raymond were born at Damville, in the department of the Eure, where their father was working in the registry office.

Maître Duchamp was married to Marie-Caroline Nicolle, whose father, Émile Frédéric, was a ship broker. But he was also a talented artist, both as a painter and an engraver; his etchings of the old town of Rouen were well-known. Villon later said that his grandfather, who was much admired by all the family, was not a direct influence on his development so much as a "witness" to it. Neither Gaston nor Marcel learnt engraving from Émile Frédéric.

The couple had six children. They were brought into the world with a regularity that delighted Duchamp: 1875, 1876, 1887, 1889, and then 1895 and 1898 for the last two sisters, Yvonne and Magdeleine. All of them were deeply attached to their Normandy home, and returned to visit it even after the property had been sold.

At Blainville, the Duchamps were rapidly accumulating emblems of the social promotion to which they aspired and the bourgeois values to which they subscribed. Besides the new house, there was Eugène Duchamp's promotion to the office of notary, and his subsequent election as mayor in 1895 – not to mention his numerous offspring. The Duchamps were enthusiastic photographers, and many pictures have come down to us of grandparents and parents, the children as they were growing up, and neighbours and friends who would occasionally pose in the garden, talking, playing cards or striking solemn attitudes. In one,

Marcel can be seen at the age of five or six, wearing a military-style uniform, doubtless the one that he wore for school – an ironic image, given his later distaste for all kinds of regimented behaviour, and the pains that he took to avoid doing military service.

The Duchamps entertained themselves with chess and music. Mrs Duchamp herself painted pictures and dinner services. Marcel said later: "She wanted to fire them in a kiln as well, but in all the seventy years of her life she never managed to. She made paper Strasbourgs.[1]" The walls of the house were decorated with the works of grandfather Nicolle. The Duchamp children grew up in an "artistic" atmosphere.

Marcel studied at the lycée Corneille in Rouen, and lodged at the école Bossuet. He was an average student. His class report for 1901-1902, when he was in the fifth form, notes: "Too much misbehaviour, insufficiently serious, young for his years, needs more maturity; his few efforts too intermittent." The following term was no better: "Success requires more serious effort. Follows the lessons without seeming to take an interest in them." Nor was the third: "Mediocre results in the arts, seems be better at science." Yet he still managed to pass both parts of his baccalauréat, the second in 1904. The previous year he had won first prize for drawing, and in 1904 was awarded a drawing medal by the Rouen Société des amis des arts. These two successes encouraged his ambition to join his brothers in Paris.

Maître Duchamp had been disappointed by Gaston's decision to abandon his law studies in favour of painting. He had expected his eldest son to follow him into the business, and attributed his decision to the bad influence of Paris. Fortunately, Gaston chose to enter the studio of a respectable master, Fernand

1 *Ingénieur du temps perdu, op.cit.*

OPPOSITE

The Duchamp family house
at Blainville.

Marcel Duchamp in military
costume, aged five.

RIGHT

Family portrait with the young
Marcel Duchamp on the left.

Cornon. Cornon was an academic painter and future member of the Institut de France, who specialised in prehistoric and orientalist subjects. What Maître Duchamp did not know was that his son was also developing his skills as an artist by publishing cartoons under a pseudonym. His squibs appeared first in *Le Rouen-Artiste*, then in *L'Étudiant*, and later, while Gaston was on military service, in *L'Assiette au beurre*, *Le Rire* and *Le Courrier Français*. These were all eminently frivolous publications – the sort of magazine that provincial notaries kept hidden in their papers, so that in their quieter moments they could meditate unobserved on pictures of young girls in corsets, lace slips and black stockings, enjoying the improper attentions of older men.

Raymond in his turn gave up medicine in 1898. He was suffering from rheumatoid arthritis, and put his enforced leisure to use by modelling. The desire to become a sculptor was taking root in his mind. In the year that Marcel made his communion, and their sister Magdeleine was born, Villon moved to 71, rue Caulaincourt, at the foot of Montmartre. There his neighbours included Renoir, the draftsman Steinlen and the future architect Francis Jourdain. Maître Duchamp could only look on in sadness as his two eldest sons set out to become artists.

The first "Impressionist" landscapes

Marcel was fifteen when he began to paint. His first model was his favourite sister Suzanne: he painted her playing tennis or patience, or looking at a picture. His admiration for Monet also led him to execute a series of landscapes in the Impressionist manner, using small, rapid brush-strokes. He painted *Landscape at Blainville, Church at Blainville*, and then, in a somewhat freer manner, *On the Cliff*, along with other landscapes and portraits of family and friends. In 1903, Raymond married Yvonne Bon, whose brother was a painter. The following year his *Reclining Nude* was accepted for the Salon organized by the Société nationale des beaux-arts.

Maître Duchamp declared himself delighted with Marcel's drawing medal, but the artistic leanings of his third son worried him. During his last year at the école Bossuet, Marcel made a charcoal drawing of the Welsbach burner (bec Auer) gas lamp in one of the prep rooms, which he signed, noting the place and date. This is the first appearance in his work of the bec Auer; it was to recur several times, ultimately in the "posthumous" installation in the Philadelphia Museum.

At the age of seventeen, Marcel was allowed to join his brothers in Paris. He later claimed: "There had been no objection from my father, whose two elder sons had accustomed him to such things." In fact, things were not so simple; the Duchamp family was not as peaceable as it has been made to appear. It was a clan, a tribe, where strategic alliances alternated with confrontations and stand-offs. Mrs Duchamp made no secret of her preference for her daughters. Was she partly responsible for her sons' departure, and for Marcel's in particular? In later life, Marcel rarely referred to his mother, save to make ironic remarks about her artistic pretentions and emotional detachment. Perhaps he

OPPOSITE
Marcel Duchamp
Landscape at Blainville
1902, oil on canvas,
61 x 50 cm (24 x 19 11/16 in).
Arturo Schwarz Collection, Milan.

Marcel Duchamp
Suzanne Duchamp Seated
1903, pencil on paper,
49.5 x 32 cm (19 1/2 x 12 5/8 in).
Private collection, Paris.

avoided discussing her precisely because he resembled her in certain ways. Did her husband force her to have so many children after the premature death of a first-born? We shall never know. If there was a secret in the Duchamp family, it was well-kept.

Maître Duchamp had abandoned all hope of seeing one of his sons succeed him. But at least, if they were to be artists, they might go further than his wife, with her paper tableware, and his father-in-law, whose views of Old Rouen had earned him a strictly local celebrity. An extremely conscientious man, he scrupulously noted the moneys that he gave to his children, and deducted them from their respective shares of his estate. Thus Villon, who, as the eldest, had been the first to leave, received the most money (150 francs a month) over the greatest period of time, and inherited nothing at all on the death of his father; while Magdeleine, the last born, who had had no need of an allowance because she lived with her parents, received a substantial inheritance.

On arriving in Paris, Marcel moved in with Gaston, in the rue Caulaincourt. Gaston had already built up quite a reputation for his satirical drawings. He designed posters for Montmartre cabarets, and his engravings were published by the art dealer Sagot in the rue de Châteaudun. He had been exhibiting his paintings at the Salon d'Automne since its foundation in 1903. In 1904, he was elected a member of the Société des beaux-arts. In 1905, Raymond too began to exhibit at the Salon.

Duchamp would later say: "At the 1905 Salon d'automne it occurred to me that I too might make a painter".

Marcel's début at the Salon des humoristes

The Blainville landscapes had been executed with surprising facility; but the early figure drawings showed greater vigour, though they were somewhat lacking in personality. The *Portrait of Marcel Lefrançois*, probably painted two or three years later than the date (1904) usually given, represents a significant advance. The face is given a very forthright treatment, and considerable effort has gone into preparing the colours, using spirit over a black-and-white oil base. Lacquers are also used to enhance some of the highlights of the face. All this suggests a technique.

In Paris, Duchamp enrolled at the Académie Jullian, where he studied for the entrance examination to the École des beaux-arts. He failed at his first attempt and chose not to resit. Instead, he spent his time sketching street scenes around Paris, and drawing cartoons which, with Villon's help, he published under his own name in *Le Courrier Français*, *Le Rire* and *Le Sourire*. He showed an immediate grasp of both the graphic conventions of the most fashionable artists, and the often salacious double entendre featured in their captions. He already affected a certain detachment about material advantage, a trait which cannot be explained simply by the fact that his father paid him a monthly allowance. Thanks to his brother, he now spent much of his time in the company of newspaper cartoonists, and was sometimes paid by the newspapers who used his work. He was developing the persona of an intellectual dandy. Already he seemed to view "professional painters" with ironic amusement. He,

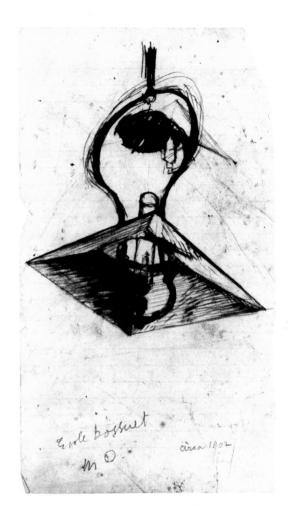

Marcel Duchamp
Hanging Gas Lamp (bec Auer)
1903-1904, charcoal,
22.4 x 17.2 cm (8 13/16 x 6 3/4 in).
Private collection, Paris.

OPPOSITE
Marcel Duchamp
Church at Blainville
1902, oil on canvas,
61 x 42.5 cm (24 x 16 3/4 in).
The Louise and Walter Arensberg Collection,
Philadelphia Museum of Art.

Marcel Duchamp

Portrait of Marcel Lefrançois

Detail. 1904, oil on canvas,

65 x 60 cm (25 1/2 x 23 7/8 in).

The Louise and Walter Arensberg Collection,
Philadelphia Museum of Art.

OPPOSITE

The three brothers at Puteaux.

From left to right:

Marcel Duchamp, Jacques Villon,

Raymond Duchamp-Villon.

Duchamp, lived at the bottom of the hill, and did not mix with the rowdy artistic Bohemians from "upper" Montmartre.

At the age of twenty, Duchamp exhibited his work in public for the first time. He made his début in the French art world as a cartoonist at the 1907 Salon des artistes humoristes.

By this time he was studying to be a printer and typesetter. This was a sub-terfuge rather than a serious ambition, but he worked hard and was eventually awarded his diploma as an *ouvrier d'art* ("art worker"). Thanks to this qualification, his military service was curtailed, and in the end he served only one year, at Rouen and at Eu. On his discharge from the army, he returned to Paris, where he enrolled once more at the Académie Jullian. But he could not take his studies seriously, and spent more time playing billiards than working with his teachers. He continued to give cartoons to the papers, and he took up painting once again. Then the summer came, and he left for a typically bour-geois vacation, holidaying with his family on the Normandy coast.

All this took place in 1907. This was the year Picasso, an inhabitant of "upper" Montmartre, painted his *Demoiselles d'Avignon*. But Duchamp only met Picasso several years later, in 1912 or 1913, and the two men were never close.

Indeed, Duchamp did not socialize with any of the young avant-garde artists of the first years of the century, though he knew their work. Eventually, however, he was forced out of his sardonic reserve by the revelation of the Fauves at the 1905 Salon d'automne. The decisive encounter may well have been with Matisse, of whom he later said: "His canvases had moved me greatly, especially the large figures defined by flat areas of red or blue… It was very striking…[1]"

"Between 1906 and 1910 or 1911, I drifted between different motions: Fauve or Cubist, sometimes returning to more classical models.[2]" It is clear that Duchamp's "vocation" lacked urgency, and in conversation he often spoke of his doubts and hesitations. Should he be a cartoonist? Or a painter? This is where the revelation of Matisse was crucial: "He was the starting point." Yet the two men hardly knew each other, and probably met some two or three times only. Matisse was not part of the group associated with "upper" Mont-martre, and like Duchamp, despised the Bohemians. No matter. Despite their similarities, Duchamp kept his distance.

His public career as a painter began at the 1908 Salon d'automne, where he exhibited three canvases under the titles *Portrait*, *Flowering Cherry Tree* and *Old Cemetery*. All three have since been lost, unless the *Portrait* is that of Marcel Lefrançois. Villon had by then moved from Montmartre to the suburb of Puteaux, which at that time was still a rural address. He settled in a pic-turesque hamlet of houses and studios, with the Czech painter Kupka as his neighbour, and was joined by his brother Raymond soon after. Puteaux was to remain Villon's home until his death fifty-seven years later.

Now Duchamp in his turn abandoned Montmartre and his cartoonist neigh-bours, and moved to Neuilly, a residential quarter where superb aristocratic properties were scattered among vast parks. In this way, he was able to put yet

1 *Ingénieur du temps perdu, op. cit.*
2 *Ibid.*

more distance between himself and the "artistic" milieux and haunts that he detested. Neuilly had two main qualities to recommend it: it was quiet, and it was near to Puteaux.

He now began to exhibit at the Salon des indépendants, the Salon d'automne and the Société normande de peinture moderne, whose show opened in Rouen before moving to Paris. Each summer he joined his family for at least part of the traditional holiday at Veules-les-Roses. *Le Sourire* and *Le Courrier Français* were probably never seen in their house, for fear they might fall into the hands of the girls. But Marcel's début as an "artistic painter" was well received – as was the news that he had sold two of his paintings through the Salons.

While at Veules-les-Roses during the summer of 1909, Marcel painted a *Portrait of Yvonne Duchamp* in which his sister is sitting beside a window, lost in her thoughts. It is a quite unprovocative picture, tending to the austere, unlike his landscapes which mix a rather busy version of Impressionism with touches of watered-down Fauve. Examples of the latter style can be found in *House in the Forest*, painted at Yport in 1907, and *House Among Apple Trees* and *Red House Among Apple Trees*, both painted near Villon's house at Puteaux. The *Red House* in question was that of Villon's neighbour Kupka. This canvas shows

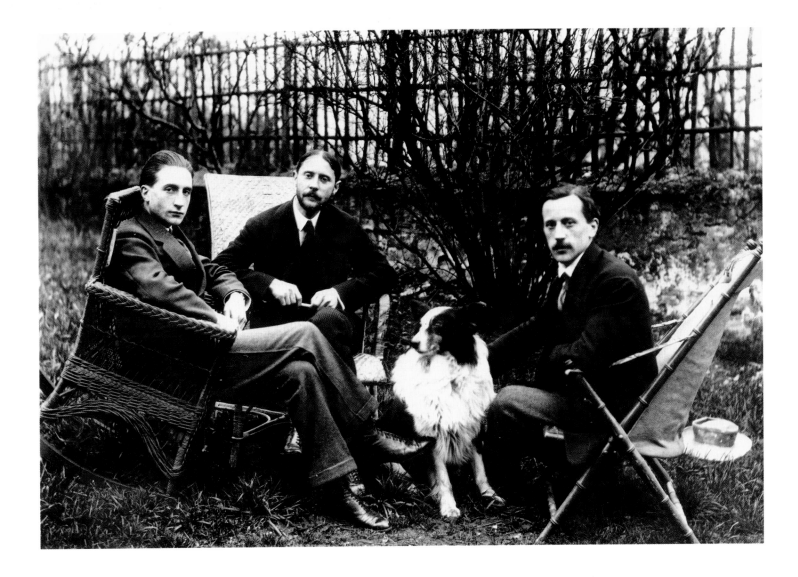

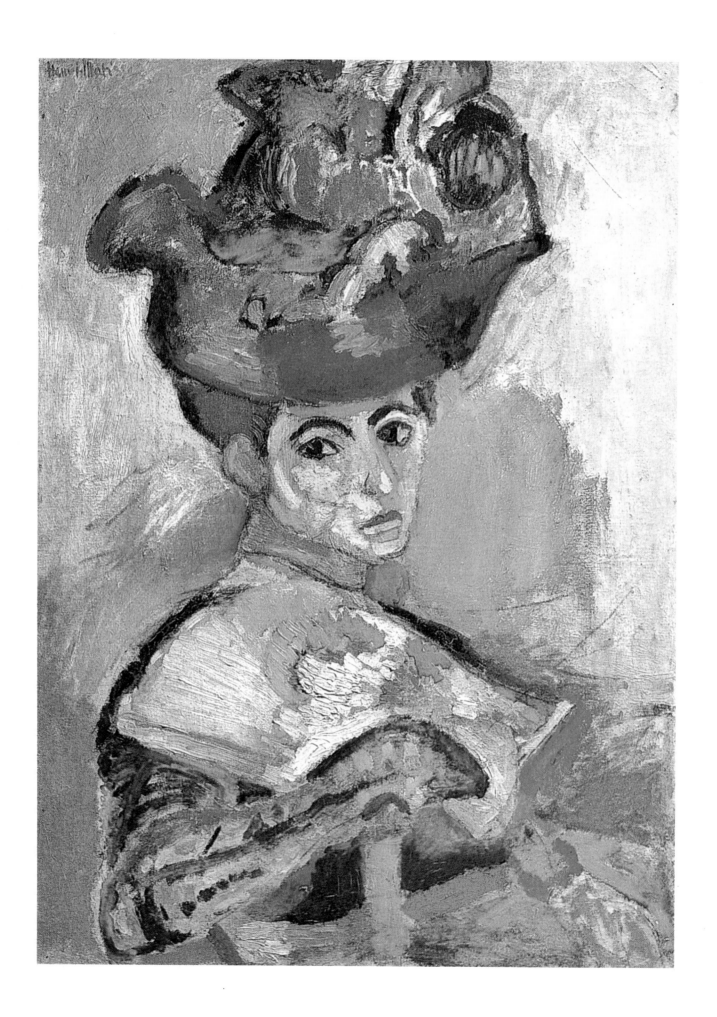

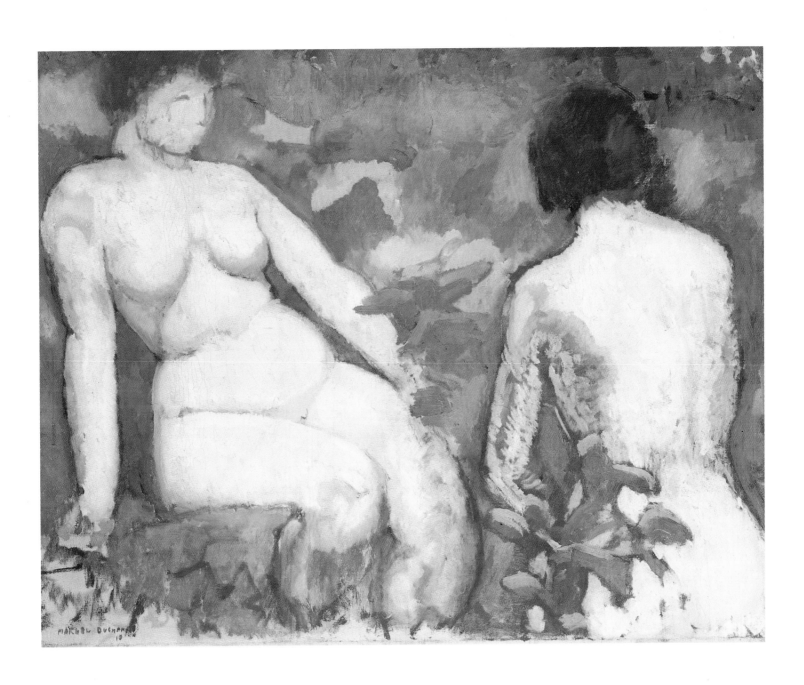

OPPOSITE

Henri Matisse

Woman with the Hat

1905, oil on canvas,

81 x 65 cm (32 3/8 x 26 in).

Museum of Modern Art, San Francisco.

Marcel Duchamp

Two Nudes

1910, oil on canvas,

71.5 x 91 cm (28 1/8 x 35 7/8 in).

Musée national d'art moderne, Paris.

Marcel Duchamp
Naked Woman in a Bathtub
1910, oil on canvas,
92 x 73 cm (36 1/4 x 28 3/4 in).
Private collection.

OPPOSITE
Marcel Duchamp
Nude with Black Stockings
1910, oil on canvas,
116 x 89 cm (45 11/16 x 35 1/16 in).
Private collection, Paris.

Marcel Duchamp photographed in
front of his *Nude with Black Stockings*.

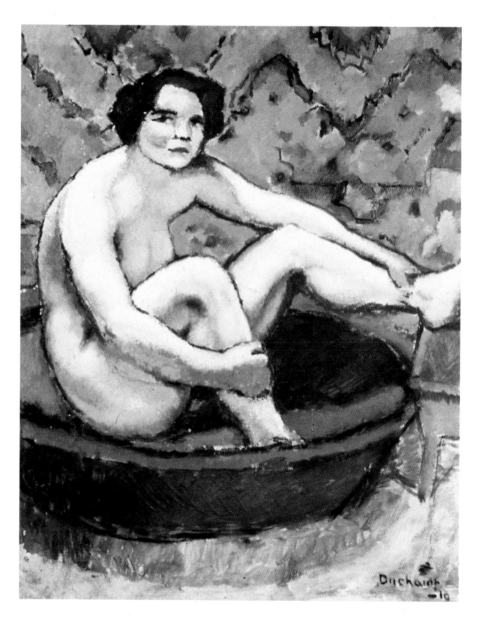

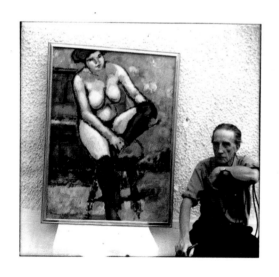

more assertive brushwork and more brilliant colours. Another example of the
tendancy to amalgamate various sources of inspiration is a picture combining
Bonnard and Vuillard on the theme, *Peonies in a Vase*. All these works are
essentially exercises. Duchamp was still learning his craft.

After this quieter interlude, Fauvism returned with a vengeance and
Duchamp's colours grew more and more vivid. They were no longer separated
into individual brush-strokes, but combined and constructed in a way he had
learnt from Cézanne, whose paintings he had seen at Vollard's gallery.
Cézanne, too, was a revelation. *Naked Woman in a Bathtub*, which dates from
early 1910, demonstrates this new mixture of influences. The woman's pose is
reminiscent of Degas's pictures of women washing; but the painting as a whole
looks much more "modern" than Duchamp's previous work in the way it mod-
ulates colour and establishes the volumes of the body by shadow and outline.
These modern touches are again present, in simpler, more expressive form, in
Two Nudes. Here the flesh has a real softness despite the tactile energy of the

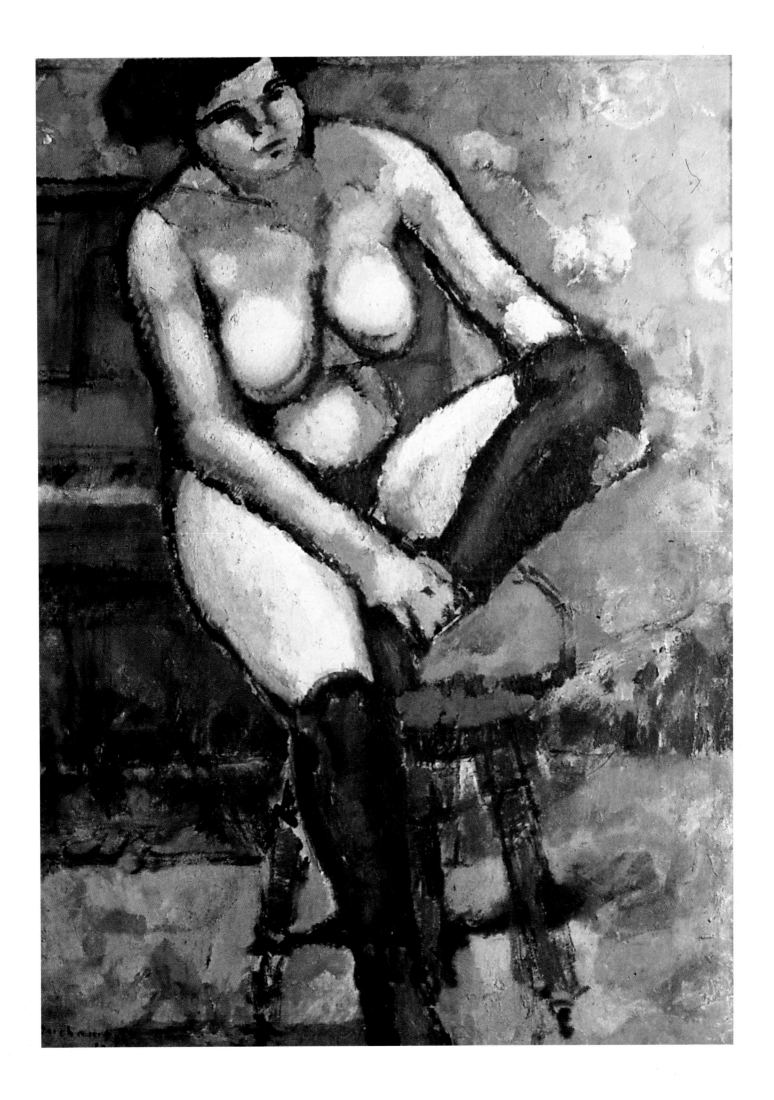

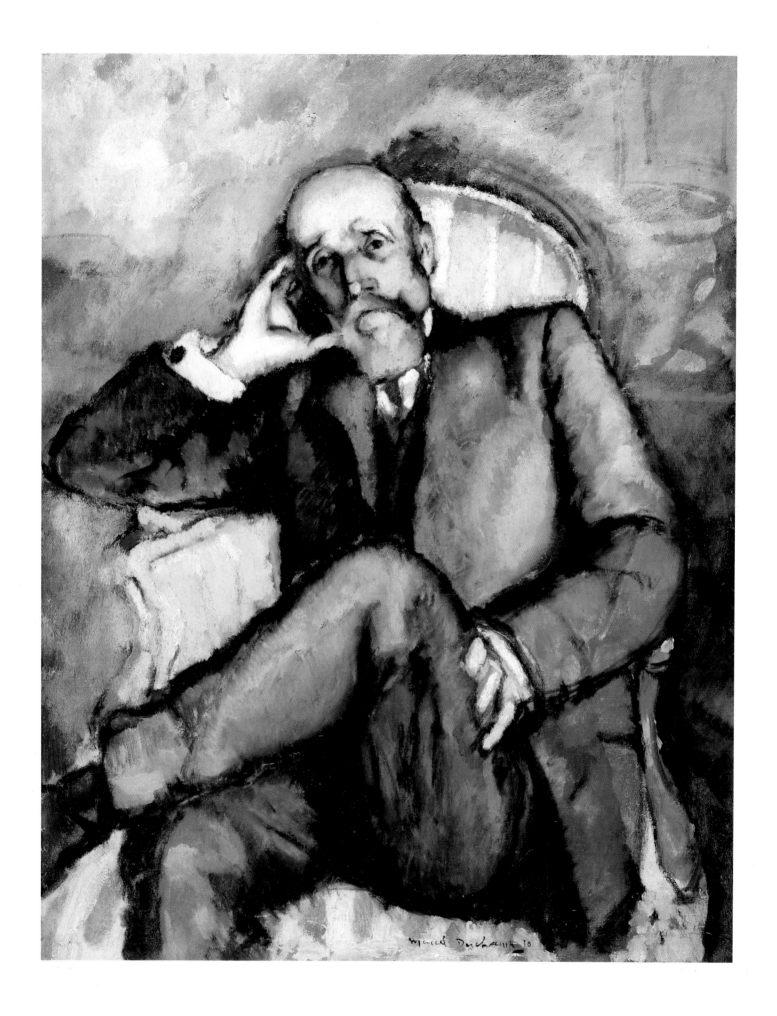

brushwork. The softness is all the more surprising when compared with the very different *Nude with Black Stockings*, painted shortly afterwards at Rouen, probably in a friend's studio. Here volume is brusquely, almost crudely asserted, using thick contours. Duchamp uses grey-white tones that shade delicately into pale greens, pinks and blues, and thus contrast with the vigour of the black. The painting had transformed the scantily dressed "young things" of Duchamp's cartoons into buxom models with heavy breasts and luxuriant pudenda. All they have retained from their former incarnation is black knee-length stockings. Is this for erotic effect, tonal contrast, or is it simply a fashion of the time? Black stockings are a common feature in the work of Lautrec, Rops, Van Dongen and Bonnard.

The *Red Nude* of 1911 lives up to its title. Duchamp effectively used a single colour to paint this squatting woman. Her face is schematically built up from flat areas of paint. The schematisation shows the influence of Matisse; the intensity of colour derives from Vlaminck and Derain. His Fauvism may have been belated, but Duchamp carried it off with conviction, in both landscape and figure paintings such as the 1910 *Portrait of Chauvel*. Chauvel was an artist and a friend of Duchamp's. He lived and worked in Rouen, and his own painting was remarkable for its energy and brilliant colours. Also in 1910, while staying with his family, Duchamp produced a superb *Portrait of the Artist's Father*. As far as we know, Marcel never made a portrait of his mother.

In *L'Intransigeant* of 20 March 1910, Apollinaire described the nudes Duchamp had shown at the Salon des indépendants, along with two other canvases, as "very ugly". At the 1911 Salon d'automne, he promoted Duchamp's entries to "interesting", and by November of the same year, visiting an exhibition at the Galerie d'art contemporain, he deemed Duchamp to be "progressing strongly". But Apollinaire too often wrote the first thing that came into his head, and Duchamp did not much care for him, feeling that he was too easily influenced and had no real convictions of his own. Like many painters, he judged Apollinaire's knowledge of art too slight to support his critical pretentions. His opinion was not improved by the chapter Apollinaire devoted to him in his book, *The Cubist Painters*.

An unusual portrait: Dr Dumouchel

In the *Portrait of the Artist's Father*, Duchamp *père* is shown sitting in an armchair, his head resting on his right hand. The tonal range is dominated by cold matt greens and browns. As his son said much later: "It is a typical example of my devotion to Cézanne, combined here with love of my father.[1]" An intelligent and liberal bourgeois patriarch thus entered the history of art thanks to his third son, the most peculiar and unpredictable member of the family. For if Marcel was practising his new "trade", he was doing so without any great conviction and with no clear sense of where it might lead. Indeed, he seemed to be motivated more by curiosity than by any consuming passion.

OPPOSITE

Marcel Duchamp
Portrait of the Artist's Father
1910, oil on canvas,
92 x 72.5 cm (36 1/4 x 28 3/4 in).
The Louise and Walter Arensberg Collection, Philadelphia Museum of Art.

Marcel Duchamp
Portrait of Chauvel
1910, oil on canvas,
53 x 41 cm (20 7/8 x 16 1/8 in).
Private collection, Paris.

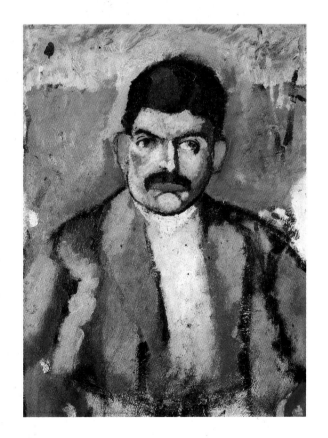

1 *Ingénieur du temps perdu, op. cit.*

Marcel Duchamp
The Bride Stripped Bare…
1968, etching,
50.5 x 32.5 cm (19 7/8 x 12 3/4 in).
Private collection, Paris.

The aura that surrounds the Bride's
body should be compared with that
around Dr Dumouchel's hands,
opposite.

OPPOSITE
Marcel Duchamp
Portrait of Dr Dumouchel
1910, oil on canvas,
100 x 65 cm (39 3/8 x 25 9/16 in).
The Louise and Walter Arensberg Collection,
Philadelphia Museum of Art.

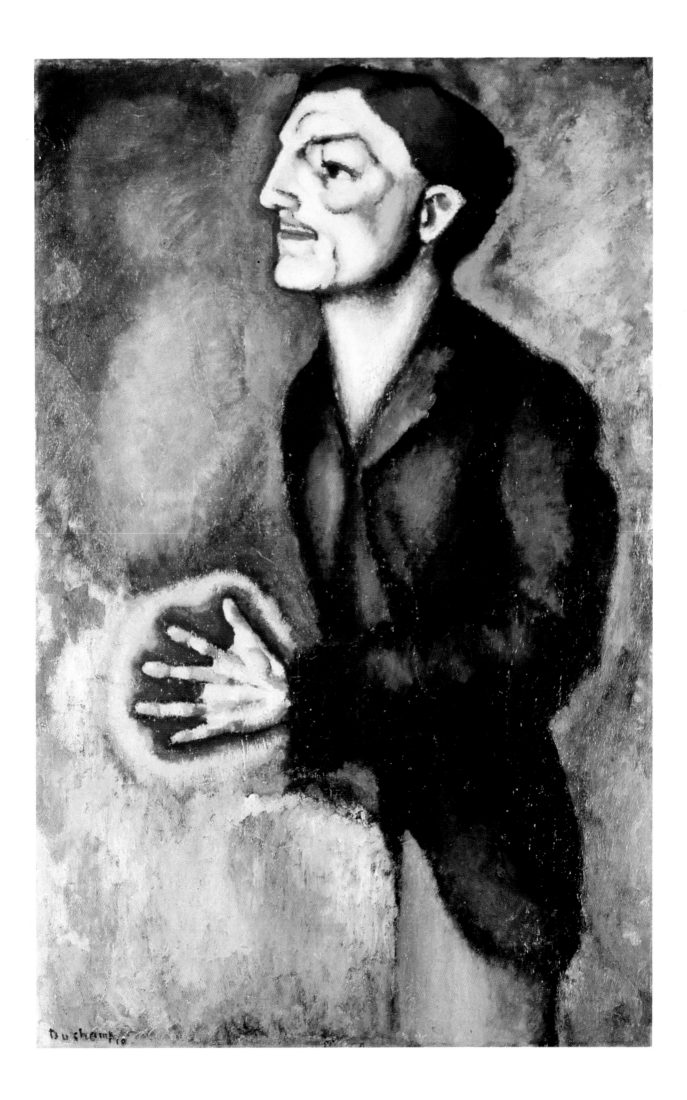

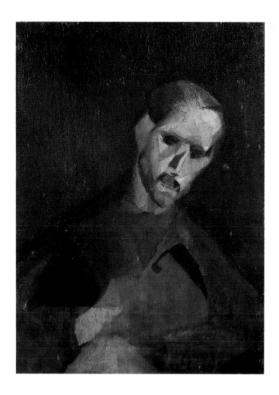

Jacques Villon
**Portrait of Raymond
Duchamp-Villon**
1911, oil on panel,
35 x 26.5 cm (13 3/4 x 10 1/2 in).
Musée national d'art moderne, Paris.

"I really didn't have a preconceived plan of action", he said later. "I didn't even think about whether I should sell my paintings or not. There was no theoretical basis… You paint because you want to be free. You don't want to go to the office every morning.[1]" Villon, still working for *Le Courrier Français*, was of the same opinion.

At Neuilly in 1910, Marcel painted the *Portrait of Dr Dumouchel*. This is perhaps the most Fauve of all his works – a riot of green, indigo, madder and Prussian blue. Much later, when the canvas was bought by the Arensbergs, Duchamp told them that it contained "a note of humour which already hints at my future change of direction and my abandonment of merely retinal painting.[2]"

This was perhaps something of an exaggeration. But in another part of the same letter of 1951, Duchamp comments on the strange iridescence that surrounds Dumouchel, as if he were in a trance, and what Arensberg called the "mist-like aura or halo" around his hand: "The 'halo'…, which is not explicitly motivated by Dumouchel's hand, is a sign of my subconscious preoccupation towards a metarealism. (…) It has no definite meaning or explanation except the satisfaction of a need for the 'miraculous' which preceded the Cubist period."

Dumouchel's halo is perhaps related to the strange nimbuses or mandorlas that surround the figures in *The Bush* and *Nude on Nude* (two juxtaposed nudes painted at different times, one in 1909, the other in 1910). It may also be connected to the flesh-coloured Milky Way that floats at the top of *The Large Glass*, and which Duchamp described as "the sum total of the splendid vibrations" given off by the Bride. The halo appears again almost at the end of Duchamp's life, surrounding the naked girl shown kneeling on a prayer stool in an etching made in 1968, under the title: *The Bride Stripped Bare…*

Duchamp's use of the halo in the Dumouchel portrait has been attributed to the influence of Odilon Redon. Duchamp was certainly interested in Redon's work at this time, but haloes did not have quite the same symbolic meaning for him as for Redon. He seems to have intended an ironic allusion to the miraculous healing powers of his friend's hand. At the time, Dumouchel was studying medicine (Duchamp knew him from their time together at the école Bossuet). Dumouchel's career enhanced the irony; though he retained an interest in new medical discoveries, Dumouchel was at best an occasional practitioner.

Duchamp made a habit of suiting his interpretations of his work to the interlocutor and the occasion. His statements were often dictated by the desire not to contradict someone else's interpretation, which was, after all, as valid as any. In 1951, when the Arensbergs wrote to Duchamp asking for his comments on this early painting, their letter was permeated with their own passion for the occult. This explains why he refers in his reply to his "subconscious preoccupation towards a metarealism". As for satisfying "a need for the miraculous", he was careful not to expand on the subject. Duchamp was always a master of understatement.

1 *Ingénieur du temps perdu, op. cit.*
2 Letter from Marcel Duchamp to the Arensbergs, Francis Bacon Foundation Archives, Claremont, California.

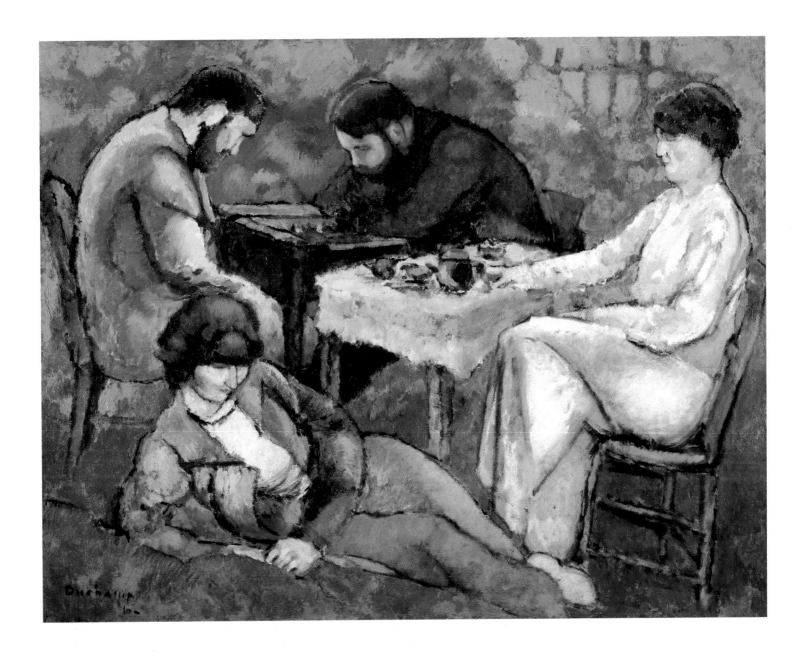

Discovering Cubism

At Puteaux, the two brothers would spend hours talking in Villon's garden. That is where, in August 1910, Marcel painted his most Cézannesque picture, *The Chess Game*. It, too, was later acquired by the Arensbergs. The figures depicted are Jacques Villon, Raymond Duchamp-Villon and their wives. This work marks the first appearance in Duchamp's œuvre of one of his central themes: chess. He had been playing chess with the other members of his family since he was a teenager, and his interest in the game continued throughout his life. For Duchamp, it was not only a form of recreation, but a way of earning money and an ethical and aesthetic discipline. *The Chess Game* was exhibited at the 1910 Salon d'automne, and on the strength of it Duchamp was admitted to membership of the Société des beaux-arts – a privilege of which he made very little use.

Marcel Duchamp
The Chess Game
1910, oil on canvas,
114 x 146 cm (44 7/8 x 57 1/2 in).
The Louise and Walter Arensberg Collection,
Philadelphia Museum of Art.

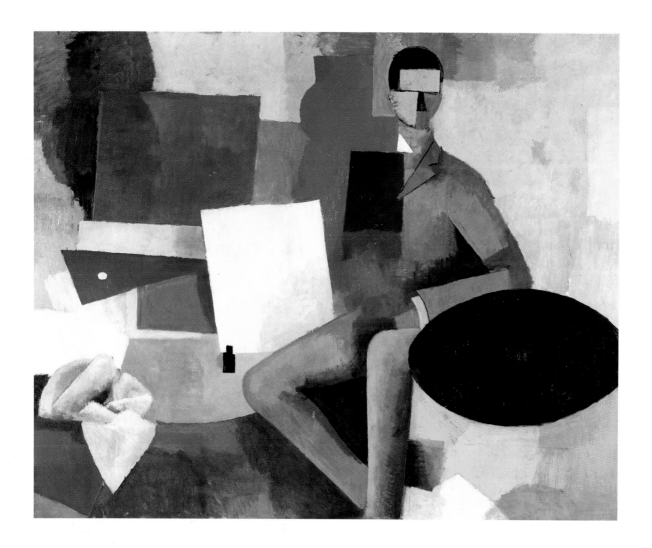

Roger de La Fresnaye
Seated Man
1913-1914, oil on canvas,
165 x 81 cm (65 x 31 7/8 in).
Musée national d'art moderne, Paris.

OPPOSITE, ABOVE
Georges Braque
Still Life with Violin
1911, oil on canvas,
130 x 89 cm (51 1/4 x 35 in).
Musée national d'art moderne, Paris.

OPPOSITE, BELOW
André Lhote
The Painter and His Model
1920, oil on canvas,
97 x 130 cm (38 1/4 x 51 1/4 in).
Musée national d'art moderne, Paris.

It was at about this time that Duchamp chanced one day to walk into Kahnweiler's gallery in the rue Vignon. The canvases on show were by Georges Braque. Duchamp was overwhelmed by what he saw. "That was when Cubism got hold of me", he said later. On leaving the gallery, he went immediately to report his discovery to Villon.

By the spring of 1911, Sunday lunch in Puteaux had become a well-established social rite. Regulars included Gleizes, Metzinger, Léger, Le Fauconnier and La Fresnaye. They were recent acquaintances of the Duchamp brothers, and all practised a less hermetic, more sensuous form of Cubism than that associated with Picasso and Braque. At the Salon d'automne of that year, Raymond Duchamp-Villon, who was in charge of the hanging, grouped these artists together with his brothers and a few others in the central hall of the Grand Palais. As at the previous year's Salon des indépendants, the "Cubist room" provoked a scandal. Gabriel Mourey, writing in *Le Journal,* was one typical voice: "May I confess that I do not believe that Cubism has a future; not the Cubism invented by Mr Picasso, nor the Cubism of his imitators, Messrs Metzinger, Le Fauconnier, and Gleizes."

Nowadays we would dissent. But in one respect Mourey's account was accurate; Picasso was not represented there, and it was his "imitators" – Braque

called them the "Cubisters" – who came to represent Cubism in the eyes of the public and critics. In the work of these hangers-on, Cubism was effectively reduced to the influence of Cézanne and geometrization of the subject.

Duchamp, for his part, was suspicious of all Cubists, whether genuine or fake. He felt, as he later said, "a mistrust of systematization. I've never been able to force myself to accept pre-established formulae, to copy or be influenced... The new technique of Cubism required a certain manual adaptation.[1]" He was, nevertheless, tempted by this new way of representing volume, which restored spatial density and solidity to the object. He thus passed through Cubism much as he had passed through Fauvism. It was never his intention to commit himself to the latest fashion, but simply to test and, where appropriate, make use of anything that painting could do.

Duchamp's interest in symbolism, already apparent in the portrait of Dumouchel, recurs in an unusual composition of 1910-1911, entitled *Paradise*. Perhaps this picture too betrays the influence of Redon. In any case, there is something distinctly humorous about its allegorical vision of Edenic innocence. Indeed,

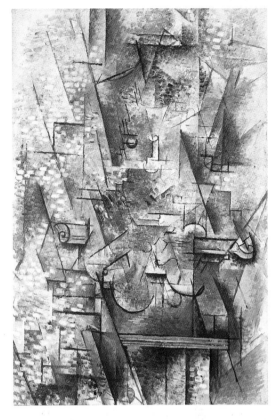

1 *Ingénieur du temps perdu, op. cit.*

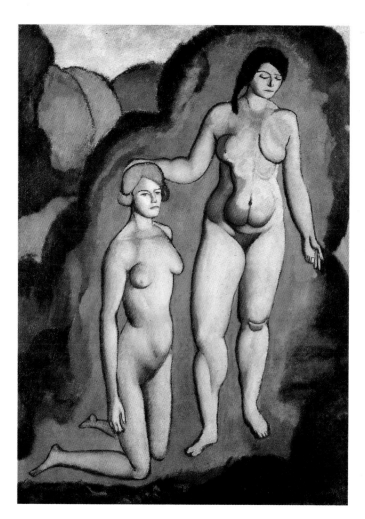

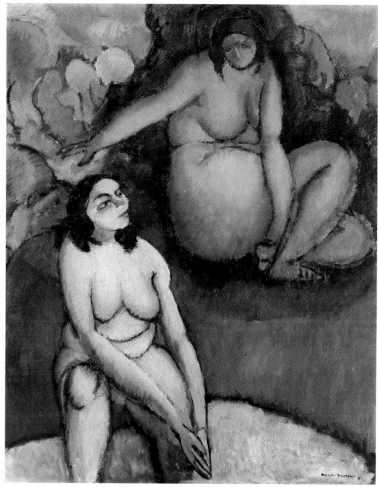

ABOVE

Marcel Duchamp

The Bush

1910-1911, oil on canvas,

127.5 x 92 cm (50 x 36 1/4 in).

The Louise and Walter Arensberg Collection,
Philadelphia Museum of Art.

RIGHT

Marcel Duchamp

Baptism

1911, oil on canvas,

91.7 x 72.7 cm (36 1/8 x 28 5/8 in).

The Louise and Walter Arensberg Collection,
Philadelphia Museum of Art.

the figures of Adam (Dr Dumouchel) and Eve (a professional model known as the Japanese Girl) are made to look completely ridiculous.

In *Baptism*, and above all in *The Bush*, Marcel took pleasure in parodying subjects dear to academic painters. Both pictures combine allegory with the representation of a kind of initiatory rite centred on a complex relationship between two female nudes. In *Baptism*, one figure seems to be protecting the other; the latter appears surprised to have a hand thus bestowed on her. In *The Bush*, this protective gesture is transformed into a blessing. A standing woman lays her hand on the head of a woman kneeling beside her. The kneeling figure is younger and more delicate, and her ochre-coloured flesh contrasts with the resplendent brick-red nakedness of her companion. Various interpretations of this scene have been proposed. In particular, it may be seen as a rite of passage, in which a buxom matron "presents" a young girl to an invisible Master of Knowledge, who is to make a woman of her. As such, it is the first version we have of a topos that recurs throughout Duchamp's work, that of the transition from Virgin to Bride.

The bush is represented by a nimbus. It was, of course, in a bush that God first appeared to Moses and told him of his mission. Duchamp uses this biblical symbol to emphasize the fact that the virgin is predestined to become a

woman. The third and final stage in this complex ritual is figured in *Draught on the Japanese Apple Tree*, painted in the spring of 1911 in the garden at Puteaux. The picture is dedicated to Duchamp's sister-in-law Gaby, Villon's wife. A flabby corpulent figure with an air of impassivity, perhaps a Buddha, has achieved illumination, and is sitting beneath the Tree of Knowledge. A breeze shakes the Tree – the same breeze that later moves the three pistons of the Milky Way in *The Large Glass*. But we can also see in it the wind that was soon to blow through Duchamp's art and sweep away all earlier influences, leaving him free to invent his own language.

On 24 August 1911 his favourite sister, Suzanne, married a pharmacist from Rouen. Duchamp was deeply upset by this union, which he felt as a betrayal. As a wedding present, he gave the couple a picture called *Spring, or Young Man and Girl in Spring*, which he had painted specially for the occasion. The dedication on the back of the canvas was to his sister alone.

The painting is both Symbolist and symbolic. The year 1911 was one of intense research for Duchamp, and *Spring* is one of the most deeply meditated of the works that came out of this period. The picture has been interpreted in many different ways. Arturo Schwarz, a former art dealer who became Duchamp's biographer, saw in it an alchemical work expressing in coded language the painter's incestuous love for his sister. Duchamp's only comment was: "If I dabbled in alchemy, it was in the only way permissible in this day and

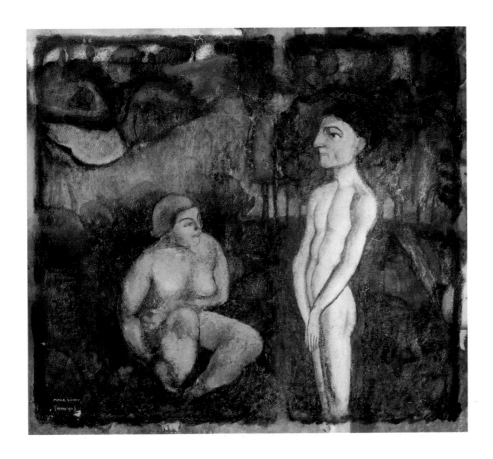

Marcel Duchamp
Paradise
1910-1911, oil on canvas,
114.5 x 128.5 cm (45 1/16 x 50 9/16 in).
The Louise and Walter Arensberg Collection,
Philadelphia Museum of Art.

OPPOSITE

Marcel Duchamp

*Spring or, Young Man
and Girl in Spring*

1911, oil on canvas,

65.7 x 50.2 cm (25 7/8 x 19 3/4 in).

Arturo Schwarz Collection, Milan.

Marcel Duchamp

Sonata

1911, oil on canvas,

145 x 113 cm (57 1/16 x 44 1/2 in).

The Louise and Walter Arensberg Collection,
Philadelphia Museum of Art.

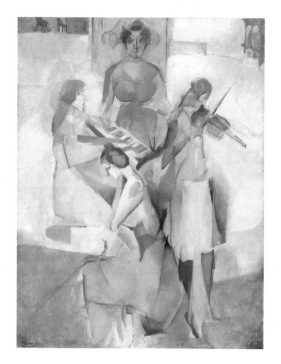

age, that is, unwittingly." He was beginning to surround himself with that aura of ambiguity and enigma which interpreters have found so inscrutable. By doing so, he secured a position of sovereign detachment in the artistic consciousness of his time.

His curious wedding present to Suzanne repays close attention. The central figure in the picture is the Tree of Knowledge. On one side of it stands a naked youth, on the other a naked girl. They are both reaching up to pluck the fruit from its boughs. In symbolic terms, they are trying to understand the meaning of the world. Between them hangs a large glass ball – which may represent the earth – inside which ill-defined forms can be seen moving. The young couple are united by their common desire. What separates them is a large black V-shape at the foot of the tree, which seems to push the two figures apart. So far, so good. However, if the young man is meant to represent not Suzanne's husband, but Marcel, then the meaning of the picture is transformed. The brother, whose genitals are strangely masked, and the sister who he thought of as his female counterpart, are struggling together to reach a common goal – the knowledge of painting. The V would then symbolize the intrusive marriage which had interrupted their common quest. Marcel, the bachelor protagonist, has lost his double, who has entered on the rite of passage from Virgin to Bride. In the trilogy of paintings which depict the stages of this initiation, we can thus already identify the premises of the symbolic-sexual epic that Duchamp was later to construct in *The Large Glass*.

The Salon de la Section d'or

At this point, Cubism made its first appearance in Duchamp's work in two new paintings: *Sonata*, which he worked on in the summer of 1911 in Rouen and in Neuilly, and *Portrait*, or *Dulcinea*, which he painted at Neuilly in October. In both works, the subject is dislocated, different points of view are juxtaposed, and the palette is deliberately pale, cold, and monochromatic. *Sonata* shows the three Duchamp sisters and their mother making music. The standing figure of Mrs Duchamp provides the central axis of the composition. She is seen both full face and in profile, while her daughters are arranged around the different facets of the lozenge that provides the painting with its basic structure. *Dulcinea* represents a young woman whom Marcel had seen several times when she was out walking her dog in Neuilly, but whom he never approached and whose name he never knew. In the picture her figure appears five times over, both naked and fully-clothed, positioned on different planes.

Duchamp said he was trying to "detheorize" Cubism, "so as to interpret it more freely". He had already moved a long way both from Picasso and Braque, and from the "Cubisters" of the Salons, and the results of his experiments must have aroused a great deal of interest. His main innovation was to give a central role to an element which all other Cubist paintings had neglected: light. The result is the unique luminous atmosphere in which the dislocated bodies seem to float. Without abandoning his jackdaw propensities, Apollinaire had by now established himself as the standard bearer of Cubism in all its many manifestations.

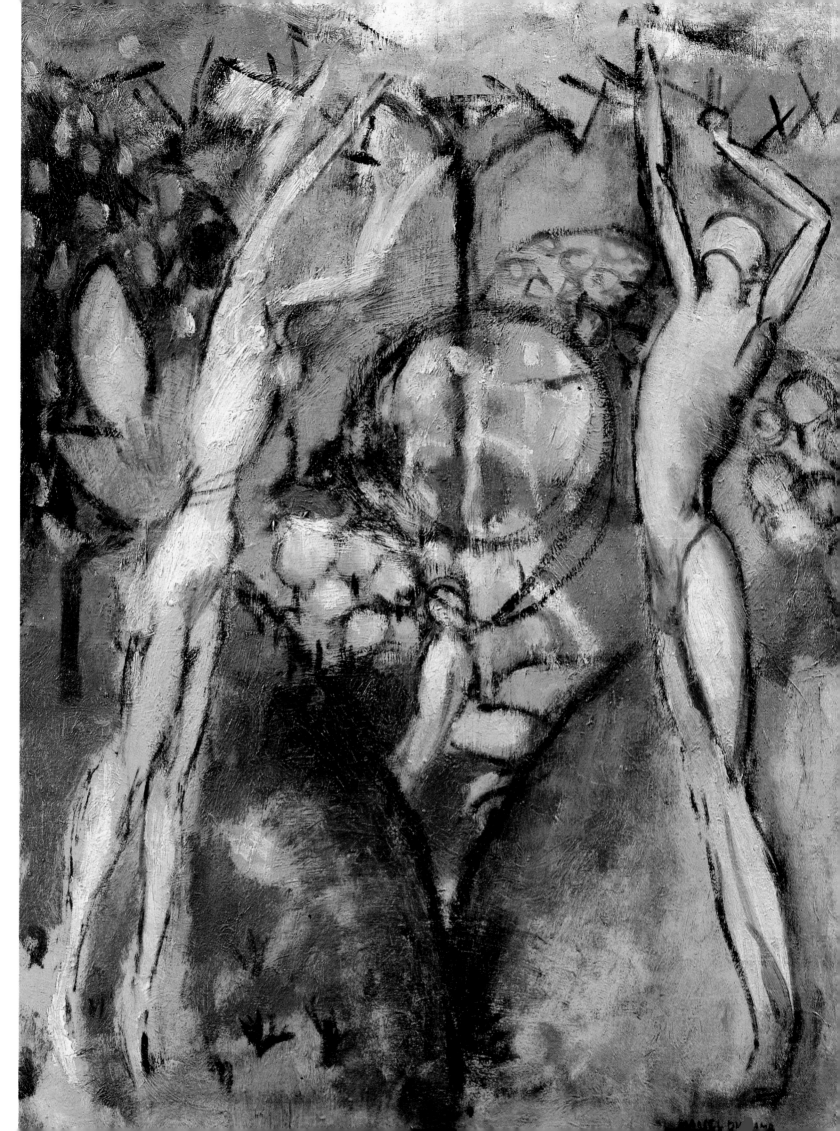

Picasso, Braque and Kahnweiler may not have trusted him, judging him to be too easily influenced and too inconsistent, but he was accepted into the Puteaux circle, who now varied their ritual by sometimes meeting at Gleize's house in Courbevoie. Following the 1911 Salon d'automne, they decided to found a more formal association. In this way they hoped to promote their identity as a group and emphasise their independence of Braque and Picasso. At Villon's suggestion, they called themselves the *Section d'or*, "the Golden Section". The term was taken from one of their favourite subjects of discussion, Leonardo da Vinci's *Treatise on painting*. The Section d'or held its first exhibition in October 1912, in the rue La Boétie. On this occasion, Marcel exhibited six works, more out of solidarity with his brothers than from any real conviction.

In the preceding months Duchamp's work had advanced far beyond anything his friends had imagined. During the traditional vacation at Veules-les-Roses in September 1911, he had painted *Yvonne and Magdeleine Torn in Tatters*. Here, for the first time, he introduced the idea of time into his painting. The picture presents four profiles of the two sisters floating in space. Each of them is drawn twice over, to two different scales and at two different ages: as they were then, adolescents, and as they would later become, their features changed and deformed by time. The result is no longer Cubism but an ironic adaptation of its conventions.

In the lecture "A propos of myself" which he gave in St Louis, Missouri, in 1964, Duchamp described this picture as "a very loose interpretation of the Cubist theories" and added: "In other words, I was trying very hard to get away from any traditional or even Cubistic composition."

Marcel Duchamp
Yvonne and Magdeleine Torn in Tatters
1911, oil on canvas,
60 x 73 cm (23 5/8 x 28 3/4 in).
The Louise and Walter Arensberg Collection, Philadelphia Museum of Art.

OPPOSITE PAGE
Marcel Duchamp
Portrait, or Dulcinea
1911, oil on canvas,
146 x 114 cm (57 1/2 x 44 7/8 in).
The Louise and Walter Arensberg Collection, Philadelphia Museum of Art.

OPPOSITE, ABOVE

Marcel Duchamp

Study For a Chess Game

October 1911, Indian ink and charcoal
on paper,

45 x 61.5 cm (17 11/16 x 24 3/16 in).

Private collection, Paris.

OPPOSITE, BELOW

Marcel Duchamp

Study for The Chess Players

October 1911, charcoal on paper,

43.1 x 58.4 cm (17 x 23 in).

Private collection, Paris.

Raymond Duchamp-Villon

Study for the Bust of Baudelaire

1910, charcoal on paper,

60 x 45 cm (23 5/8 x 17 3/4 in).

Musée national d'art moderne, Paris.

In 1911, at the age of twenty-four, he was, to all appearances, a pleasant young man who lived in a nice part of town. He could, on occasion, be sardonic and mocking, and he was apparently quite indifferent to all material questions. Though he did not openly make fun of them, he tended to look down on the "artistic painters" of the Puteaux group and their attempts to elaborate theories to justify their work. He was attractive to women, and knew it, but he never tried to impress people with what Breton later called his "admirable beauty".

The machine: a new idea in painting

Duchamp cultivated an air of indolence, but in fact worked very hard, albeit discreetly and without talking about what he was doing. The canvases he was exhibiting at the Salons d'automne, des indépendants and the Société normande de peinture in Rouen surprised and disturbed those who saw them, but Duchamp paid little heed to their reactions, and when he noticed them, was rather pleased. He thought a great deal about how to go beyond Cubism, but did little to put his ideas into practice. Above all, he never long confined himself to any one formula. Thus in autumn 1911, he began a series of preparatory studies for two paintings which he painted in December, one called *The Chess Players* and the other *Portrait of Chess Players*. Both turned out very differently from the Cézannesque picture of August 1910.

In the interim, Marcel had read Élie Jouffret's *Elementary Treatise on Four-Dimensional Geometry*, which was published in 1903. In the first study for *The Chess Players*, now in a private collection, the two players (Duchamp's two brothers) are represented by geometrically inflected yet still naturalistic outlines, inscribed within two adjacent rectangles. In the subsequent studies, the chess pieces gain ever greater importance, while the forms of the two players are no longer separated, but confront one another at close quarters, and ultimately combine. In the pictures painted that December, the protagonists are stripped of the last vestiges of their individuality as their images echo and multiply across an abstract monochrome space.

The final version of *The Chess Players* was painted by the light of a bec Auer gas lamp. The two players brood intensely on their game, while the artist replicates their forms so as to represent their internal division: each becomes the other as he tries to work out what his opponent is planning. As for the choice of lighting, Duchamp later said: "I wanted to see what the results would be if I changed the colours. If you paint in a green light, the next day what you see by daylight is much more mauve, more grey, like the canvases the Cubists were producing at that time. It's an easy way of lowering the tonal range, to get a sort of grisaille effect.[1]"

At the same time, Duchamp had begun a series of illustrations of texts by his favourite poet, Jules Laforgue. He made ten or so of these elliptical pencil sketches. Only three have survived. *Mediocrity*, which for a time belonged to André Breton, represents a bizarre machine, the first of many that Duchamp

1 *Ingénieur du temps perdu, op. cit.*

OPPOSITE

Marcel Duchamp
The Chess Players
December 1911, oil on canvas,
50 x 61 cm (19 11/16 x 24 in).

Musée national d'art moderne, Paris.

Marcel Duchamp
Portrait of Chess Players
December 1911, oil on canvas,
108 x 101 cm (42 1/2 x 39 3/4 in).

The Louise and Walter Arensberg Collection,
Philadelphia Museum of Art.

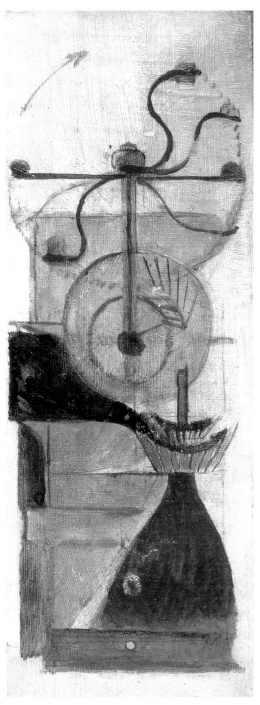

handle is repeated many times to show it turning as it grinds the beans, while the direction of the movement is indicated by a dotted line with an arrow. This was the first work in which Duchamp experimented with an explicitly mechanical form. For Breton, alongside the Cubists' guitars, it seemed a "fatal, infernal machine". He was right; for Duchamp, the action of the mill was clearly a metaphor for the sexual act. He even told Lawrence D. Steefel that he "knew the sensual pleasure that could be obtained by synchronized grinding". Steefel comments that: "He could hardly have failed to notice the feminine character of the *machine*, evident in both the gender of the word [in French] and in the ironic reference to the act itself, which suggests a sexual embrace… On these grounds, *Coffee Mill* may be interpreted as a hymn to erotic auto-satisfaction" .

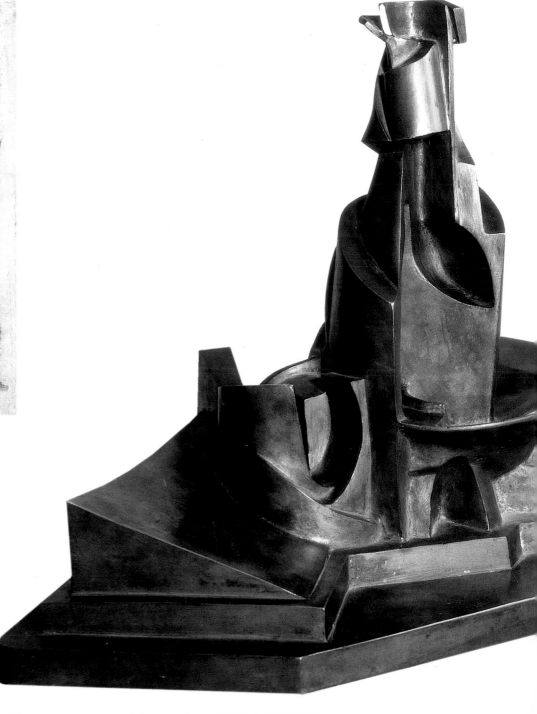

Marcel Duchamp, around 1920.

OPPOSITE
Marcel Duchamp
Coffee Mill
1911, oil on cardboard,
33 x 12.5 cm (13 x 4 15/16 in).
Tate Gallery, London.

CENTRE
Umberto Boccioni
**Development of a Bottle
in Space**
1912, bronze, height: 38.1 cm (15 in).
Mattioli Collection, Milan.

From circular movement, Duchamp turned his attention to syncopated move-ment. During a train journey from Paris to Rouen in December 1911, he went out to smoke a pipe in the corridor. As soon as he was back in Neuilly, the sen-sation of being jolted by the train as he stood at the window became the basis for a picture which he called *Sad Young Man in a Train*. The experience it evokes is an unpleasant one, and yet strangely sensual. The image of the traveller – that is, of Duchamp himself – is multiplied countless times by the train's vibrations.

"First there was the idea of the movement of the train, and then the idea of the sad young man walking up and down in the corridor. Thus there were two movements going on in parallel one with the other. And then there was the distor-tion of the young man's form, which I called elementary parallelism."

Giacomo Balla
The Violinist's Hand
1912, oil on canvas,
52 x 75 cm (20 1/2 x 29 1/2 in).
Private collection, London.

The colours – brown and dark ochre – and the black outlines that define the forms express the young man's sadness. The title of the painting is a phonetic joke in French, playing on the alliteration of sad (*triste*) and train. In Duchamp's words: "The young man is *triste* because of the *train* that is to follow. 'Tr' is very important."

On the back of the canvas, he wrote: "Marcel Duchamp nude (sketch), Sad young man in a train / Marcel Duchamp."

After this exercise in parallel movement, Duchamp's next step was to freeze the physical frame of reference and paint a moving figure in a stationary environment. The result was *Nude Descending a Staircase*. The first version dates from December 1911, the second from January 1912. Both versions were painted at Neuilly.

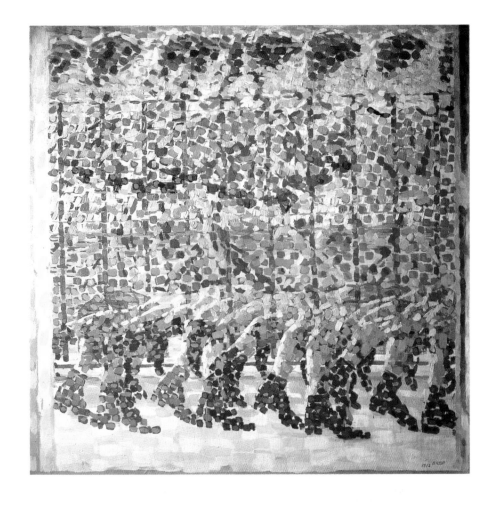

Giacomo Balla
*Young Girl Running
on a Balcony*
1912, oil on canvas,
125 x 125 cm (49 1/4 x 49 1/4 in).
Galeria d'Arte Moderna, Milan.

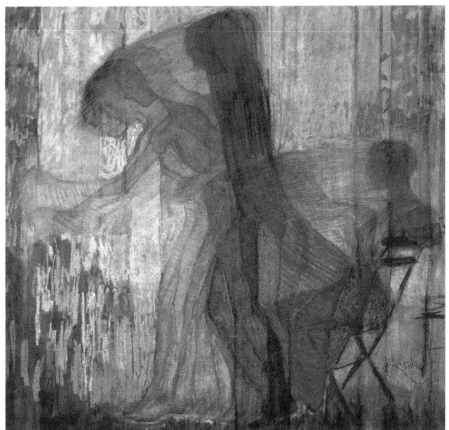

Frantisek Kupka
Woman Picking Flowers
C. 1907-1908, pastel on white paper,
45 x 47.5 cm (17 3/4 x 18 3/4 in).
Musée national d'art moderne, Paris.

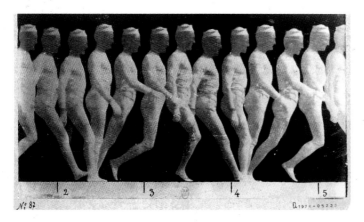 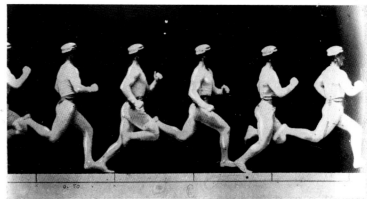

Étienne-Jules Marey

Chronophotographs

of a Man Moving

1894.

Bibliothèque nationale, Paris.

OPPOSITE

Marcel Duchamp

descending a staircase.

1912: *Nude Descending a Staircase*

According to Duchamp: "The starting point was the nude itself. How to paint a nude that would be different from the classical reclining or standing nude, and how to make it move." And he added: "Movement soon became the reason that I went ahead with it. In *Nude Descending a Staircase*, I wanted to create a static image of movement. (…) The movement of a form over a given period of time leads inevitably to geometry and mathematics, just as if one were constructing a machine.[1]" Premonitory words.

Cubism was another of the *Nude's* starting points. Futurism, he claimed, had not yet caught his eye. And indeed, the first Futurist exhibition in Paris did not take place until February 1912. We have already observed his mistrust of Cubist theory. From Cubism, Duchamp – who in this sense was a true "Cubister" – retained only the geometrization of plane surfaces, a sort of dislocation that he combined with the representation of movement, and with light used to define volume and perspective. As in classical painting, light, for Duchamp is merely an artifice that serves to articulate the hierarchical relations of things. Duchamp was always reluctant to admit the influence of chronophotography – "that thing of Marey's" – on his work. Marey was a celebrated physiologist, and his book *Movement* had appeared in 1894. Duchamp probably came across Marey's work through his brother Raymond when Raymond was studying at the Salpêtrière hospital under Marey's assistant, Albert Londe. However, he admitted that he took the principle of decomposing movement into a sequence of geometrical figures from the photographs in Marey's book, one of which depicted a man running. Marey had used science to test a hypothesis

1 *Ingénieur du temps perdu, op. cit.*

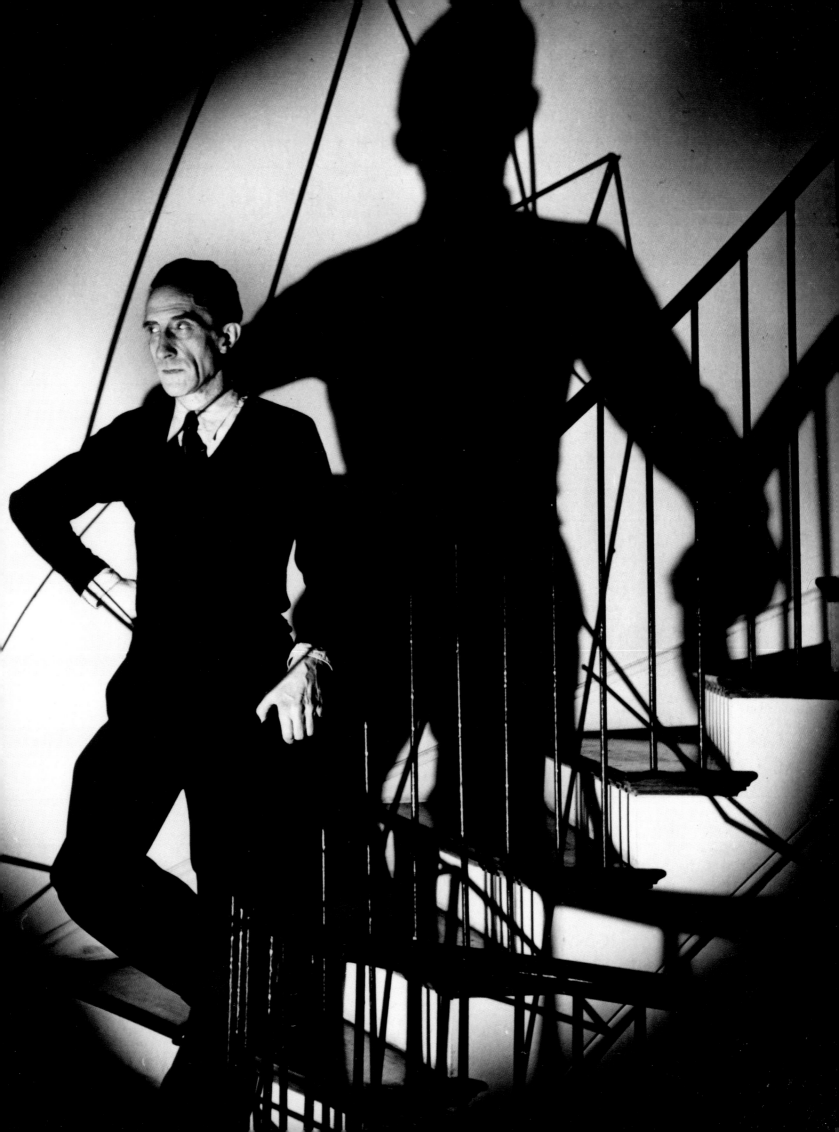

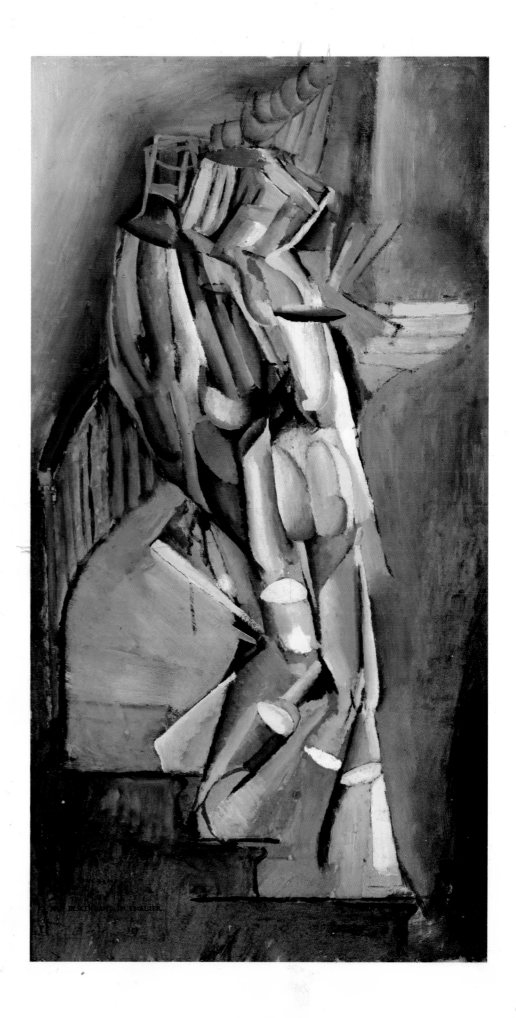

Marcel Duchamp
**Nude Descending
a Staircase no. 1**
1911, oil on cardboard,
96.7 x 60.5 cm (38 1/16 x 23 13/16 in).

The Louise and Walter Arensberg Collection,
Philadelphia Museum of Art.

OPPOSITE
Marcel Duchamp
**Nude Descending
a Staircase no. 2**
1912, oil on canvas,
146 x 89 cm (57 1/2 x 35 1/16 in).

The Louise and Walter Arensberg Collection,
Philadelphia Museum of Art.

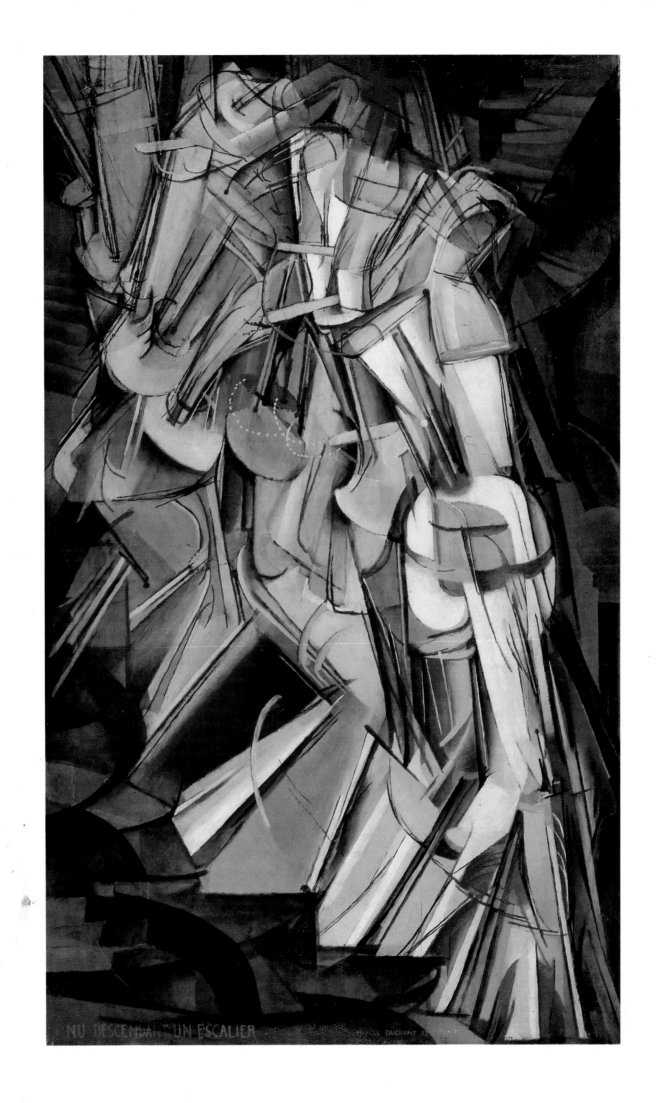

NU DESCENDANT UN ESCALIER

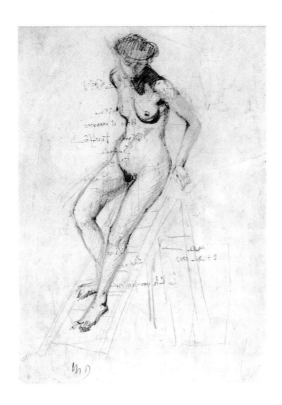

Marcel Duchamp

Nude on a Ladder

1907-1908, pencil on paper,

29.5 x 21.5 cm (11 5/8 x 8 1/2 in).

Private collection, Paris.

OPPOSITE

Gerhard Richter

Emma – Nude on a Staircase

1966, oil on canvas,

200 x 130 cm (78 3/4 x 51 1/4 in).

Museum Ludwig, Cologne.

This painting, inspired by Duchamp's
Nude Descending a Staircase, was Ger-
hard Richter's way of trying to prove to
Duchamp that painting was not dead.

arrived at through rational speculation. In doing so, he discovered a reality invisible to the naked eye.

Duchamp felt that "The idea of elementary parallelism was a pretentious formula, but entertaining." He combined it with another idea, that of the mechanization of the individual, which he set up against traditional conventions of beauty. Yet he had not always been hostile to those conventions, as is shown by the two studies of a *Nude on a Ladder* drawn from life at Puteaux in 1907-1908.

Duchamp said that the *Nude Descending a Staircase* "has no flesh, just a simplified anatomy". It is certainly a peculiar vision of the human body, though not as strange as that which Duchamp would later invent for the Bride – a conflagration of forms rocked by a series of "swift" vibrations.

The break with the "artistic painters"

In the first *Nude*, which Duchamp referred to as a sketch, we can still see the curving staircase behind the figure. The second painting, which is much larger, is also more abstract. The entire surface of the canvas is given over to dislocating the movement of the anatomical machine. In both versions, the dominant colours are shades of brown, light ochre, red ochre and grey. The first version also has some dark green in the background and some blue-green in the upper part. The colour harmony of the second version is particularly unified. The title of the painting is written along the bottom in capital letters, thus incorporating language into the shock effect produced by the image.

Duchamp decided to show the second *Nude* at the Salon des indépendants in March 1912. This decision was doubtless intended in part as a provocation, though it was also motivated by a desire to show how the techniques of Cubism could be adapted to express movement. He was prepared for violent reactions, but the source was unexpected. Certain of his friends, Gleizes and Le Fauconnier in particular, felt that the work made a mockery of their own brand of Cubism, and insisted that Jacques Villon and Raymond Duchamp-Villon ask Marcel to withdraw it. This they reluctantly did, dressing up in black as if in mourning when they called on Marcel.

Marcel received the news with outward indifference, but he never forgot this blow. More than half a century later, he was still smarting from the insult, and angry about the inevitable break that followed. Many years later he spoke to me of these events, toying with a cigar, as he sat in the large armchair of his Neuilly studio, not far from where he had lived at the time. He affected detachment, but it was obvious the wounds had never healed. This unfortunate episode was still not closed for him: "It helped me", he said, "to free myself completely from the past, in the personal sense of the word. I said to myself: Right, since that's how things are, I'll never join a group again, I have to rely on myself, I have to go it alone.[1]"

In *Nude Descending a Staircase*, which was soon to provoke uproar in New York, Duchamp deliberately flouted the conventions of "art". In doing so, he not

1 *Ingénieur du temps perdu, op. cit.*

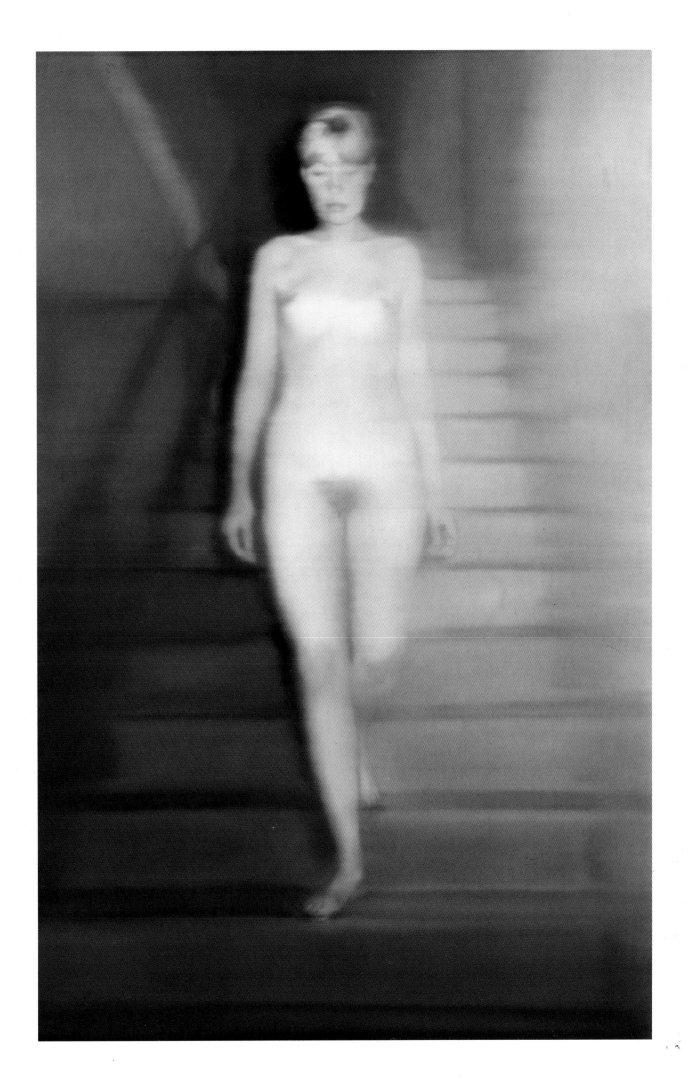

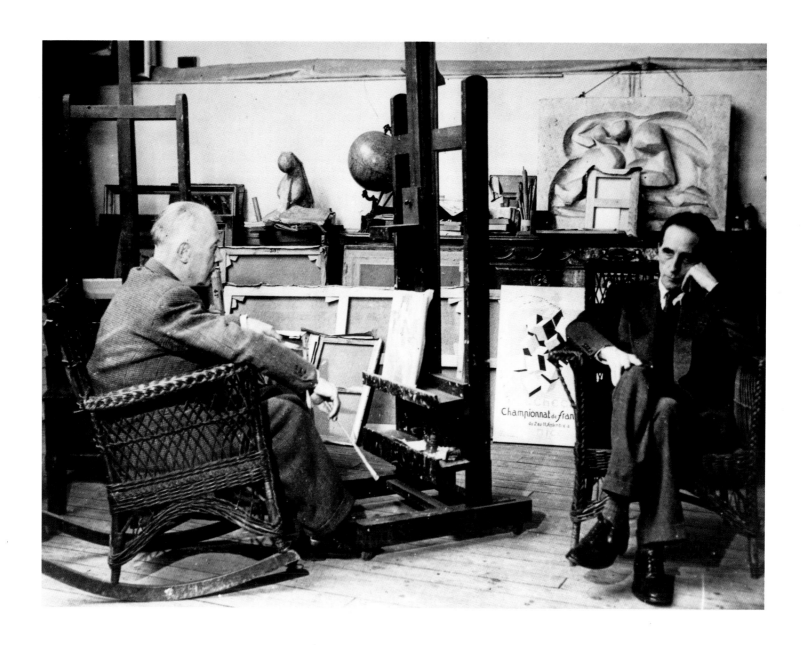

Marcel Duchamp and Jacques Villon in
Villon's studio at Puteaux.
In the back, resting on the ground,
is a poster for the French national chess
championship designed by Duchamp.

OPPOSITE
Fernand Léger
Contrast of Forms: The Staircase
1913, oil on canvas,
100 x 80 cm (39 3/8 x 31 1/2 in).
Formerly in the Brame and Lorenceau Collection.

merely innovated upon "analytical" Cubism, he went far beyond even the most
daring avant-garde experiments of the day, including those of the "Futurists",
to create one of the crucial works of the 20th century.

Impressions of Africa: a decisive shock

In February 1912, Duchamp was finally able to see the work of the Futurists in
an exhibition at the Bernheim-Jeune Gallery. But for Duchamp, the event of
the year was Raymond Roussel's *Impressions of Africa* at the Théâtre Antoine,
which he attended in May, in the company of Apollinaire, Picabia and
Gabrielle Buffet. Duchamp was bowled over: "It was wonderful. There was a
dummy on stage, and a snake which moved just a little, it was quite extra-
vagantly bizarre. I don't remember much about the text. We weren't really
listening.[1]"

1 *Ingénieur du temps perdu, op. cit.*

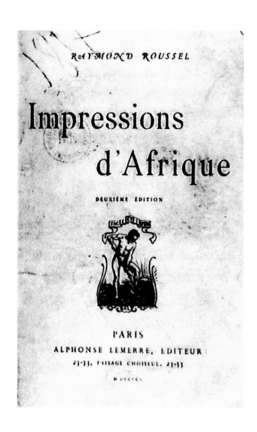

The second edition of *Impressions d'Afrique* by Raymond Roussel, who was one of the precursors of surrealism.

Chess pieces carved by Marcel Duchamp in Buenos Aires.

He immediately got hold of a copy of this four-act play and read it. Roussel tells the unlikely story of a group of ship-wrecked men held prisoner by Talou VII, the King of Ponukélé, who have time to kill while they wait to be ransomed. They form a club and organize what they call a Gala of Incomparables. At this Gala, each member of the club must present a *completely original work*. Despite his great love of language, it was the story, not the text, that fascinated Duchamp. He himself, it turned out, had an equally strange plan for a fantastical, absurd work of fiction which would use the *machinery* of those humourless art forms, Cubism and Futurism, to explosive humorous effect.

Impressions of Africa changed Duchamp's life. He himself said that it was Roussel who freed him "from my whole physico-plastic past" – the past from which his work of the previous few months had been intended to deliver him. A new man was born. It was not clear yet whether he would be an artist. But his greatest ambition was clear: to deserve membership of the Incomparables Club, by creating a work that would be entirely *invented*, without precedent or point of reference in the past. A work which, like Roussel's play, would be as disturbing as it was hilarious.

Nevertheless, he continued to keep the world at a safe distance, and never attempted to meet the eccentric Roussel, whose inspired madness was to influence several generations of writers, from André Breton – who called him the "greatest hypnotist of modern times" – to Alain Robbe-Grillet, and from Michel Leiris to Michel Foucault.

Impressions of Africa had first appeared as a serial in the very conservative *Gaulois du Dimanche*; its readers seem to have been oblivious to the resolutely improbable conventions of its plot. As serial and book, it had been a complete flop. To add to the paradox, it was, of all people, Edmond Rostand who deemed it fit for the stage (Roussel had sent him a copy). The ensuing performances, at the Théâtre Femina, then at the Antoine, caused uproar. Audiences whistled, jeered, and hurled coins and insults at the actors.

Shortly afterwards, Duchamp began work on his "General Notes for a hilarious picture".

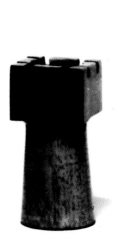
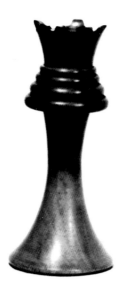
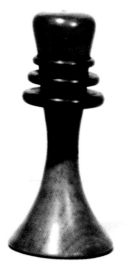
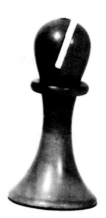

2 - "I was preoccupied with the idea of the Bride"

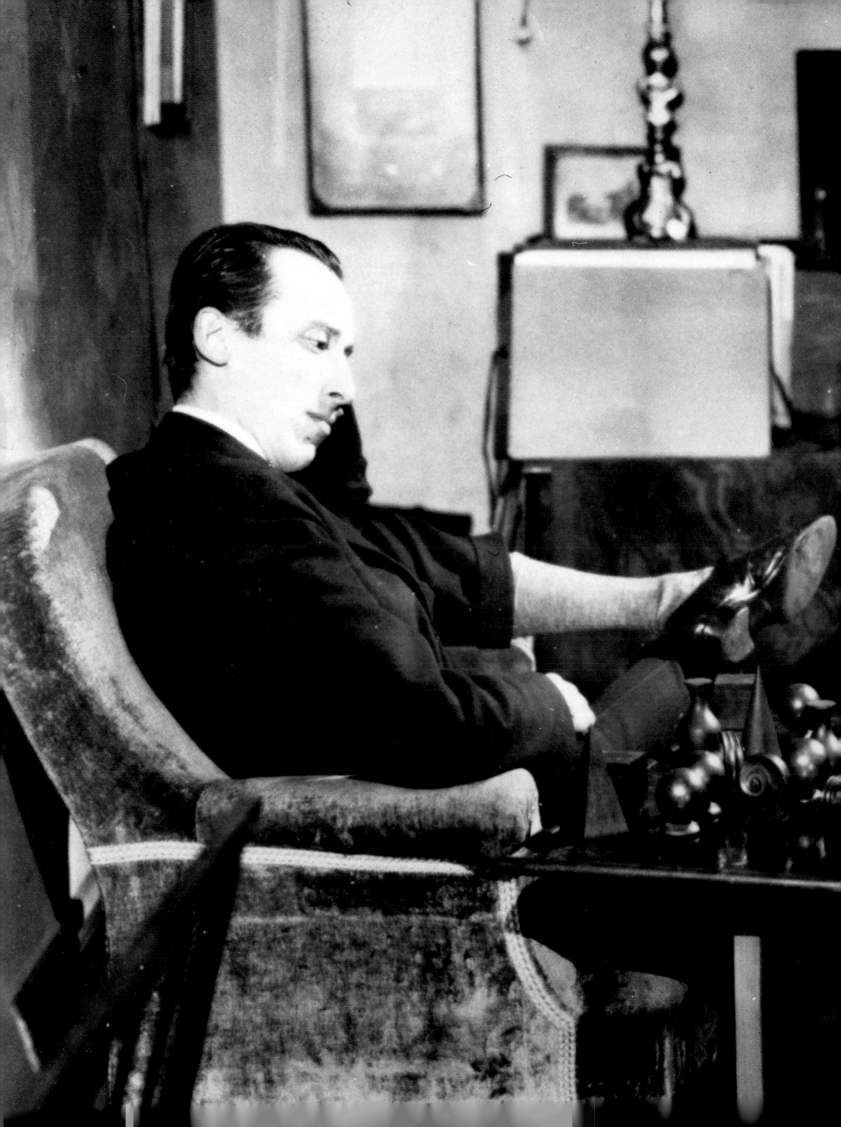

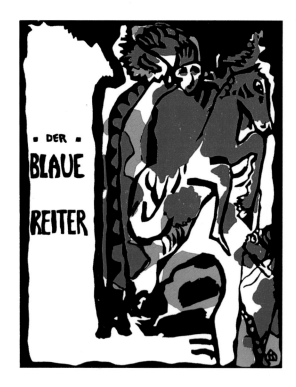

Cover for the *Blaue Reiter Almanac*
by Wassily Kandinsky, 1912.

PREVIOUS PAGES
Marcel Duchamp and Roussy de Salles
playing chess in 1924.

OPPOSITE
Marcel Duchamp
**The King and Queen Surrounded
by Swift Nudes**
May 1912, oil on canvas,
114.5 x 128.5 cm (45 1/16 x 50 9/16 in).

The Louise and Walter Arensberg Collection,
Philadelphia Museum of Art.

In June 1912, Marcel Duchamp left Paris to spend two months in Munich. The Bavarian capital was then a hotbed of artistic invention and activity. In February of that year, it had hosted the second Blaue Reiter exhibition of watercolours and drawings. The participants had included leading representatives of Die Brücke, French Cubism, the Russian Cubist-Futurist avant-garde, and the Swiss Sonderbund. The biggest artistic event of the year was the publication of the *Blaue Reiter Almanac*, in the context of a major exhibition organized by the Sonderbund in Cologne.

While in Munich, Duchamp read Kandinsky's *Concerning the Spiritual in Art*, and made notes in the margins of his copy. But he made no attempt to contact the author, or indeed any other German artists, during his stay.

Duchamp had passed through a Fauvist phase, a Cubist phase, and a Futurist phase. Would he proceed to an abstract phase, as so many of his contemporaries did? He had left in Neuilly the studies that he had been working on during the preceding months. In March, he had drawn *Two Nudes: One Strong and One Swift* – an incendiary mixture of abstract rhythms in pencil on paper of which he later coyly remarked: "It was perhaps a little Futurist." The following month, he drew *The King and the Queen Traversed by Swift Nudes*, in which the two chess pieces are besieged by mechanical objects whose trajectories cut across one another. Later in April he painted *The King and the Queen Traversed by Nudes at High Speed*, using watercolour, pencil and gouache. Here the opposition between the two pieces is still further complicated. Replacing the fraternal *Chess Players* of 1910 is a King-Queen, Father-Mother, Husband-Wife coupling. In May, this abstruse vision of the couple as robots locked into a conflict of forms reached a new pitch of dynamic intensity in a painting called *The King and the Queen Surrounded by Swift Nudes*. This picture was painted on the back of the 1910-1911 picture, *Paradise*, an arrangement which satisfied the twin imperatives of self-mockery and economy. Here, the mechanical and the organic are joined in an antagonism that is also an erotic and symbolic conspiracy.

Duchamp had embarked on this new phase of his work a convinced disciple of Roussel. He pursued the project of "invention" with ironic detachment and cool intensity. He called this attitude "affirmative irony", as opposed to the "negative irony which depends exclusively on laughter" that he identified in Picabia's work.

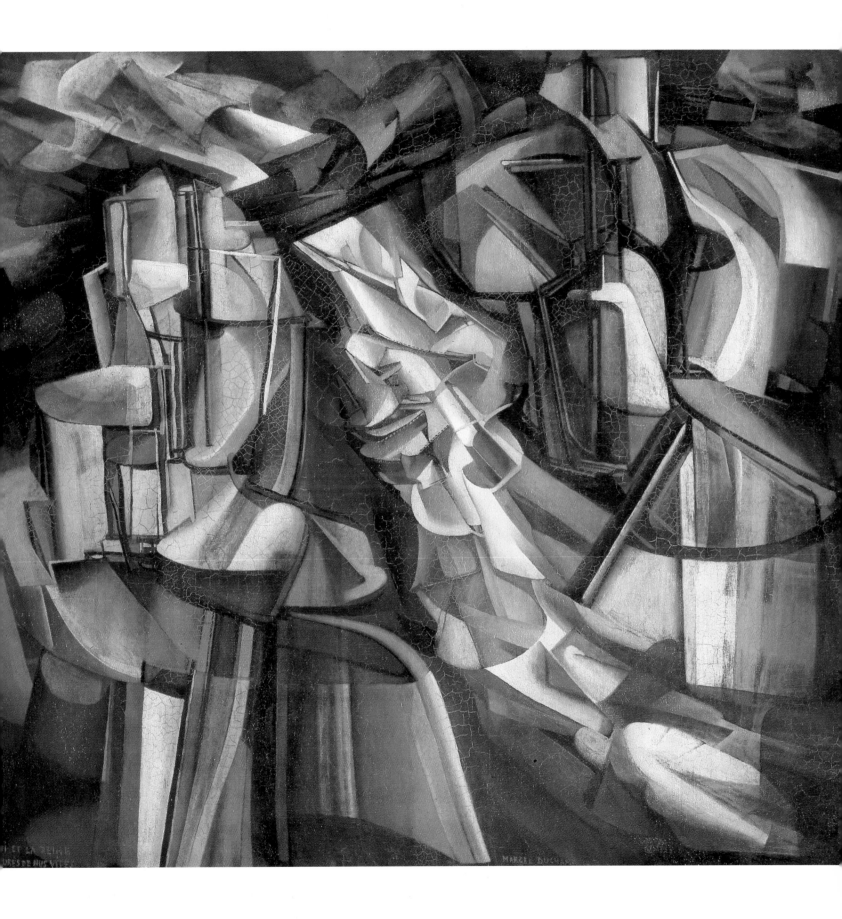

Discussing these studies, Duchamp later said: "There was the strong nude, who was the king; as for the rapid nudes, they are just traces that intertwine with one another, they have no anatomical value.[1]" No one could match him when it came to reducing ideas to their most shockingly simple form. In the hands of his exegetes, these ideas gave rise to complex speculations and astonishing conclusions, which afforded Duchamp a certain mild amusement.

Nothing is known about Duchamp's activities during the two or three months of his stay in Munich. His trip extended through October with a return journey that took him in Vienna, Prague, Dresden, Berlin and maybe Cologne. We do not know what he did, or who he met, or whether it is true, as Jack Burnham has suggested, that he used his time in Bavaria to study alchemical symbolism. For Burnham, it was this knowledge that finally enabled Duchamp to "break the chains of naturalism.[2]"

We do know that in Munich, in July 1912, Duchamp made a pencil and wash drawing on paper entitled *The Bride Stripped Bare by the Bachelors*. At the bottom of the picture, he wrote in ink: "First study for: *The Bride Stripped Bare by the Bachelors*". And in pencil he added: "Mechanism of modesty/Mechanical modesty". Countless explanations have since been given of the origin and meaning of this image.

While in Munich, Duchamp also did two mechanistic drawings of the Virgin, as well as two paintings, *The Passage from Virgin to Bride* in July-August, and *Bride* in August. In August-September, he made a wash drawing on paper, called *Aeroplane*.

By then, he had been able to put his break with the "artistic painters" behind him, and bid good-bye for ever to their taboos and scruples. Duchamp knew that he was no Picasso, no Matisse, and never would be, and he had no desire to be a minor Cubist or a second-division Futurist. In the two paintings and two drawings that explicitly developed the symbolism of *Young Man and Girl in Spring*, he set out an strategy to uncover new territory for art – territory that was both complex and unsettling. In the Munich pictures, the transition from the virginal state, in both moral and physical terms, is achieved through the peculiarly mechanical means of a contraption made of con rods, pistons, gears, and visceral forms whose movement is indicated by dotted lines. *Bride* shows this machine at rest.

These canvases seem to come from nowhere in the history of art. They draw on no known visual language. Duchamp later said: "I was obsessed with not re-using the same old things." He gave *Bride* to Picabia, and the picture later belonged to Paul Eluard, and then to Breton, before being bought by the Arensbergs.

For a long time, Duchamp seems to have deliberately concealed the fact that these works were a reaction to his sister Suzanne's marriage. He later admitted the fact, but when Arturo Schwarz rashly suggested that the pictures had their origin in "unconscious incestuous love[3]", he dismissed the idea out of hand.

1 *Ingénieur du temps perdu, op. cit.*
2 Jack Burnham, "Unveiling the Consort", *Art Forum*, New York, March and April 1971.
3 Arturo Schwarz, *Marcel Duchamp*, Paris 1975.

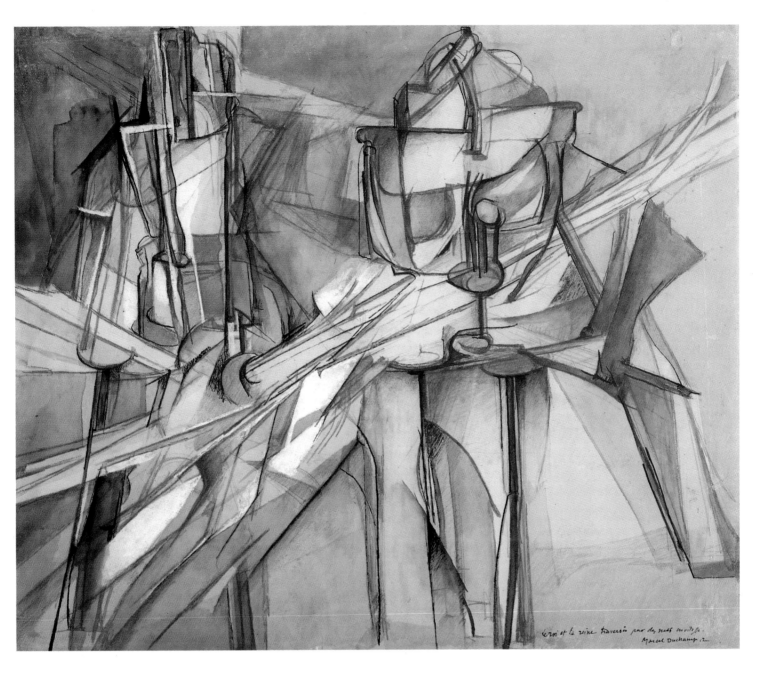

Le roi et la reine traversés par des nefs en vitesse.
Marcel Duchamp 12

Le Roi et la Reine traversés par des nus vites
Marcel Duchamp
1912

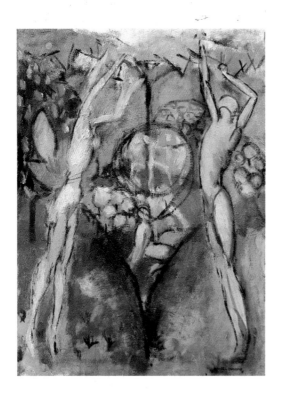

Marcel Duchamp
*Spring, or Young Man
and Girl in Spring*
1911, oil on canvas,
65.7 x 50.2 cm
Arturo Schwarz Collection, Milan.

OPPOSITE
Marcel Duchamp
Bride
August 1912, oil on canvas,
89.5 x 55 cm (35 1/4 x 21 5/8 in).
The Louise and Walter Arensberg Collection,
Philadelphia Museum of Art.

Did Duchamp resent the fact that his sister had married? That she had thus become a woman, and – potentially at least – a mother? (Suzanne never, in fact, conceived.) Did he identify all women and all mothers with his own mother whose indifference he resented? In 1911, he painted a highly schematic portrait of Magdeleine, the youngest of the family, which he entitled *A Propos of Little Sister*. Why did he write on the back: "Study of a woman/Shit"? Was he afraid that his younger sister might follow Suzanne's example and marry? Did he think that his painting might somehow be able to ward off this turn of events? As it happened, Magdeleine never married, and none of the Duchamp siblings had children. Or at least, none is known. Suzanne divorced her husband in 1914.

Is the tree in *Young Man and Girl in Spring* the tree of sexual knowledge? If so, then the innocent young girl who, like the boy opposite her, stretches out with her whole being towards the fruit above, will gain the knowledge she desires after she has been stripped bare, after she has passed from the state of Virgin to that of Bride, and through this metamorphosis realized her own nature. Duchamp, too, had to undergo a transformation, so as to accomplish his destiny as an artist, and the intuition of this metamorphosis would seem to be present in *The Passage from Virgin to Bride* and *Bride*, thus confirming his sense of their place in his development. When, more than fifty years later, Duchamp was asked about his thoughts of that time, he merely observed: "I was preoccupied with the idea of the Bride."

So preoccupied was he that he painstakingly honed the technique of these two pictures, so as to eliminate anything that might remind the viewer of his previous manner. He chose the Dutch make, Behrendt, for his oils and used a palette knife instead of a brush. He even used his fingers, as if he were modelling the different elements that make up the paintings. The result is a texture, in the words of Robert Lebel, "So dense and brilliant that it might have been taken directly from the Old Masters.[1]"

First signs of a "delay in glass"

In 1914, Duchamp decided to keep his notes and writings (in no particular order) in a box. He imagined the result would be something like a Sears, Roebuck catalogue. This was the origin of the *Green Box*. He made the original himself in 1934, and then had it reproduced in an edition of three hundred. It contained notes concerning *The Bride*, together with reproductions of various studies for *The Large Glass* and of the different states of the work itself. Altogether, it comprised facsimiles of fifty or so notes, sketches and documents from the period 1912-1915. The quantity and variety of these items are testimony to Duchamp's seemingly boundless capacity for intellectual invention during this crucial period.

"It was during my stay in Munich that I finally achieved complete liberation", Duchamp was to say later. "There I defined the general outline of a large-scale

1 Robert Lebel, *Sur Marcel Duchamp*, Paris, 1959, 1985.

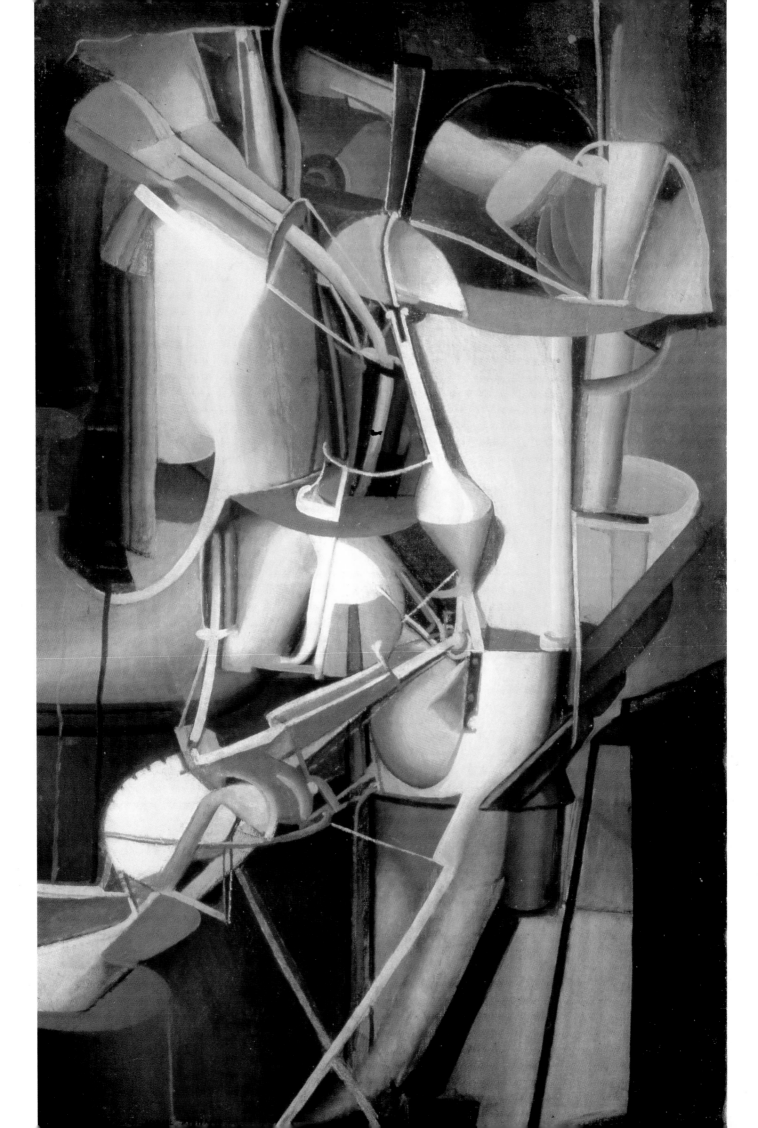

Marcel Duchamp

Two Personages and a Car

1912, charcoal on paper,

35 x 29 cm (13 3/4 x 11 7/16 in).

Private collection, Paris.

OPPOSITE

Marcel Duchamp, around 1920.

work which was to occupy me for a long time, on account of the many new technical problems that had to be resolved.[1]"

In October, having returned to Paris where he made a flying visit to the Salon d'automne, Duchamp set off with Apollinaire, Picabia and Gabrielle Buffet on a car trip to the Jura, where Gabrielle's mother had a house, at Étival. The little drawing entitled *Two Personages and a Car* is a souvenir of this expedition. It is one of the rare works by Duchamp to represent the automobile, which was then such a fashionable symbol of speed, progress and modernity. The image is difficult to interpret, but the opposition it sets up between the moving machine and the two standing figures, one male, one female, is directly related to the symbolism of the Bride. This study must have been important to Duchamp, because he included the original in the luxury edition XIV/XX of the *Box in a Valise* "For Teeny Matisse".

1 *Ingénieur du temps perdu, op. cit.*

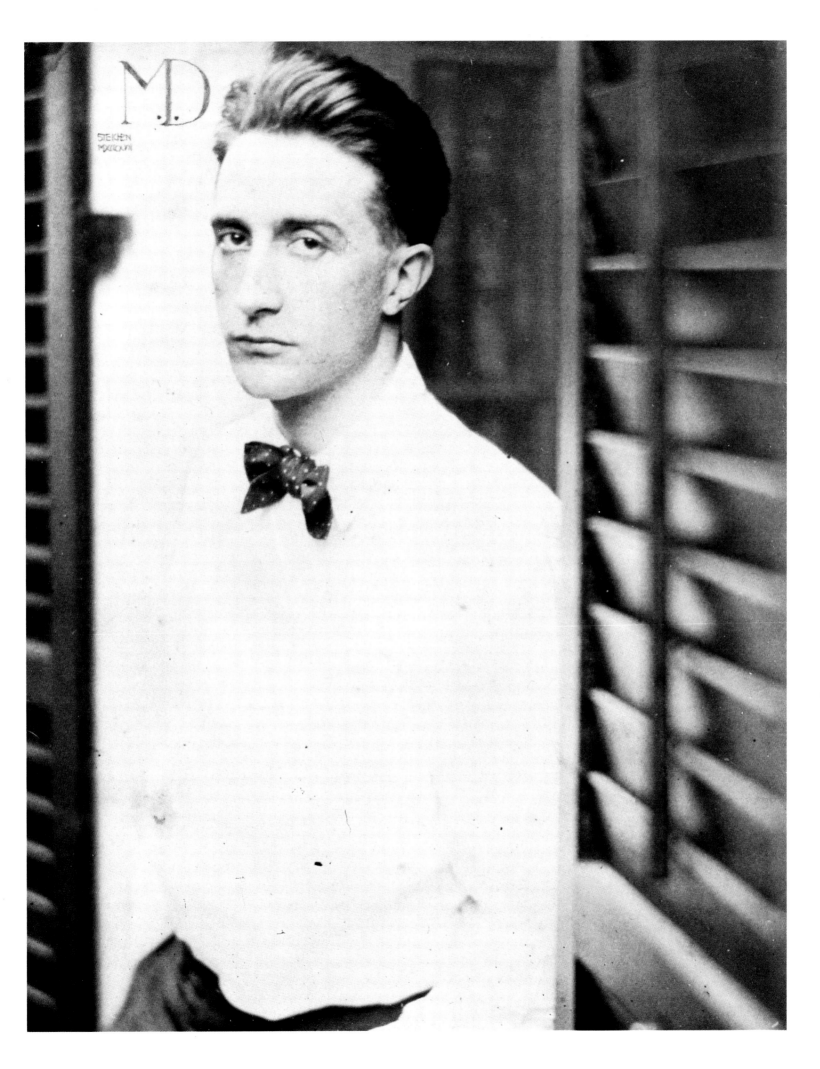

Francis Picabia in his studio,
July 1917.

Francis Picabia
Guillaume Apollinaire
1918, ink and watercolour on paper,
58.4 x 45.7 cm (23 x 18 in).
Musée national d'art moderne, Paris.

["You will not die entirely" –
"Guillaume Apollinaire, irritable poet" –
"The master of himself, Picabia"]

One of the notes dated 1912 in the *Green Box* describes a "Jura-Paris road", which "the machine with 5 hearts, the pure child of nickel and platinum, must dominate. (…) On the one hand, the chief of the 5 nudes will be ahead of the 4 other nudes *towards* this Jura-Paris road. On the other hand, the headlight child will be the instrument conquering this Jura-Paris road."

"This headlight child could, graphically, be a comet which would have its tail in front, the tail being an appendage of the headlight child, appendage which absorbs by crushing (gold dust, graphically) this Jura-Paris road."

"Graphically, this road will tend towards the pure geometrical line without thickness…"

"The pictorial matter of this Jura-Paris road will be *wood*, which seems to me like the affective translation of powdered silex."

The note, here transcribed in part, is a project for a canvas that Duchamp never painted, but it also gives us an accurate description of his state of mind and intentions at that time. The influence of Roussel is apparent, as is that of Picabia, whose caustic energy and mastery of nonsense were beginning to rub off on Marcel. The two were now inseparable companions, whence the puns, the associations of ideas and sounds, the hermeticism and disregard for logic, the use of humour as a tool for constructing lapidary and definitive formulae or laconic aphorisms imbued with a serene self-confidence. Duchamp was reading not just Roussel but Alfred Jarry, Lautréamont and his favourite poet, Mallarmé. It was to these authors that he looked in his effort to create a verbal language directly related to his visual language, a dialectic as aleatoric, ironic, contradictory and challenging as that of his pictures.

As Duchamp later said, when speaking of this strategy: "That was the point at which I became a literary man. I began to take an interest in words." This interest was apparent when he referred to *The Bride* as a "delay in glass": "It was the poetic aspect of words that I liked. I wanted to give this 'delay' a poetic meaning that even I could not explain.[1]" Yet, in the *Green Box*, we find the following clue: "Use 'delay' instead of picture or painting: 'picture on glass' thus becomes 'delay in glass' – but 'delay in glass' does not mean 'picture on glass'." And later in the same note, he added: "a 'delay in glass', as you would say a poem in prose or a spittoon in silver".

Between Apollinaire and Picabia

The jaunt from Paris to the Jura and back offered Apollinaire, Picabia and Duchamp plenty of time to indulge their shared enthusiasm for paradoxes and provocations, argument and quibbling. In the course of their conversations, Picabia proposed that Apollinaire should write a book which, according to Gabrielle Buffet, was to describe in detail the current state of the new painting, and in particular "the tearing apart of Cubism[2]". The result was not quite what Picabia had had in mind. Apollinaire produced a rag-bag collection

1 *Ingénieur du temps perdu, op. cit.* The expression "retard en verre" is a homophone of several others, notably "retard d'envers" [delayed reversal], "retard envers" [delay in relation to/delay towards], etc. (Translator's note).
2 Gabrielle Buffet-Picabia, *Rencontres*, Paris, 1977.

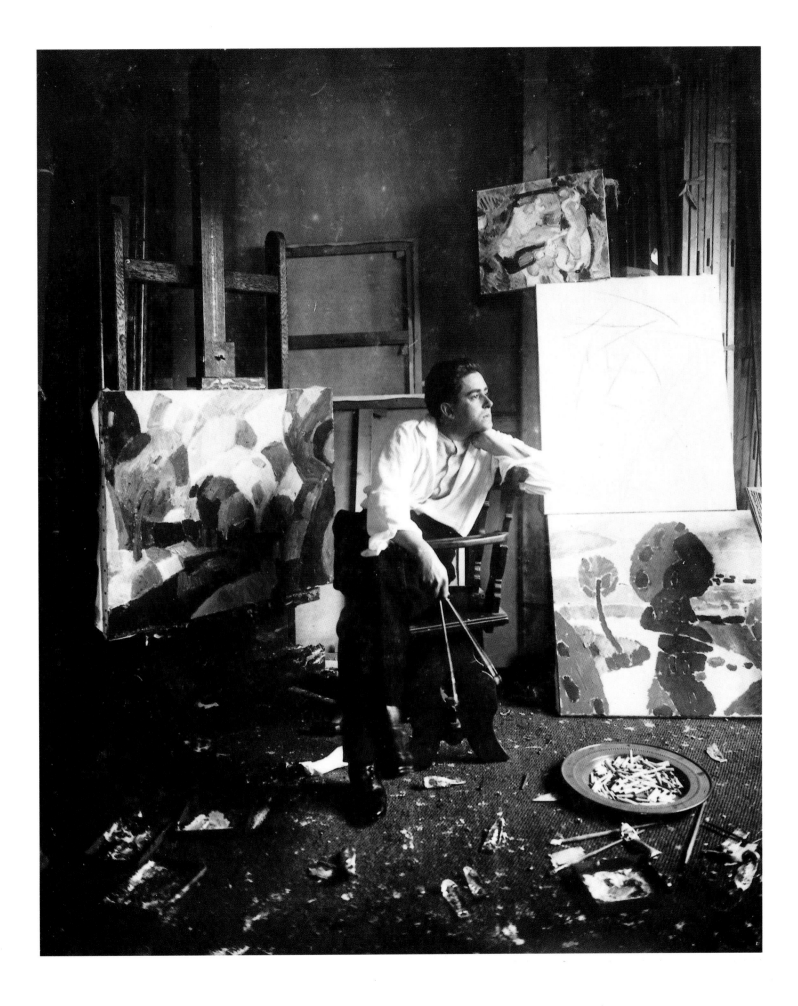

Francis Picabia
Udnie
1913, oil on canvas,
290 x 300 cm (114 1/8 x 118 1/8 in).
Musée national d'art moderne, Paris.

of previously published articles, lectures and prefaces, which he had merely extended and edited for their new purpose. Published in 1913 under the title *The Cubist Painters – Aesthetic Meditations*, it was neither a manifesto nor a sustained polemic, but a patchwork of texts on the avant-garde stitched together for the occasion.

The chapter on Duchamp is laboured but premonitory. Apollinaire foresaw that "This art may produce works whose strength will go far beyond anything we can imagine", adding that "It may even come to perform a social function." And he spelled out the same idea several pages later: "Perhaps it will take an artist as remote from aesthetic preoccupations and as preoccupied with energy as Marcel Duchamp to reconcile Art and the People."

In his book on Duchamp, Robert Lebel singled out this "prophetic" passage for praise, calling it "the most illuminating text we have concerning these decisive moments". For Lebel Apollinaire's prediction that Art and the People would be reconciled had been vindicated. Duchamp, he claimed, had discovered "a form of communication hitherto inaccessible to the new painting".

Duchamp saw things differently: "I'll admit that he sometimes guessed what I was going to do, but reconciling Art and the People, that's a good laugh! That's Apollinaire for you! (…) He wrote whatever was going through his head, maybe it was poetic from his point of view, but it was neither truthful nor analytically precise. Apollinaire was charming, and he had a gift for seeing certain things, and imagining others, all of which is quite fine, but what he says there is his words, not mine.[1]"

From Munich, Duchamp sent one of his drawings of the Virgin to the Salon d'automne, which opened on 1st October. He was in Paris on the 10th, for the opening of the Salon de la Section d'or organized by his brothers and the Puteaux group, at which Apollinaire gave a lecture on "Cubism Torn Apart". There Duchamp took his revenge by exhibiting the *Nude Descending a Staircase* refused by the Indépendants a few months earlier. He also showed the *Portrait of Chess Players*, *The King and the Queen Surrounded by Swift Nudes*, *The King and the Queen Traversed by Swift Nudes (watercolour)*, and another watercolour (catalogue numbers 17 to 22).

This was Duchamp's first major exhibition of his work in Paris, and it was to be his last until 1977. (In 1967, he showed a selection of his work at the Musée national d'art moderne.) It was a turning point in his life. Comparing his own work with that of the other exhibitors, he realized how little he had in common with them. He shared neither their techniques nor their ambitions. Duchamp was not interested in playing around with brushes in the hope of one day becoming famous for producing yet another painting just like the ones that could be seen in every exhibition, about which the critics and the public knew what to think before they even looked at them.

Picabia's influence seems to have been crucial here. He came from a world that was elegant, wealthy and cosmopolitan – and very different from the milieu in which Duchamp had been brought up. He lived a free life, and moved in circles where drugs were commonplace and artists rarely encountered. He

1 *Ingénieur du temps perdu, op. cit.*

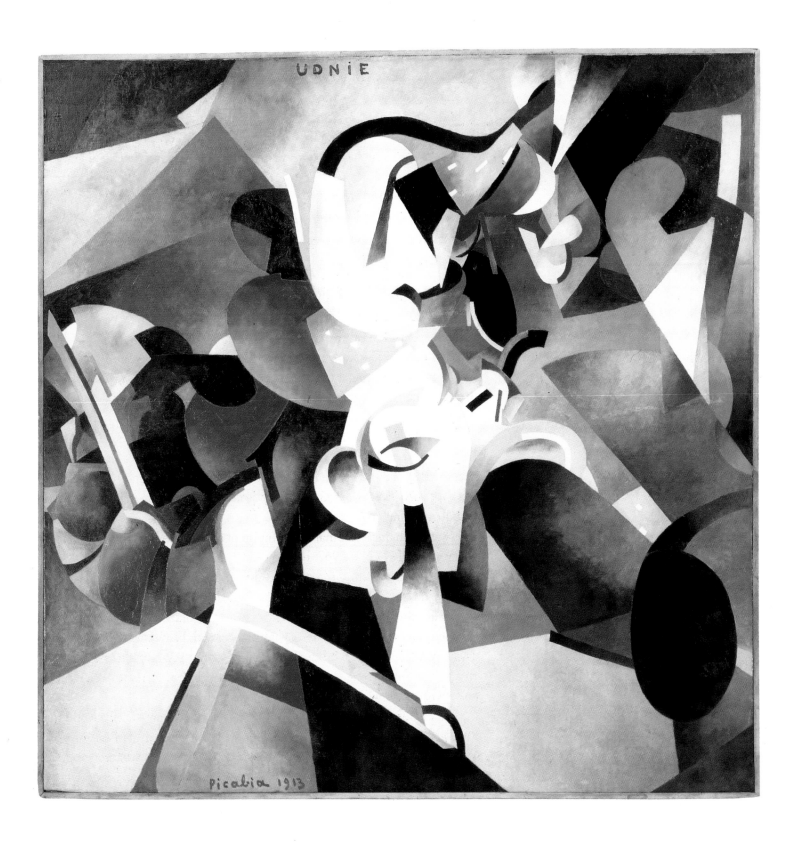

Marcel Duchamp
Musical Erratum
1913, ink on double sheet
of music paper,
32 x 48 cm (12 1/2 x 19 in).
Private collection, Paris.

impressed Marcel with his refusal to be impressed: "With him it was always: 'Yes, but…', 'No, but…' Whatever you said, he contradicted you. That was his game… Obviously, you had to defend yourself a bit.[1]"

But only a bit. The notary's son had fallen under the spell of a man who was by turns insolent, provocative, charming and a bore. "He had access to a world that I had never seen before." Thus one of the most fascinating "couples" of modern art was born. In the autumn of 1912, Duchamp decided to give up all artistic activities, or at least to replace manual work with intellectual reflection. So that he could survive without having to depend, as "artistic painters" did, on unpredictable dealers and hypothetical clients, he found himself a "position". With help from an uncle of Picabia's, he was taken on as a volunteer assistant at the Sainte-Geneviève Library, with a daily salary of five francs. At the same time, he began to attend classes at the École des Chartes, "for entertainment". He took advantage of the facilities provided by his job to read the pre-Socratic philosophers and several technical works on optics.

How *The Large Glass* came about

Duchamp already possessed the idea for his *magnum opus*. He had been planning it ever since the discovery of Roussel prompted him to take up the challenge of "invention". The drawings and paintings done in Munich had helped to define the direction in which he was heading. His decision to renounce the manual slavery and retinal routine to which his brothers and friends submitted was no sudden impulse but a product of mature reflection.

"Since etymologically the word 'art' means to make", he decided to make a "thing" based on a process of calculation, a "fabricated" object and not a "work" or "art object". It would be the continuation of all that he had achieved up till then, and the starting point for all that was to follow. He worked on *The Large Glass* for eight years, from 1915 to 1923. Like Picasso's *Demoiselles d'Avignon*, it was left unfinished.

He spent Christmas and New Year with his family in Rouen. There he composed *Musical Erratum*, using notes pulled out of a hat, as an ironic homage to the Duchamp family's love of music. This was followed by a more ambitious work on the same principle, executed in ink, but this time with the addition of grey and coloured pencils, on double sheets of music paper. '*The Bride Stripped Bare by her Bachelors Even. Musical Erratum*[2]' (the comma before *Even* was still to come) was a first step towards new forms of creation and new aesthetic criteria. Duchamp used chance to invent a "new musical alphabet", recording his method in a user's manual, which described the "apparatus" that would be required to play the piece. Years afterwards, the composer Petr Kotik had this apparatus made, and used it to perform the score with the SEM Ensemble of Buffalo.

1 *Ingénieur du temps perdu, op. cit.*
2 Foundation for Contemporary Performance Arts, New York. The first title, *The Large Glass*, is posterior to that of *Musical Erratum*.

Slowly, Duchamp's conception of the work grew clearer. What form would it take? At first, he thought of a painting on canvas, then gave up canvas in favour of glass. Glass "was a very interesting support, because of its transparency. Also because when colour is applied to glass it can be seen from the other side, and all risk of oxidation can be eliminated by enclosing it".

"What would I put into it? A mixture of history, and anecdote in the best sense of the word... visuality, the visual element would be less important than usual in a painting... Everything would become conceptual, that is, dependent upon something other than the retina.[1]"

Duchamp knew that the planning of the work would take a long time. If he was to achieve a "hilarious" effect, it could only be by delayed reaction. He designed the "delay in glass" accordingly. It was to be the perfect illustration of the spirit of "affirmative irony".

1 *Ingénieur du temps perdu, op. cit.*

Marcel Duchamp
**Study for the Chocolate Grinder
no. 2**
1914, oil and pencil on canvas,
73 x 60 cm (28 3/4 x 23 5/8 in).
Kunstsammlung Nordrhein-Westfalen, Düsseldorf.

OPPOSITE
Marcel Duchamp
Chocolate Grinder no. 2
1914, oil, thread and
black lead on canvas,
65 x 54 cm (25 9/16 x 21 1/4 in).
The Louise and Walter Arensberg Collection,
Philadelphia Museum of Art.

Towards the fourth dimension

Duchamp had always been fascinated by the window of Gamelin's shop in the rue Beauvoisine in Rouen. Behind the glass, passers-by could see the chocolate sold in the shop being made. Early in 1913, Duchamp painted a *Chocolate Grinder* in oil on canvas. It was his first attempt at "dry art", the totally impersonal approach that was to characterize all the works on mechanical themes associated with *The Large Glass*. Duchamp made three other versions of the *Grinder* in January and February 1914, using different techniques, including two *Studies, no. 1* and *no. 2*. The early 1913 version was painted at the same time as the ink studies for the *Bachelor Apparatus*, which was to form the lower part of the *Glass*, the *Elevation* and *Bachelor Apparatus, 1. Plan and 2.Elevation*. At the same time he made perspectival scale drawings at 1/10th life-size of the main elements of the *Glass* in pencil on tracing paper. The details of these parts were defined in several other drawings in which he worked out their precise measurements.

Duchamp had long been preoccupied with the problem of the fourth dimension. He had read Élie Jouffret's book, and shown a passionate interest in theoretical works on the subject, in particular those of Henri Poincaré. At that time an important figure in Parisian circles was Gaston de Pawlowski. An enormous man of truly Rabelaisian appearance, he was the editor of a widely-circulated literary and artistic review known as *Comœdia*. In 1912, *Comœdia* published a series of popularizing articles on science fiction by Pawlowski, which appeared as a book shortly afterwards, under the title *Journey to the Land of the Fourth Dimension*. The book was a great success, and ran into several editions. Its success should not be attributed exclusively to the colourful personality of its author or the scarcity of works on this subject. At that time, the idea of a fourth dimension was a favourite topic of discussion in educated artistic circles, and such speculations were particularly popular with the Cubists. There was also a thread of humour running through Pawlowski's brand of fantasy, a fondness for contradiction and a gift for mockery, all of which must have appealed to Duchamp. The fourth dimension as such never formed part of Duchamp's artistic practice, but he was fascinated by it as a field for imaginary experiments: "I couldn't get it out of my head, even though *The Large Glass* contains almost no calculations of this kind. But I had the idea of a projection, a fourth dimension that would be invisible, because you could not see it with your eyes."

"Since I found that one could do the shadow cast by a three dimensional object, any object – because the sun projects onto the earth in two dimensions – by purely intellectual analogy, I imagined that the fourth dimension could project a three-dimensional object, in other words, that all those three-dimensional objects on which we scarcely waste a glance are projections of four-dimensional things quite unknown to us."

"There was something sophistical about this idea, but nevertheless it was possible. That was the basis for *The Bride* in *The Large Glass*, which I conceived as the projection of a four-dimensional object.[1]"

1 *Ingénieur du temps perdu, op. cit.*

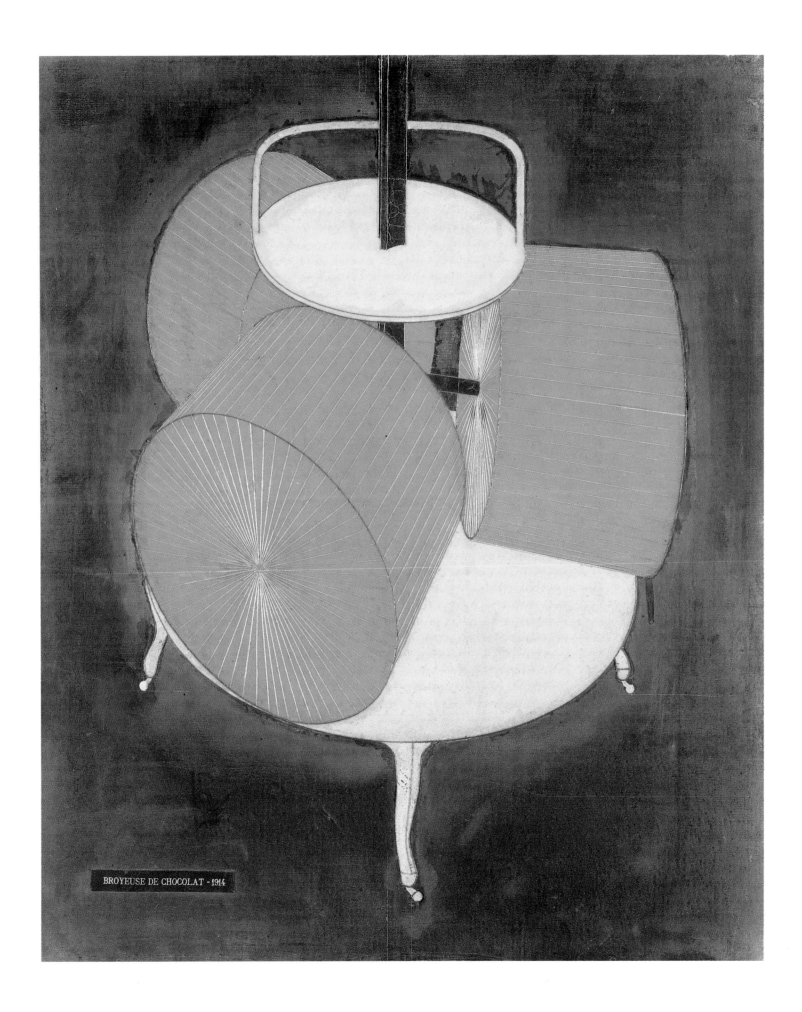

BROYEUSE DE CHOCOLAT - 1914

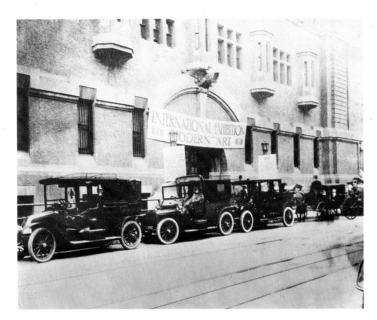
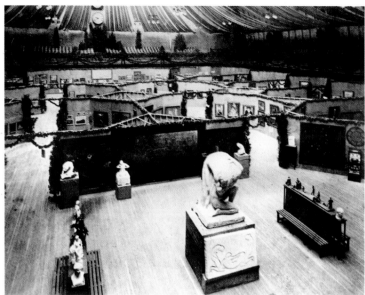

Two views of the Armory Show,
New York, where Duchamp's
Nude Descending a Staircase
created a huge scandal.

OPPOSITE

Marcel Duchamp

**The King and the Queen
Surrounded by Swift Nudes**

Detail. 1912, oil on canvas,
114.5 x 128.5 cm (45 1/16 x 50 9/16 in).

The Louise and Walter Arensberg Collection,
Philadelphia Museum of Art.

Uproar at The Armory Show

A group of American artists and collectors had decided to organize an exhibition at which the new trends in European art would be presented for the first time in the United States. To this end they founded the Association of American Painters and Sculptors, and asked certain well-known figures in the art world to help them to choose artists who should be invited to participate. One of these advisers was the critic Walter Pach. He was a friend of Villon and Raymond Duchamp-Villon, and the brothers promptly introduced him to Marcel and to their friends in the Puteaux group. The planned exhibition was suffciently catholic, not to say disparate, to accomodate them all.

It was held in February – March, 1913, in the artillery barracks on Lexington Avenue, New York, from which it took its name: the Armory Show. It was destined to become one of the most famous art exhibitions of the century. Duchamp sent four works: *The King and Queen Surrounded by Swift Nudes*, *Portrait of Chess Players*, *Sad Young Man on a Train* and *Nude Descending a Staircase*. To the unprepared eye they were all fairly shocking, but the *Nude* created an immense scandal.

The "Cubist room" was the show's leading attraction. As in Paris, the pictures provoked insults, laughter, and protest. Some irate members of the public even threatened to destroy them. There were one hundred thousand visitors to the exhibition, and most of them queued for several hours to see the notorious *Nude Descending a Staircase* that was soon the talk of New York. Duchamp's painting was the undisputed star turn. It was the subject of countless articles in the press, and numerous caricatures with ridiculous captions such as "Vulgar Character Descending a Staircase (Rush Hour in the Subway)", or "Explosion in a Shingle Factory".

Marcel Duchamp
Bicycle Wheel
1913, original lost, 1964 replica,
readymade, bicycle wheel
mounted on a stool,
110 x 205 x 94 cm
(43 1/4 x 80 3/4 x 37 in).
Musée national d'art moderne, Paris.

The *Nude Descending a Staircase* had been refused, in humiliating fashion, by the Salon des indépendants. At the Section d'or, it had been treated as an elaborate legpull. Now, in America, it made him famous overnight. In New York first, and then in Chicago and Boston, wherever the Armory Show toured, it was received as *the* symbol of the European avant-garde. It was the painting that brought modernism to America.

The canvas at the centre of the scandal was bought by a dealer in Chinese antiquities from San Francisco, F.C. Torrey. A Chicago lawyer, A.J. Eddy, who acquired no less than thirty pictures from the exhibition, became the owner of *Portrait of Chess Players* and *The King and Queen Surrounded by Swift Nudes*. The following year Eddy's book, *Cubists and Post-Impressionists*, was the first work on the new European painting to be published in the United States.

Duchamp received the news of his success on the other side of the Atlantic with his usual detachment. He later said: "It was a local success, I didn't think about it much. But I was very happy to sell the *Nude* for 240 dollars, because in those days 240 dollars was worth 1.200 gold francs."

"People were interested in the painting partly because of its title. You don't paint a naked woman coming downstairs, it's ridiculous. Nowadays it doesn't seem ridiculous because the painting has become very well known, but when it was new, especially because it was a nude, it was a scandal. A nude should be treated with respect.[1]"

In Paris, the Armory Show scandal went unnoticed, and the horrified reactions of the American press and public were not reported. No one in France knew that Duchamp had thus acquired a sulphurous reputation in America – one which was to stand him in good stead when he arrived in New York two years later. The exception was Picabia, himself an exhibitor, who visited the Armory Show with his wife, and was able to bring back news of the astonishing reception that the French artists had been given.

Thus a new idea began to gain currency: that in America, the most daring experiments of modern art would be welcomed with open arms. France was an old and backward-looking nation, and its sensibilities were too easily offended. The United States, on the other hand, was a young republic, unburdened by the past, and unencumbered by prejudice...

"Indifference" and "dryness"

Duchamp's next experiment was to fix a bicycle wheel upside down on a kitchen stool by its fork, so he could watch it turning in mid-air. He did not show it to anyone, having no particular purpose in mind when he made it. Later he said: "there was no idea of a readymade or of anything else, I was just trying to entertain myself. I had no definite reason for doing it, no intention of exhibiting it, no description of what I was looking for.[2]"

Thus, by chance, Duchamp took his first step towards baptizing everyday objects into the religion of art. The idea of the readymade only emerged as

1 *Ingénieur du temps perdu, op. cit.*
2 *ibid.*

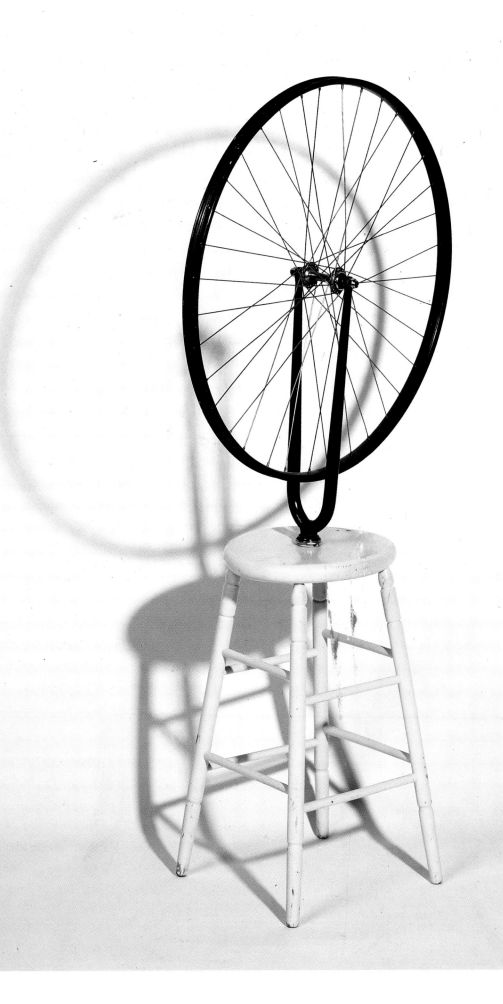

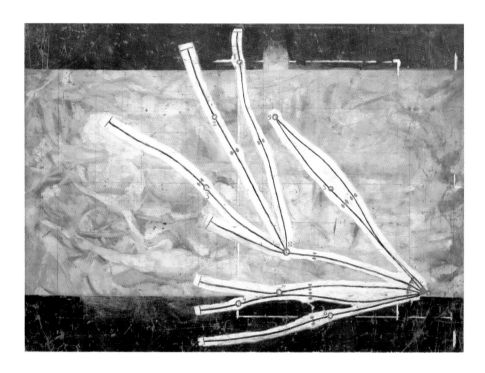

such two years later, in New York. When it did, Marcel wrote to his sister Suzanne and asked her to go to his studio where she would find the *Bicycle Wheel* and a bottle dryer [1] that he had bought at the Bazar de l'Hôtel-de-Ville, as he wanted to give them titles and sign them. He suggested that she keep the bottle dryer as a present. The originals of these first two readymades were both lost at some later date.

In the autumn of 1913, Duchamp moved to the rue Saint-Hippolyte in the 13th arrondissement of Paris. His sister Yvonne was studying for her degree in English, and he had spent part of the summer visiting her on the south coast of England, at Lynton College in Herne Bay; they went up to London together. But he also found time to maintain traditions and join the family holiday at Yport, where his parents had rented a villa.

Once installed in his new home, Duchamp lost no time in sketching on one of the walls the outline of the machinery of *The Bride Stripped Bare*. Next, in a characteristic volte-face, he produced a work whose conceptual approach was exactly the opposite of that of his great project. *Pharmacy* is a simple chromolithograph depicting a winter landscape, to which Duchamp simply added luminous dots of red and green gouache, to represent the glass jars in a dispensary as seen at sunset from a distant train on the way into Rouen. The result seems to have been designed to show that painting is merely an uninteresting supplement to nature, and that it does not take much to produce a work of art. In *Box of 1914*, under the heading "The Idea of the Fabrication", Duchamp wrote: "If a straight horizontal thread one metre long falls from a height of one metre onto a horizontal plane, distorting itself *as it pleases* and creates a new shape of the measure of length – 3 patterns obtained in more or less similar

1 The choice of the object was not innocent: there is a pun in French on the word for dryer (*égouttoir*) and its pseudo-etymological shadow, *égoûtoir*, that which denies good taste.

conditions: *considered in their relation to one another* they are an *approximate reconstitution* of the measure of length.

The *3 standard stoppages* are the metre diminished…"

The work described in this passage is an assemblage of three threads each of less than a metre's length which are fixed to strips of canvas; these in their turn are glued to a sheet of glass. They are accompanied by three wooden slats shaped to match the curves of the threads. The whole work is then enclosed in an elegant croquet case.

"I keep the line and that gives me a deformed metre. It's a canned metre, if you like, a piece of canned chance… It's amusing to put chance in a can…[1]"

On a black leather label at the end of each strip of canvas, Duchamp printed the words: "3 STANDARD STOPPAGES/1913-14" in gold letters. On the reverse, on the strips of canvas themselves, are the following words, legible through the glass: "A metre of straight thread, horizontal, that fell from a height of one metre (3 Standard Stoppages; property of Marcel Duchamp/ 1913-14)."

This work made a mockery of the received ideas and habits of mind that define "art". Duchamp was not only distancing himself from tradition and history, he was trying to cut all ties with the past, and produce an impersonal language of "indifference" and "dryness". It was in this language that ideas for the various components of the *Glass* slowly began to crystallize.

Three such ideas were the *Networks of Stoppages*, executed in oil and pencil on canvas, and the two successive drawings in pencil and watercolour of the *Cemetery of Uniforms and Liveries*, which were preparatory studies for the *Nine Mâlic Moulds*. The lines of the *Moulds* are defined using lead wire fixed to the glass with drops of varnish, and the "moulds" are the outer casings of nine moulds for different uniforms. As Duchamp explained: "In other words, you cannot see the real form of the police man or the hotel page boy, or the undertaker, because each of the real forms of these uniforms is hidden within its own mould." The *Glider Containing a Water Mill in Neighbouring Metals* was another preparatory study for the *Glass*. It was executed on a semi-circular sheet of glass held upright, and was Duchamp's first painting to use such a support. The wheel inside the box was supposed to be activated by a waterfall, but Duchamp omitted the waterfall, "so as not to fall into the trap of landscape art". In

1 J.J. Sweeney, A Conversation…, *op. cit.*

OPPOSITE, ABOVE

Marcel Duchamp

Networks of Stoppages

1914, oil and pencil on canvas,

148.9 x 197.7 cm (58 1/8 x 77 5/8 in).

Museum of Modern Art, New York.

OPPOSITE, BELOW

Marcel Duchamp

Pharmacy

1914, rectified readymade, gouache

on a commercial print,

26.2 x 19.2 cm (10 5/16 x 7 9/16 in).

Arturo Schwarz Collection, Milan.

BELOW AND NEXT PAGE

Marcel Duchamp

3 Standard Stoppages

1913-1914, replica 1964, assemblage,

28 x 129 x 23 cm

(11 1/8 x 50 7/8 x 9 in).

Musée national d'art moderne, Paris.

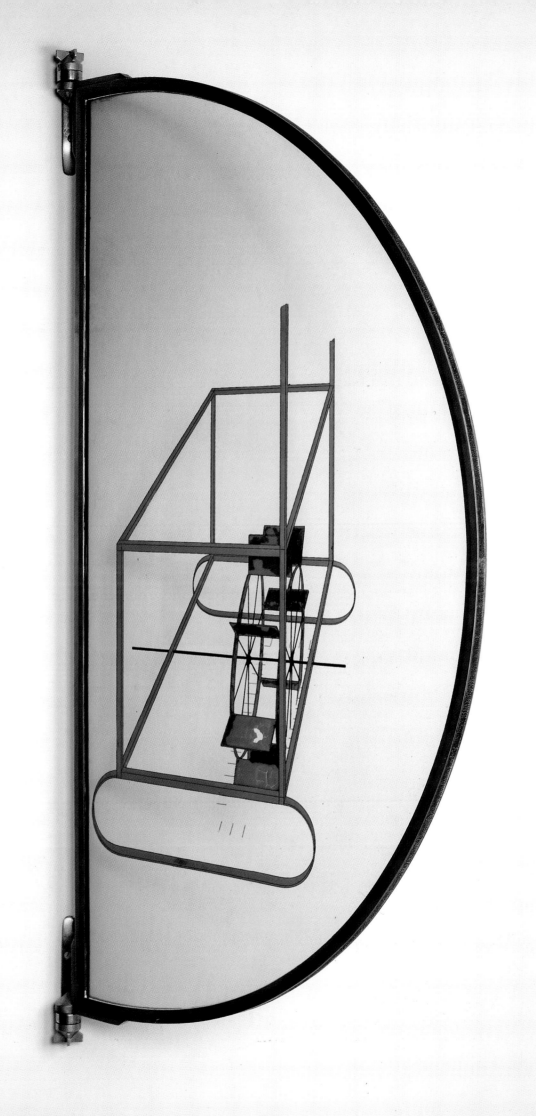

PREVIOUS PAGE

Marcel Duchamp

Glider Containing a Water Mill

1913-1915, oil and semi-circular glass,

lead and lead wire,

147 x 79 cm (57 7/8 x 31 1/8 in).

The Louise and Walter Arensberg Collection,
Philadelphia Museum of Art.

ABOVE

Man Ray

Marcel Duchamp

1931.

Private collection.

OPPOSITE

Marcel Duchamp

Bottle Dryer

1914, replica 1961, readymade,

galvanized iron,

119 x 219 x 106 cm

(46 3/4 x 86 1/4 x 41 3/4 in).

The Louise and Walter Arensberg Collection,
Philadelphia Museum of Art.

neuf moules mâlic (verre — 1ᵐ long. — 1913-14) coll. H. P. Roché

Marcel Duchamp
Nine Mâlic Moulds
1914-1915, oil, lead wire and
sheet lead on glass, mounted
between two glass plates,
66 x 101.2 cm (26 x 39 13/16 in).
Reproduction from 1934
cardboard box,
The Bride Stripped Bare.
Musée national d'art moderne, Paris.

OPPOSITE
Raymond Duchamp-Villon
The Large Horse
1914, bronze,
150 x 97 x 153 cm
(59 x 38 1/4 x 60 1/4 in).
Musée national d'art moderne, Paris.

creating these different elements, Duchamp drew for the first time on his researches into perspective and anamorphoses. Their specific materials and techniques, the use made of glass in lead framing to prevent rust, and the mathematical precision of drawing were all to reappear in *The Large Glass*.

The approach of war

When not engaged on these different works, Duchamp was covering scraps of loose-leaf paper with notes and sketches later collected in the *Green Box*. Whenever an idea occurred to him, he would write it down, before deciding whether or not to try and realize it. As we have seen, words were important to Duchamp. Many of the phrases that are found in the *Box* are enigmatic, because they are an attempt to capture his thought processes on paper as they happened. He kept them in this form, as fragments of "canned chance". Meanwhile he was progressing methodically towards the construction of the *Glass*, executing his plan step by step. Concrete production of the elements for the final work did not begin until 1915, after he moved to New York.

It was now the summer of 1914. War was about to break out in Europe. As usual, the Duchamp family had gathered at the villa which they rented each

summer at Yport. This was the last time the three brothers would find themselves living together under the same roof. As artists, they had little left to say to each other, but they were still bound together as members of the same clan, united by an affection that had stood the test of time.

Of the three Duchamp brothers, Villon was the most discreet. Although he was the leader of the Section d'or, and all nine of the pictures he had exhibited at the Armory Show had been sold, he was still far from famous. Apollinaire liked the paintings by Villon which he had seen, but in *The Cubist Painters*, where both Marcel and Raymond are given a chapter to themselves, Villon appears only in a rather dubious note on the subdivisions of the Cubist movement which was tacked on at the very end of the volume. Apollinaire had added this note to make up for any omissions that might have given offence. Its claims to be taken seriously can be judged from the fact that, in it, he classified Villon as a representative of "scientific Cubism".

That summer, Raymond Duchamp-Villon was working on *The Large Horse*. This was a major undertaking, requiring many preparatory studies, in which he tried to analyse his chosen subject into form and idea. The finished piece is a powerfully dynamic figure, at once animal and machine. Marcel for his part spent his time at Yport drawing *Sieves* and *Parasols* in coloured pencil and ink on paper. He took care to draw them reversed, ready to be traced onto the back of the *Glass*.

On 2 August 1914, war broke out. Villon and Duchamp-Villon were mobilized. Marcel was twenty-seven but, despite his apparent good health, was declared unfit for service because of a weak heart. The inevitable allegations that he had shirked his duty angered him, and prevented him from working. One mild November evening, he was sitting on a bench on the avenue des Gobelins talking with Walter Pach, when Pach said to him: "Why don't you come to America?" After the huge success of the *Nude Descending a Staircase*, Duchamp would be well received in the US, and could even hope to find a good job. When Marcel appeared before the military authorities in January 1915, they confirmed their earlier decision. Duchamp immediately took steps to leave France.

Picabia had been mobilized as soon as war broke out. He had even less reason than Duchamp to feel patriotic, given his origins. He spent a few months acting as occasional chauffeur to a general, then managed to have himself sent on a mission to Cuba, where his father had been born. There his task was to negotiate a bulk purchase of molasses. Having received his instructions, he sailed for New York in May 1915.

Almost three months later, on 6 August, it was Duchamp's turn. He boarded the *Rochambeau* at Bordeaux, and arrived in New York on 15 August. In his luggage were the plans and studies for *The Large Glass*, as well as the second of the two small glasses, the *Nine Mâlic Moulds*. It was the start of a new epoch.

3 - New York – Paris: The Dada years

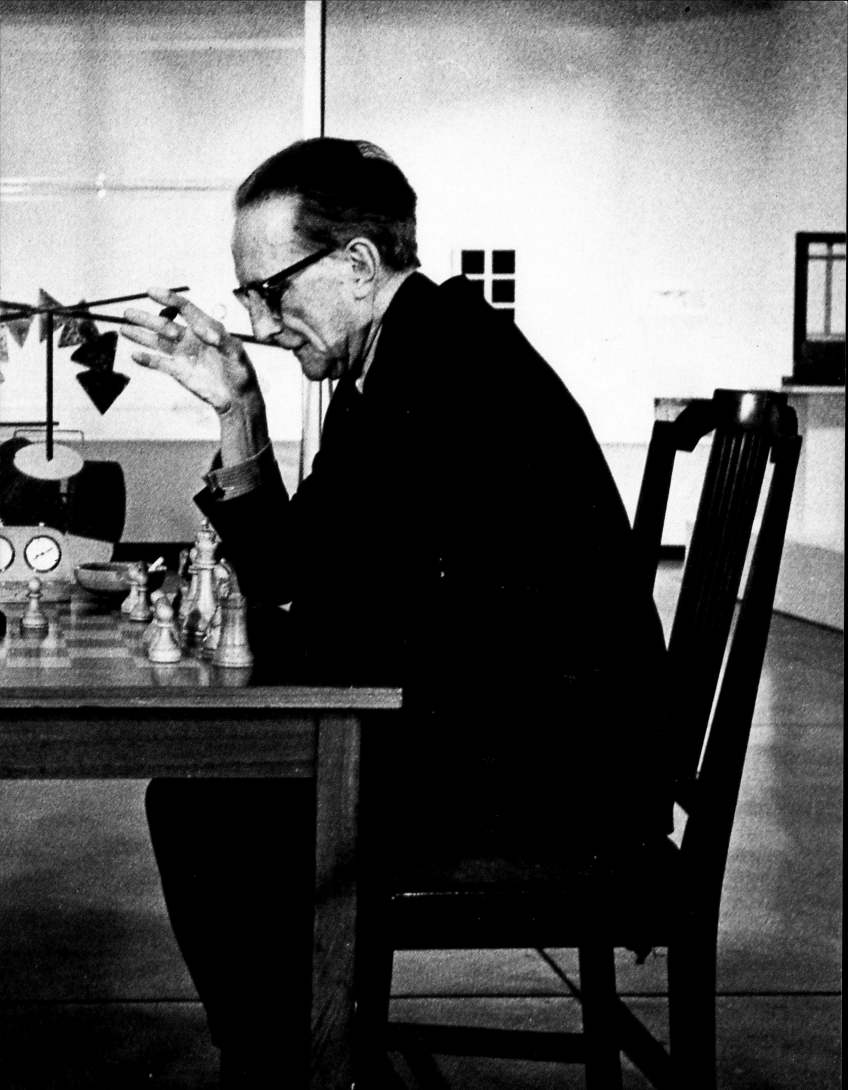

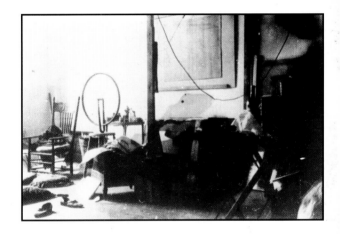

On arriving in New York, Duchamp was met by Walter Pach, who took him straight to the Arensbergs' house at 33 West 67th Street, where he was to stay. Walter and Louise Arensberg were important patrons and collectors of the New York avant-garde, and they were impatient to meet the man behind the scandalous *Nude Descending a Staircase*. What would this avenging angel look like, this insolent, rebellious youth who had dealt a razor-slash to tradition? Imagine their surprise when they found themselves confronted by a pleasant yet reserved young man, dressed in such sensible clothes that he hardly looked like an "artist" at all. Duchamp, however, was gracious enough to accept the role in which he had been cast. The Arensbergs had notified the press of the imminent arrival of their extraordinary house guest, and a crowd of reporters soon appeared. Although he knew not a word of English, Duchamp was happy to give an improvised press conference, answering their questions as best he could.

A new man was born. In New York, nothing was known of Duchamp's early work, nor of the experiments he was then conducting on the themes of the Virgin and the Bride. For America, Duchamp was simply the painter of the scandalous *Nude*. This ignorance freed him from his past, transforming him overnight from a minor Cubist with no great prospects into a uniquely valuable artistic terrorist. Duchamp adapted perfectly to this new role, which he somehow contrived to play for the rest of his life, even though his non-artistic behaviour, in public and in private, was entirely devoid of provocation.

The stage was set when, a few weeks after his arrival in New York, the review *Art and Decoration* published its report of a remark he had made with the headline: "A Complete Reversal of Art Opinions by Marcel Duchamp, Iconoclast". For America, whatever happened, he would always be the archetypal iconoclast, an agent of providence whose paramount status would survive even the most aggressive developments of the avant-garde. For more than half a century, his name was almost unknown in his native France. Yet throughout this time he was venerated as an idol by the progressive tendency in American art.

In October 1915, he rented a small furnished apartment at 34 Beekman Place. To general astonishment, it emerged that he was not working. Moreover, he apparently had no plans to produce more paintings in the vein of the *Nude*, even though they would be bound to sell on the back of the scandal. Worse still, he had no plans to earn money either. "He was incomprehensible", according to his friend Pierre-Henri Roché, "he went against every convention."

ABOVE
Duchamp's New York studio at
33 West 67th Street, where he worked
in 1917-1918.

OPPOSITE
Duchamp with the American collectors,
Louise and Walter Arensberg.

PREVIOUS PAGES
Marcel Duchamp and Eve Babitz
posing for the photographer
Julian Wasser during the Duchamp
retrospective at the Pasadena
Museum of Art in 1963 (detail).

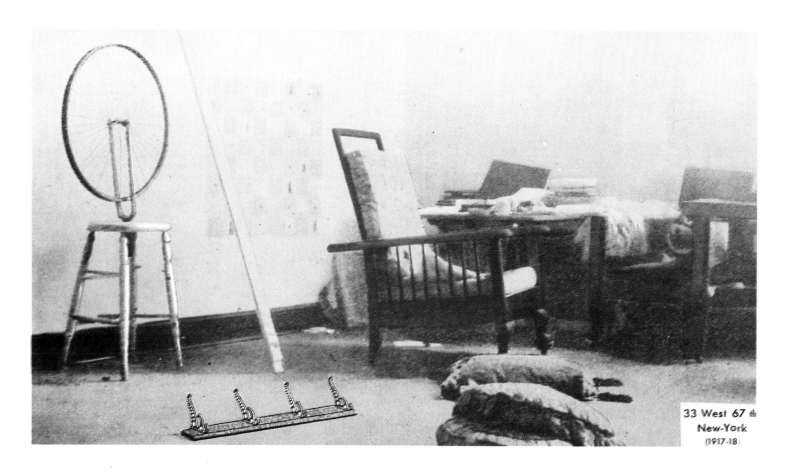

33 West 67 th
New-York
(1917-18)

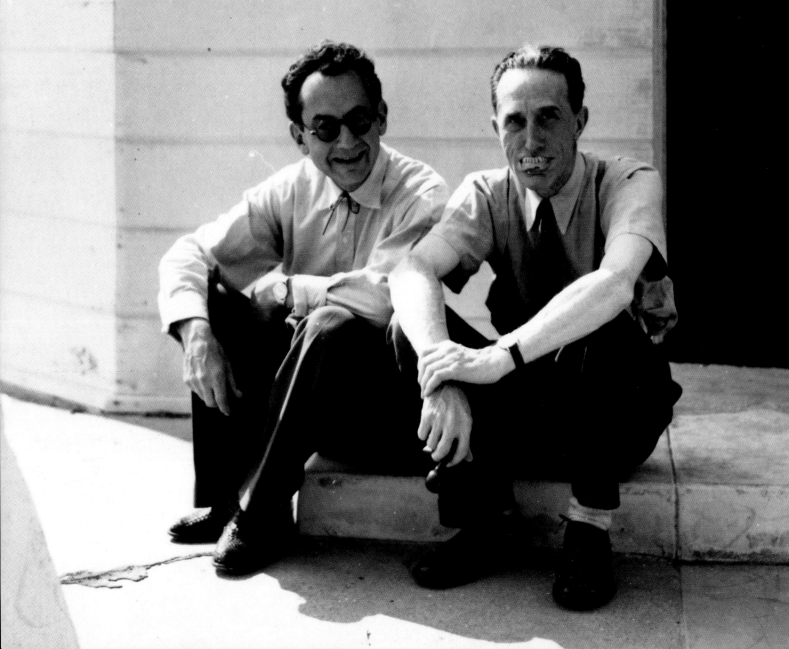

He would spend his evenings at the Arensbergs, where everyone who was any-one in Bohemian and artistic New York came to play chess, talk, drink and flirt. There, Duchamp introduced Picabia to his new friends. Picabia had com-pletely forgotten about his mission to Cuba, and quickly became a star of the Arensbergs' salon. His life in New York was "an unimaginable orgy of sex, jazz and alcohol", according to his wife Gabrielle, who was so worried she came to America to join him. In between these excesses, Picabia nevertheless found time to produce his first works based on mechanical forms.

The Arensbergs' salon was a focal point for mockery and revolt, not only against conservative ideas of art and culture, but against the war and its con-sequences for humanity. It was here that the spirit of what was to become Dada first emerged. The regulars formed a hard core of activists, attended by a bevy of beautiful young women. Besides Duchamp and Picabia, they included the photographer and gallery owner Alfred Stieglitz, the painters Man Ray and Arthur Dove, Yvonne Chastel and her husband Jean Crotti, who was also a painter, the composer Edgar Varèse, Walter Pach, the poet Barzun, the Futur-ist Joseph Stella, the poets Alfred Kreymborg and William Carlos Williams, the poet and boxer Arthur Cravan and his companion Mina Loy, and even Gleizes, who had previously distinguished himself as a leading critic of the *Nude*. In the course of 1916, they enlisted a new recruit in the form of Pierre-Henri Roché, a charming dilettante writer who had been entrusted with an official mission that proved almost as undemanding as Picabia's. Roché's arrival is significant from our point of view, because he left a valuable memoir of his friendship with Duchamp during his time in New York.

The first readymades

Duchamp soon swopped his flat on Beekman Place for a large studio in the Lincoln Arcade Building, at 1947 Broadway, where the Crottis had also set up home. There he began work on *The Large Glass*. At the same time, he took a job at the Institut français. He also gave French lessons, which not only earned him money but proved a useful way of learning English. His devotion to his *magnum opus* demanded much solitary labour, which could easily have jeopar-dized his reputation as an intellectual terrorist. Fortunately, Duchamp was adept at switching rapidly between different modes of behaviour. This facility allowed him to combine active participation in the hectic Bohemian life of New York – and especially in the many romantic opportunities it provided – with intense concentration on his artistic project. And he could still find time to live up to the idea that people there had formed of him. It was to this end that he invented the "three-dimensional pun".

The Arenbergs and their circle were relieved that Duchamp seemed at last to be doing something. He was not doing much, however: simply buying a snow shovel on which he wrote "In Advance of the Broken Arm, Marcel Duchamp.[1]" He called this "work" a readymade. Duchamp was not, apparently, aware of the significance of what he had done. After the shovel, came a *Comb*

1 Original lost. Three later versions: 1945, 1963 and 1964.

PAGE 102
Marcel Duchamp
33 West 67th Street
Photograph of Duchamp's New York studio, coloured in Paris using a stencil for inclusion in the *Box in a Valise*.

BELOW
Marcel Duchamp in Hollywood, photograph by Beatrice Wood.

PAGE 103
Marcel Duchamp
Monte Carlo Bond
1924, collage with photograph of Marcel Duchamp by Man Ray on coloured lithograph, 31.5 x 19.5 cm (12 1/4 x 7 3/4 in). Private collection, Paris.

OPPOSITE
Marcel Duchamp and Man Ray in Los Angeles.

(*for dogs*) in grey steel, which he signed MD and dated FEB. 17 1976 11 A.M., later adding a nonsensical inscription: "3 or 4 drops of height [arrogance] have nothing to do with savagery".

This was followed by *With Hidden Noise*, which Duchamp called an "assisted" readymade. It consists of a ball of string held between two brass plates. The plates were fixed together by four long screws, and on each plate various phrases in English and French were inscribed, from which certain letters had been deliberately omitted. Arensberg unscrewed the plates, placed an object inside the ball of string, then screwed the plates back together again. "I never knew what it was", said Duchamp: "Even for me, the noise was a secret."

These readymades surprised and disconcerted Duchamp's public. They thus confirmed his reputation as an iconoclast and, increasingly, an enigma. Duchamp then devised a less rigid kind of readymade than those he had made so far. He bought an Underwood typewriter, and turned its case into the first ever soft sculpture, fifty years before Claes Oldenburg and Robert Morris. He called it: *Traveller's Folding Item*[1].

After the "assisted" readymade came the "rectified" readymade. Duchamp took a coloured metal advertising plate for Sapolin Enamel, and changed the letters to read *Apolinère Enameled*, in homage to Guillaume Apollinaire. Apollinaire died the following year, 1918, and never knew of the work's existence. The only "artistic" thing Duchamp added to this object was the reflection of the girl's hair in the mirror. In the *Green Box*, there is a note which reads: "Specifications for 'Readymades'. By planning for a moment to come (on such a day, such a date, such a minute), 'to *inscribe* a *readymade*' – The *readymade* can later be looked for. – (with all kinds of delays). The important thing then is just this matter of timing, this snapshot effect, like a speech delivered on no matter what occasion but *at such and such an hour*. It is a kind of rendez-vous".

1 Original lost. Two later versions, in 1962 and 1964.

By relying solely on such encounters with objects of no special interest or aesthetic quality, but which all possessed a certain inherently humourous nature, Duchamp made thirty or so of these "things". It was his will alone that extracted the readymade from its everyday context and turned it into a work of art. We have already quoted one of his early remarks on the subject: "When I put a bicycle wheel on a stool, with the fork underneath the wheel, There was no idea of a readymade or anything else, I was just trying to entertain myself." Two years later in New York the nature of the act had become much clearer. It is the primacy of the artist's moral responsibility which justifies this new vision. What was interpreted as an attack on the dignity of the artist has since come to be seen as an affirmation of that very dignity.

Among the New York readymades, Duchamp included a *Bicycle Wheel*, which was an identical replica of the one he had made three years earlier in Paris. He later explained his fondness for the readymade concept by saying that: It allowed me to reduce aesthetic considerations to a mental decision, thus excluding the skill and intelligence of the hand, which I was rebelling against." At the same time, however, he was showing several of his earlier works – including *The King and Queen Surrounded by Swift Nudes* and the two *Chocolate Grinders* from 1913 and 1914 – at an exhibition at the Bourgeois Gallery in April 1916, entitled "Modern Art after Cézanne". A few weeks later, several other works from his Parisian period went on display at the Montross Gallery beside canvases by Gleizes, Metzinger and Crotti. Was this timing the result of a fundamental indifference to how he was perceived, or part of some calculated strategy?

Arensberg had failed to persuade F. C. Torrey to sell him the *Nude Descending a Staircase*, so Duchamp made him a life-size photograph of the original, which he coloured by hand and signed: "Marcel Duchamp (Junior)". He later remarked: "It's not one of my proudest achievements."

The second New York scandal: *Fountain*

Duchamp had settled easily into New York life. He quickly found loyal friends and female admirers, and made a little money by selling off his early work to Arensberg. His reputation as an iconoclast also helped, as did his alarmingly dilettante attitude to work. He played on the curiosity and admiration of his audience in the art world and in high society, and knew how to keep them waiting for the next scandal.

No-one knew about the efforts that *The Large Glass* cost him; he worked on it in secret. His readymades, such as *Trap*[1] of 1917, a hat-stand that would usually have been mounted on a wall, which he fixed to the floor for people to stumble over, were shocking enough. But there was also his carefree behaviour, a matter of astonishment in a world where artists were expected to fight hard in order to obtain exhibitions, build up a reputation, win the support of collectors and thus sell their work.

1 Original lost. Second version dating from 1964. The French title – *Trébuchet* – is a chess term for a pawn placed so as to 'trip' up an opponent's piece (*trébucher*, to trip).

Long before
Claes Oldenburg,
Duchamp
created the first
soft sculpture
with his
*Traveller's
Folding Item.*

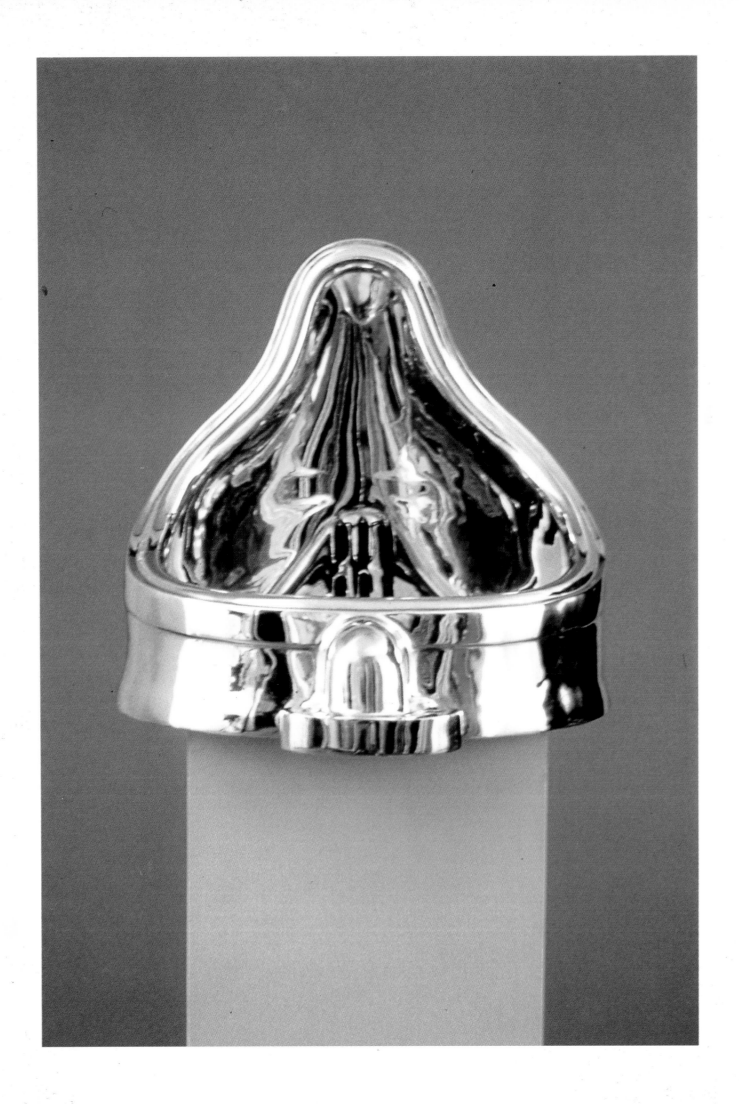

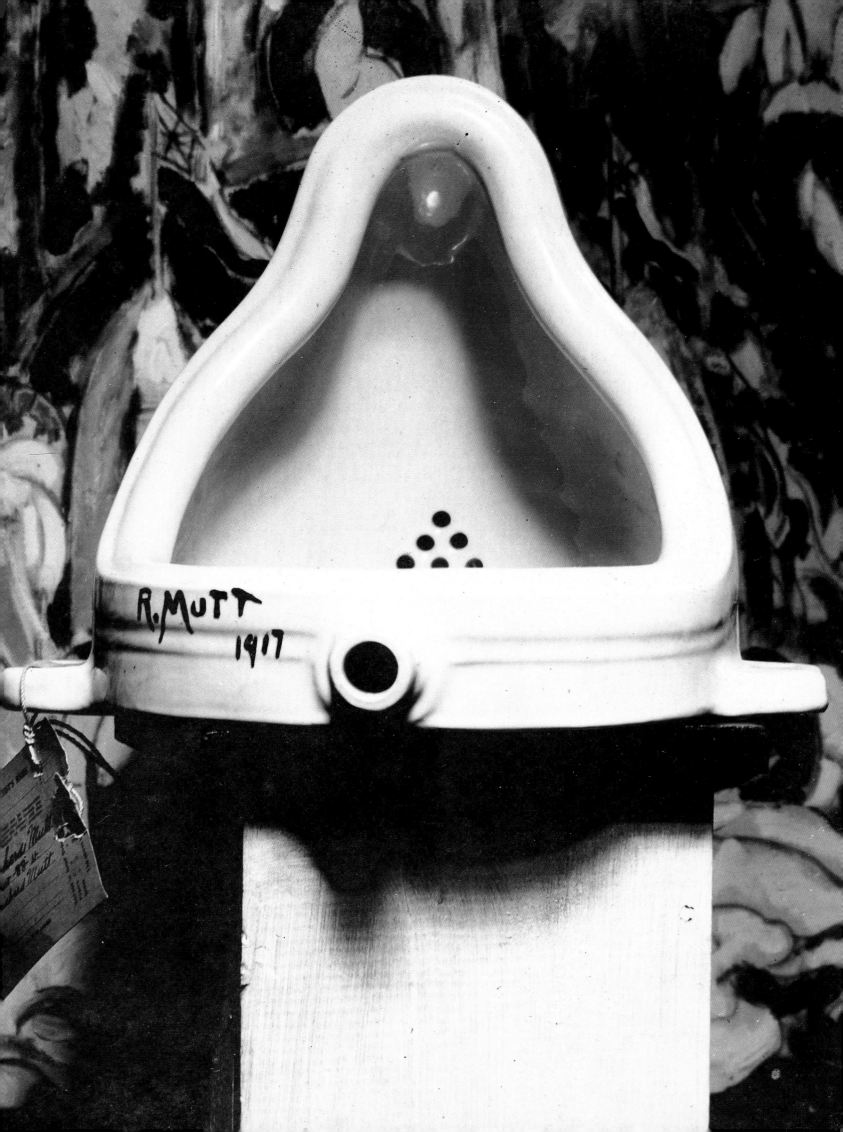

Duchamp's urinal has had many imitators. Robert Gober reintroduced banality into the readymade concept with his series of urinals and sinks in resin and wax (left and below). Sherrie Levine gave her *Fountain (after Duchamp)* nobility by casting it in a brilliant gilded bronze (page 110). Claes Oldenburg's contribution to the theme was his *Soft Toilet* from his series of soft sculptures (opposite).

LEFT

Robert Gober
Three Urinals
1988, plaster, wood,
metal board, enamel paint,
55 x 39 x 38 cm
(21 5/8 x 15 3/8 x 15 in).
Private collection, New York.

Robert Gober
Untitled
1984, plaster, wood,
metal board, enamel paint,
66 x 73.5 x 61 cm
(26 x 29 x 24 in).
Private collection.

PAGE 110
Sherrie Levine
Fountain (After Duchamp)
1991, gilded bronze,
23.5 x 18.5 x 60 cm
(9 1/4 x 7 1/4 x 23 5/8 in).
Courtesy of the Jablonka Gallery, Cologne.

PAGE 111
Marcel Duchamp
Fountain
1917, readymade, porcelain urinal,
23.5 x 18.8 x 60 cm (9 1/4 x 7 1/4 x 23 5/8 in).
Photograph taken by Stieglitz for the review *391*.

OPPOSITE
Claes Oldenburg
Soft Toilet
1966, vinyl filled with kapok,
132.08 x 81.28 x 76.2 cm (52 x 32 x 30 in).
Whitney Museum of Art, New York.

Marcel Duchamp
Tu m' (You–Me)
1918, oil and pencil on canvas
with bottle brush, three safety pins
and a bolt,
69.8 x 313 cm (27 1/2 x 122 3/4 in).
Yale University Gallery of Art, New Haven.

America was just then entering a particularly difficult phase in its history, one which was to have far-reaching repercussions. On 6 April 1917, Congress voted to join the war against Germany. A few days earlier, the French military mission in New York had declared Duchamp definitively unfit for military service. Out of gratitude, he worked for the mission for six months, as secretary to a captain whom he later described as an "idiot".

Shortly afterwards Duchamp was appointed chairman of the hanging committee of the Society of Independent Artists which he had helped to found, along with Arensberg, Man Ray and Manuel de Zayas, among others. His own submission to the Society was an upturned porcelain urinal, which he called *Fountain*[1], and signed with a paintbrush: "R. Mutt 1917". A scandal was more or less guaranteed, since the statutes of the Society prevented it from refusing any work that was offered to it, whatever it might be. To get round this, *Fountain* was hidden behind a screen for the duration of the exhibition. Duchamp himself later said: "I didn't know where it was… No one dared talk about it." Long afterwards, Duchamp enjoyed recounting this near-repeat of the refusal of *Nude Descending a Staircase* by the Salon des indépendants in 1912. This time, the joke was on his colleagues.

"My fountain-urinal originated as an experiment in the matter of taste; I chose the object that was least likely to be liked", he told Otto Hahn. "The danger is artistic pleasure. But you can still get people to swallow anything if you try, and that's what happened.[2]"

1 Original lost. Two versions dating from 1950 and 1964.
2 Quoted in *L'Express*, 23 July 1964.

Though the identity of the man behind R. Mutt was soon uncovered, Duchamp was delighted by the result of his experiment. He had demonstrated that anything could be "art", which meant, in its turn, that art could be any old thing. Duchamp's *Fountain* was hidden from the eyes of the public because the New York painters, like their Parisian colleagues, understood the implicit threat. Duchamp's strategy was perhaps less perverse than it now appears; it was only when the readymade was displayed in a museum under Duchamp's own name that his act took on its full subversive meaning. The object, deprived of its original identity, thus became the creature of its place and time of exhibition.

In protest against an incident he had deliberately provoked, Duchamp resigned from the Society of Independent Artists. His next action was to start a review, *The Blind Man*, with Roché and Béatrice Wood. The second issue, which was also the last, reproduced a photograph of the *Fountain* taken by Stieglitz, alongside an editorial commenting on its rejection by the Society. *The Blind Man* was followed by *Rongwrong*, another collaboration with Roché and Wood. This second publication ran to only one issue, and marked the end of the trio's adventures in the world of magazine publishing.

According to Duchamp's own testimony, it was either late in 1916 or early in 1917 that he and Picabia received a book sent to them by an unknown author, one Tristan Tzara. The book was called *The First Adventure of Mr Antipyrine*, and had been published in Zurich. Duchamp later said: "We were intrigued, but I didn't know who Dada was, or even that the word existed.[1]"

1 *Ingénieur du temps perdu, op. cit.*

RIGHT
Marcel Duchamp
Sculpture for Travelling
1918, rubber and string, dimensions
ad lib, seen here hanging from the
ceiling of the studio
at 33 West 67th Street, New York.

OPPOSITE
Chess pieces from Duchamp's
personal set.

BELOW
Marcel Duchamp
King and Queen
1968, engraving,
50.5 x 32.5 cm (19 7/8 x 12 3/4 in).
Private collection, Paris.

In February 1918, Picabia wrote to Tzara from Lausanne, but it was another year before they finally met in Zurich. By then, Picabia had published *Poems and Drawings of the Girl Born without a Mother*, and was travelling with Gabrielle. When Tzara arrived in Paris in January 1920, he naturally went to stay with Picabia's mistress, Germaine Everling. Her apartment on the rue Emile-Augier was soon established as the headquarters of the Dada movement. In New York, Duchamp was still working on *The Large Glass*. However, to his friends' surprise, he agreed to do a work in oil, pencil and collaged objects on canvas for a rich admirer of his, Katherine S. Dreier. The composition was called *Tu m' (You-Me)*, and was intended to hang above Dreier's bookcase. This large readymade picture is a sequential synthesis of different illusionistic procedures derived from readymades Duchamp had already either made or planned. The effects brought together included projected shadows, receding outlines, gradations of colours produced by a pile of lozenges fixed in place by a real nut and bolt, distortions, false perspectives, trompe-l'œil, imitation tears held together by real safety pins, and a sign in the form of a hand made by a professional sign painter and signed (in pencil) A. Klang.

Tu m' is a joke at the expense of artistic creation. It was also the last painting made by this scorner of "intoxication by turpentine".

When America entered the war, New York succumbed to a wave of militaristic fervour. Duchamp felt the need to escape to a neutral country. He chose

Argentina, moving there in September 1918 with his friend, Yvonne Chastel, who was now divorced from Jean Crotti. Together they set up house at 1507 Sarmiento in Buenos Aires. Katherine Dreier soon joined them there, though her presence was kept a secret.

On 27 October Duchamp learned that his brother Raymond Duchamp-Villon had died in Cannes on 9 October. Guillaume Apollinaire died a month later, just two days before the armistice was signed.

Duchamp brought with him to Buenos Aires a *Sculpture for Travelling*[1]. It was his second soft work. It was made from pieces of different coloured rubber, and was meant to be hung from a ceiling. Before leaving America, he had sold *The Large Glass* to the Arensbergs, even though only the upper half of the work was effectively finished. This sale took the original form of an agreement that the purchasers would pay the artist's rent for a period of two years. In 1921, the Arensbergs themselves began to have money problems, and had to sell Duchamp's *magnum opus* on to Katherine Dreier.

Suzanne's "Unhappy Readymade"

Duchamp was soon bored in Buenos Aires. He spoke no Spanish. He slept during the day, and at night played chess, using a set whose pieces he had carved himself, save for the knights which he had made for him by a local artisan. He continued work on *The Large Glass* nonetheless, in particular on the *Oculist Charts* for the lower half, for which he made a small study entitled "To be Looked at (from the Other Side of the Glass) with One Eye, Close to, for Almost an Hour". The materials were oil paint, silver leaf, lead wire and a magnifying lens, mounted between two sheets of glass in a metal frame. The work depicts a small obelisk with a lens fixed to its summit, standing at the centre of a clock face. Duchamp then used oil colours to paint a pyramid above this structure.

Back in Paris, Suzanne was about to marry Jean Crotti. Duchamp sent his favourite sister instructions on how to make herself an "unhappy readymade". She was to take a geometry textbook and tie it by a string to the balcony of her apartment in the rue de La Condamine. The wind would then work its way through the book, choosing problems and flicking over the pages until they had all been torn off and blown away. Duchamp remarked laconically: "It was an

1 Original lost. Second version dating from 1966.

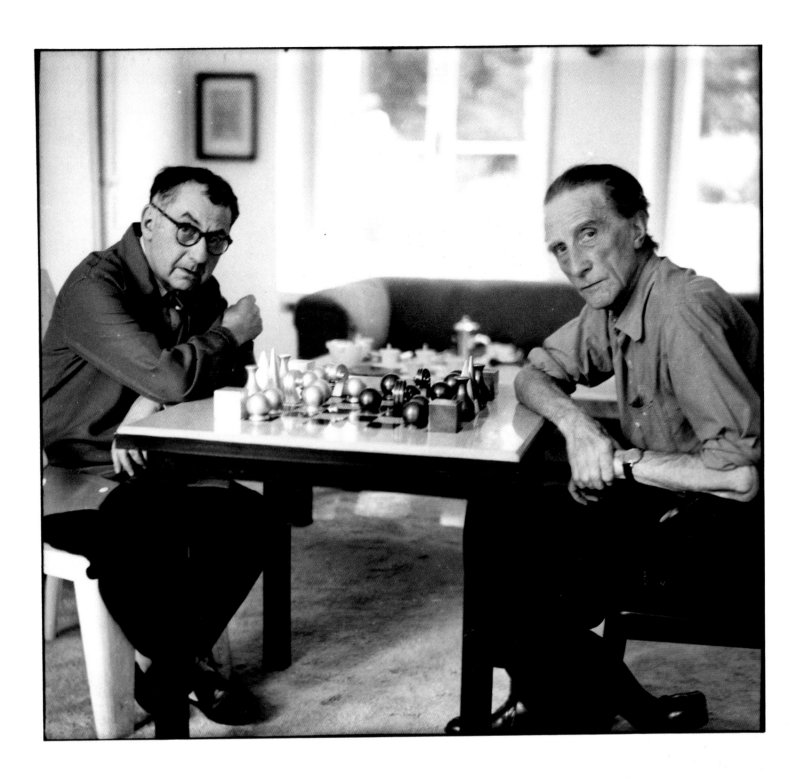

Man Ray and Marcel Duchamp playing chess.

OPPOSITE

Duchamp's travelling chess set.

Private collection, Paris.

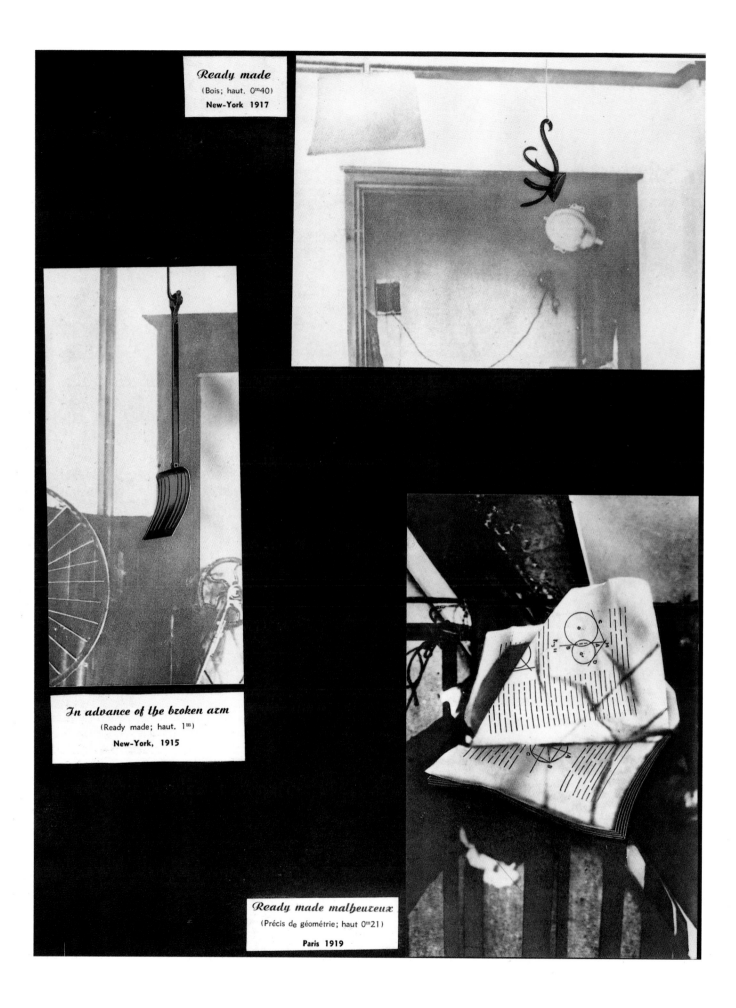

Ready made
(Bois; haut. 0m40)
New-York 1917

In advance of the broken arm
(Ready made; haut. 1m)
New-York, 1915

Ready made malheureux
(Précis de géométrie; haut 0m21)
Paris 1919

OPPOSITE

Page layout by Marcel Duchamp for the *Box in a Valise* of 1934, showing three ready-mades: *In Advance of the Broken Arm* (left), *Hatrack* (above) and Suzanne's *Unhappy Readymade* (below).

Marcel Duchamp

Unhappy Readymade

1919, readymade, geometry textbook hung from the balcony of her appartment by Suzanne, Duchamp's sister, following instructions sent her by her brother from Buenos Aires.

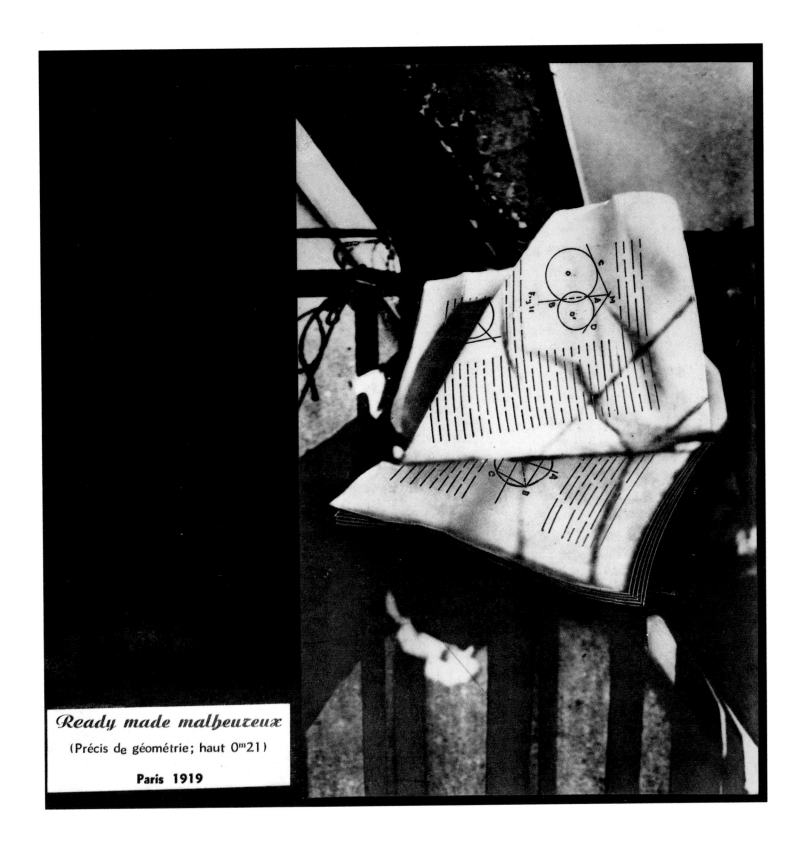

Ready made malheureux
(Précis de géométrie; haut 0ᵐ21)

Paris 1919

Marcel Duchamp
Air of Paris
1919, 1964 replica, readymade,
50 cc glass ampoule,
height 14.5 cm (5 3/4 in).

The Louise and Walter Arensberg Collection,
Philadelphia Museum of Art.

OPPOSITE
Man Ray
Rrose Sélavy
1921.
Photograph of Marcel Duchamp
taken by his friend.

Private collection.

amusing idea." Today, this first recorded work of conceptual art by correspondence is known to us from Suzanne's painting, *Marcel's Unhappy Readymade*. At the end of July 1919, Duchamp visited Paris. He was determined not to stay there long. He began by visiting Germaine Everling. At her apartment he met not only Picabia, but also the Paris Dadaists, who already regarded him as a mythical figure. Shortly before his return to New York, he met Tzara.

It was there too that Duchamp made the famous "rectified" readymade, known as *L.H.O.O.Q.*, which seems to have been intended initially as an aggressive riposte to the curiosity he aroused among the members of Picabia's circle. He took a reproduction of the *Mona Lisa*, the symbol of all that was sacred in museum art, and added a moustache and beard in pencil. In transforming Leonardo's woman into a man, Duchamp was following Freud's lead in his celebrated essay, "A Childhood Memory of Leonardo da Vinci", in which he had raised the issue of the artist's homosexuality. He was also prefiguring his own subsequent experiment in cross-dressing when he "became" Rrose Sélavy. *L.H.O.O.Q.*, with moustache but without beard, was featured on the cover of issue XII.1 of Picabia's review *391*, under the title: *Dada Painting by Marcel Duchamp*.

Arensberg had asked Duchamp to "take" the Paris "air", and Marcel dutifully returned to New York with a 50cc glass phial which he had emptied of the serum it contained and then resealed. This was his idea of *Air of Paris*. Breton, who was not easily surprised, claimed that shortly before Duchamp's departure he had seen him "do an extraordinary thing: he threw a coin into the air, saying, 'Heads, I leave for America tonight, tails, I stay in Paris'." But in fact, his return passage had been booked in advance. Arriving back in New York, Duchamp stayed at 246 West 73rd Street before moving back into the Lincoln Arcade Building. There he threw himself into the only activity he practised continuously throughout his entire life: chess.

He did, however, have another, more "artistic" preoccupation: movement. With Man Ray, he set out to construct his first optical machine, *Rotating Glass Plates (Precision Optics)*. This used a black on white spiral, the spacing of whose bands was the result of painstaking calculations. The effect of the rotation changed according to the speed of the machine, which was regulated by a rheostat. At low speeds, the spiral seemed to be moving in towards its centre, but at high speeds, it produced the illusion of a convex or concave surface. This work has been reconstructed by Michael Moses, a student at Yale University, who has made an exhaustive study of both its mode of operation and its meaning[1]. He has shown that it was just one of a series of experiments in the perception of relief which Duchamp conducted in preparation for his *Rotoreliefs*.

Mastering time

In his *Coffee Mill* of 1911, Duchamp had indicated the virtual movement of the parts by a circular dotted line. He had borrowed this device from Marey, who used a series of signs or dots to show the path travelled by a figure. Two years later, *Bicycle Wheel* had opened the way to working with real movement

1 His notes are kept in the Yale University Archive.

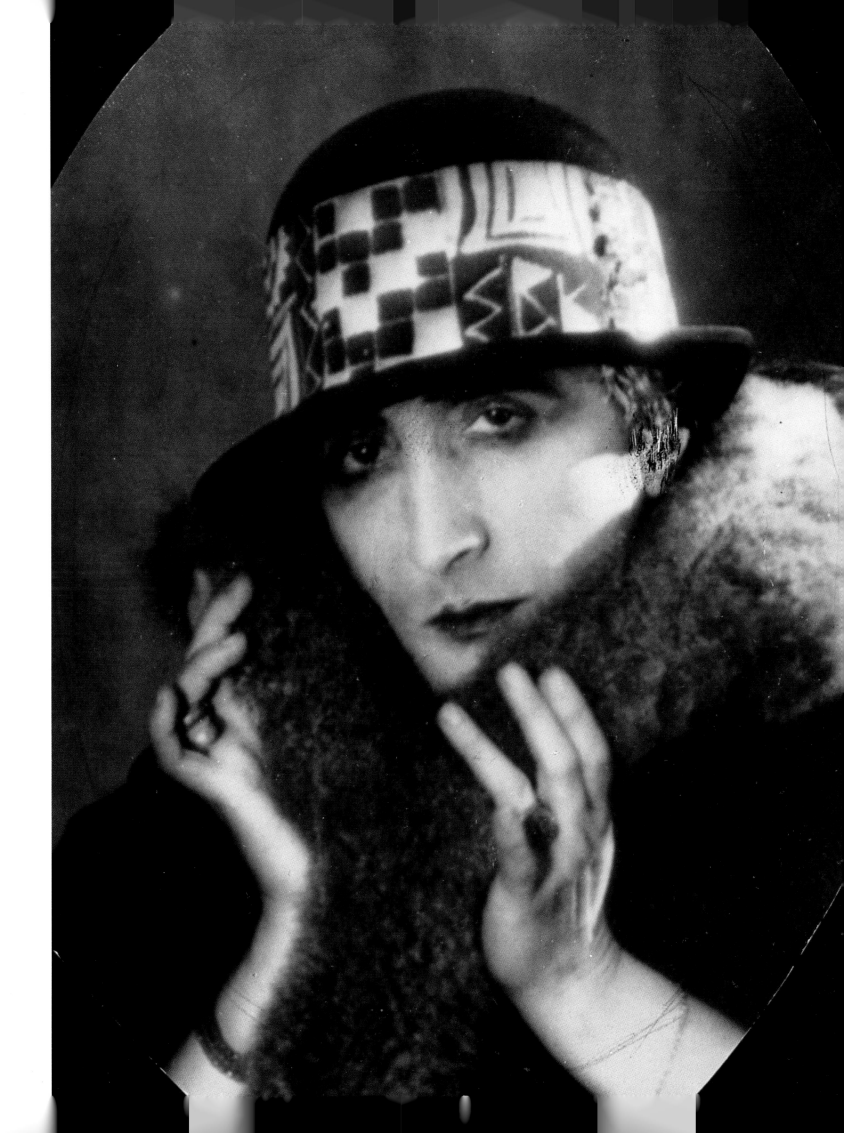

Marcel Duchamp
**Rotary Glass Plates
(Precision Optics)**
1920, five glass plates turning on a metal
axis so as to appear to form a continuous
disc when seen from one metre (39 in),
170 x 125 x 100 cm
(67 x 49 1/4 x 39 3/8 in).
Yale University Art Gallery, New Haven.

PAGE 126
Marcel Duchamp
Why not Sneeze Rrose Sélavy?
1921, readymade, birdcage, marble cubes,
thermometer and cuttlebone,
12.4 x 22.2 x 16.3 cm
(4 7/8 x 8 3/4 x 6 3/8 in).
The Louise and Walter Arensberg Collection,
Philadelphia Museum of Art.

Below: replica 1964, in the Musée
national d'art moderne, Paris.

PAGE 127
Marcel Duchamp
Fresh Widow
1920, replica 1964, miniature French
window with panes of glass covered
with black leather,
77.5 x 45 cm (30 1/2 x 17 5/8 in).
Musée national d'art moderne, Paris.

in space. But what Duchamp really wanted to achieve was to master time by controlling both the origin of its movement and its unfolding as duration. That is why he was interested in the cinema, which can concentrate an infinitely long period of time, so that "before", "during" and "after", which in reality consitute a series of discrete events, can be seen simultaneously. Painting was by nature static, repetitive, immured in the past. By contrast, the cinema had progressed by leaps and bounds since the beginning of the century. It was the quintessentially modern medium.

Man Ray was injured while testing *Rotating Glass Plates* (he later claimed that he had nearly been decapitated). Despite this setback, he continued to collaborate with Duchamp as the latter began to experiment with motion pictures.

Duchamp took *The Large Glass* to a factory on Long Island to have the right-hand part of the work – which included the *Oculist Charts* – silver-plated. He made a drawing of this part of the work on carbon paper, so that it could then be easily reproduced on the silver-plated section. He also continued to switch with disconcerting rapidity between the slow meticulous elaboration of *The Large Glass* and his undemanding and often jokey readymades. His next work in this line was called *Fresh Widow*, a pun on French window. In Duchamp's window, the glass was replaced by black leather which was to be waxed each morning. He followed *Fresh Widow* with *Why not Sneeze Rrose Sélavy?* The title appears to have nothing to do with the work itself – a birdcage containing small pieces of marble carved to look like sugar cubes, a thermometer and a cuttlebone, all painted white. This complex piece is very different from the ready-mades that had gone before. It has more in common with the "objects operating in the symbolic mode" that the Surrealists would later produce. It was a commission from Dorothea Dreier, Katherine's sister. Katherine took advantage of her sister's dismay and surprise on first seeing the object to buy it from her.

Rrose Sélavy thus became Marcel Duchamp's *alter ego*. He was photographed under this new identity by Man Ray for a label which they then stuck onto a bottle of Rigaud perfume, baptizing the result *Belle Haleine. Eau de Voilette* ("Beautiful Breath. Veil Water" – a pun on *Belle Hélène*, "Fair Helen", and *Eau de Toilette*). The following year, Rrose Sélavy, the femme fatale with the coal-black eyes, posed again for Man Ray. This time she was wearing an elegant and extremely fashionable hat designed by Germaine Everling, who also lent her hands to this anti-Mona Lisa. Duchamp later retouched the hat; he also altered Germaine's hands, which were not sufficiently feminine for his taste.

Katherine Dreier was planning to establish an international collection of contemporary art, which would be the first of its kind in the United States. Duchamp was enthusiastic about this initiative, and agreed to act as secretary and administrator for the project. He, Man Ray, and Dreier became the founding directors of the Société Anonyme, Inc. The Society came to own six hundred works by one hundred and seventy artists, representing twenty-three different countries, and in the years up to 1939 organized eighty-four exhibitions. On its dissolution in 1941, the collection was bequeathed as stipulated in the statutes to the Yale University Art Gallery. The task of writing the catalogue

Marcel Duchamp and Man Ray
Beautiful Breath, Veil Water
1921, photo-collage and ink,
29.6 x 20 cm (11 5/8 x 7 7/8 in).
Private collection.

notes was shared between Katherine Dreier herself, George Heard Hamilton, who was the curator of the collection, and Duchamp, who was responsible for thirty-two entries in his own inimitable style.

Meanwhile, Dada was beginning to make a name for itself in Paris. Duchamp came up with the idea of establishing a subsidiary branch of the movement in New York. To this end, reviews would be founded, and sales of Dadaist objects organized. His inevitable collaborator, Man Ray, thought this an idea of genius, and together they published *New York Dada* in April 1921. It took the form of a large sheet of paper printed on one side only, and folded twice. There were several articles, including one by Tristan Tzara, translated by Man Ray. But despite its many qualities, and the added attraction of a reproduction of *Belle Haleine. Eau de Voilette* on the cover, *New York Dada* was a flop.

By then peace had returned, and the atmosphere in New York had changed radically. Most of the artists who used to live there had left the city, Stieglitz had closed his gallery, and the Arensbergs, whose business had collapsed, had moved to a little-known suburb of Los Angeles called Hollywood.

Duchamp was disappointed. He could no longer extend his residence permit for the United States, and began to make ready to return to Paris, where the Dadist group had invited him to show work at their June exhibition at the Galerie Montaigne. In reply, Jean Crotti received a telegram which stated baldly: "Podebal.[1]" Duchamp set sail a few days later for France, followed by Man Ray who reached Paris on the 14th of July. *The Large Glass* was left behind in New York.

1 A phonetic transcription of the French words *Peau de balle*, the first half of a popular expression meaning "Nothing doing!" After a considerable delay, Dada finally riposted with the second half of the tag; in 1957 (!), the organizers of the Dada retrospective at the Institut de Paris Gallery sent Duchamp a telegram reading simply: *"Et balai de crin"* – literally, "And a horse hair broom".

4 - *The Large Glass* in context

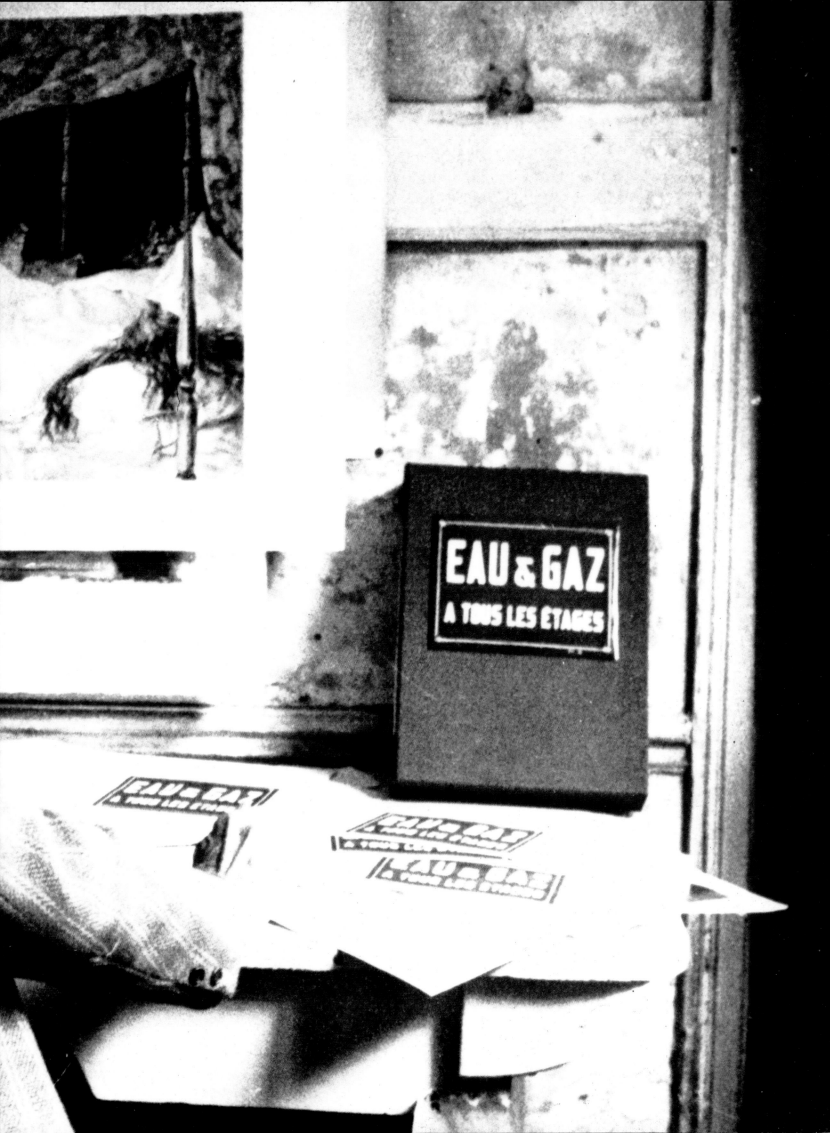

"I was obsessed with it right up till 1923", said Duchamp: "it was the only thing I was interested in and I even regret I didn't finish it. But in the end it became so monotonous, it was just a transcription, there was no invention left in it.[1]"

The Large Glass, also known as *The Bride Stripped Bare by her Bachelors, Even*, consists of two sheets of glass held together vertically in a frame that measures 175.8 cm wide by 272.5 cm high (69 1/4 x 107 1/4 in). Into this new support, Duchamp introduced meticulous copies of several of his earlier works.

Duchamp called *The Large Glass* an "agricultural machine". Its central theme is a complex and disturbing initiatory journey through the experience of love and desire. Its forms and meanings have been dissected and argued over by countless critics, some more prone to flights of fancy than others, and the result has been many different, and often contradictory, interpretations, drawing on alchemy, tarot, esoteric and symbolic traditions, literature and psychoanalysis, amongst other disciplines. There have been cabalistic readings which have cast Duchamp as a gnostic, as well as more conventionally religious interpretations for which the abstract figure of the Bride is a modern equivalent of the Assumption of the Virgin Mary. There have even been analyses inspired by the tantric philosophy of Tibet.

The notes found among Duchamp's papers after his death were deciphered and put into chronological order by Paul Matisse. However, even when taken together with the commentaries published in the *Green Box* of 1934 and the *White Box* of 1966, they record only isolated fragments of the complex intentions that lay behind this work. They do however shed important light on the different methods and approaches Duchamp tried out – successively, or even sometimes simultaneously – as he sought to represent the transition operated by the deflowering of the Bride.

In Duchamp's hands, this theme, as André Breton said, "was subjected to a profoundly unemotional investigation – as if an extra-human being were trying to work out what went on in this kind of operation".

Duchamp had first imagined this ironic-erotic machine when he was still living in Neuilly. He worked on his ideas for it in Munich, Paris and even Buenos Aires. Finally, he assembled it piece by piece in New York over a period of fifteen years. His aim was neither fame nor fortune. In his own words, the work served as a "platform" on which he could erect a monument to "intellectual expression" in art, as opposed to "retinal expression". The result is an object that is accessible to the viewer's gaze only insofar as the rational mind guides it towards the object's structure and meaning.

In 1949, Duchamp wrote to Jean Suquet – without doubt the *Glass*'s most intelligent commentator[2] – stating that his work was "not made to be looked at (with aesthetic 'eyes'), and was meant to be accompanied by a piece of 'literature' which was to have been as amorphous as possible, but which never took shape; the two elements, glass for the eyes, text for the ears and under-

1 *Ingénieur du temps perdu, op. cit.*
2 Jean Suquet, *Miroir de la Mariée*, Paris, 1974.

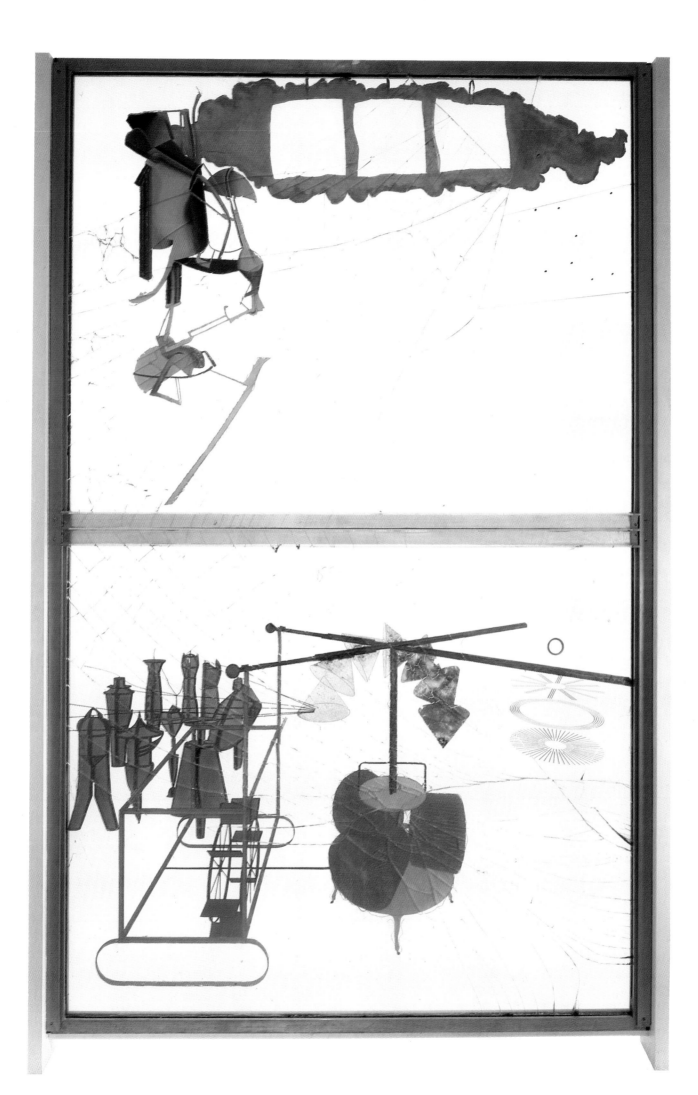

1 Chariot
1a Water Mill
1b Pinion
1c Trap-Door opening to the Basement
1d Pulley
1e Revolution of the Bottle of
 Benedictine
1f Runners of the Sleigh
1g Sandows [Mechanical Chest-
 Expanders]
2 Cemetery of Uniforms and Liveries
 or Eros' Matrix
2a Priest
2b Department-Store Delivery Boy
2c Gendarme
2d Cuirassier
2e Policeman
2f Undertaker
2g Flunkey
2h Chasseur de Café [Messenger Boy]
2i Stationmaster
3 Capillary Tubes
4 Sieves
5 Chocolate Grinder
5a Nickeled Louis XV Chassis
5b Rollers
5c Necktie
5d Bayonet
6 Large Scissors
7 Bride
7a Ring for hanging the Pendu Femelle
7b Patella-Mortice
7c Pole carrying the Filament Substance
7d Wasp
7e Head or Eyes
7f Weathervane
8 Flesh coloured Milky Way
9 Draft Pistons
10 Churn-Ventilator
11 Slopes or Planes of Flow
12 Crashes-Splashes
13 Horizon – Bride's Clothes
13a Vanishing Point of the Bachelor's
 Perspective
13b Prism with the Wilson-Lincoln
 Effect and 9 Holes
14 Battering Rams
15 Oculist Charts
16 Kodak Lens
17 9 Shots
18 Tender of Gravity
18a Tripod
18b Rod
18c Black Ball

▸── Journey of the Illuminating Gas
──▸ Language of the Bride

From Jean Suquet, *Le Miroir de la Mariée*
(Ed. Flammarion).

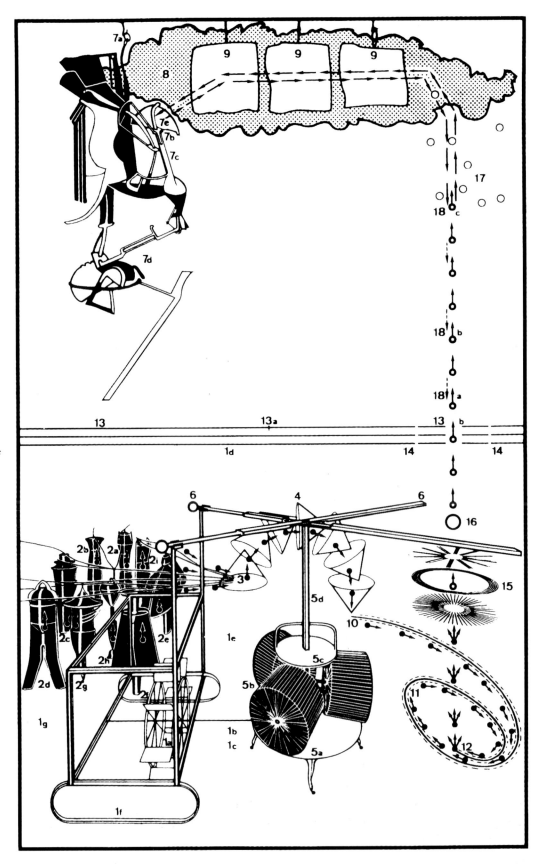

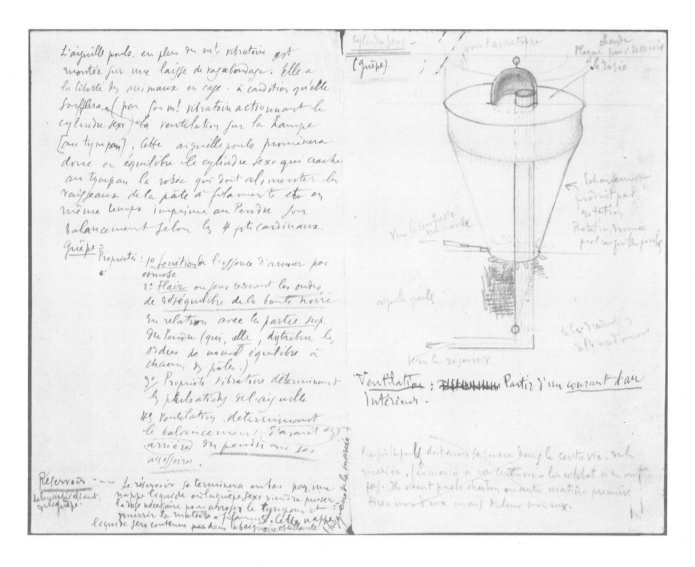

standing, were to have complemented each another, and above all prevented each other from assuming either a plastic-aesthetic or a literary form".

The horizontal bar that divides the work into two parts separates the domain of the Bride, above, from the *Bachelor Apparatus* below, at the centre of which is the *Chocolate Grinder*. "The bachelor has to grind his chocolate himself", Duchamp remarked, referring to the solitary activity to which the latter is apparently reduced. On the left is the *Glider*, which moves back and forwards "with a convulsive movement". Its jolts and jerks serve to open and close the *Large Scissors*, behind which can be seen first the *Bachelors*, then the *Nine Mâlic Moulds*, trapped in their rigid upright poses in the *Cemetery of Uniforms and Liveries*. Their forms are swollen with that vital urban fluid, illuminating gas, which reaches them through the *Communication Canals* of the *Capillary Tubes*, whose forms are derived from the *Standard Stoppages*.

The *Canals* serve a double purpose: they supply gas to the *Moulds*, then route it away again to the funnel-shaped opening of the first of the seven *Sieves* or *Parasols*. Here, and only here, Duchamp deliberately left the dust that had collected while the *Glass* was in storage during his absence from New York, fixing it under a layer of varnish. (The dust had already been photographed by Man Ray.)

Study by Duchamp for *The Large Glass* in *The Green Box* of 1934.

The *Capillary Tubes* and the *Sieves* then channel the gas across the *Slopes* or *Planes of Flow*, through the *Splash Mobile* as far as the *Oculist Charts* which are shown in perspective. (This is the part of the *Glass* that Duchamp left unfinished.) From there the gas continues its journey until it reaches the frontier with the domain of the *Bride*.

In *The Large Glass*, the Bride is reduced to a kind of perfect mechanical organ, held in suspension: "The Bride basically is a motor. But before being a motor which transmits her timid power – she is this very timid power... a sort of auto-mobiline, love gasoline, that, distributed to the quite feeble cylinders... is used to fragment and scatter this virgin who has reached her desire's term.[1]" Her blossoming, which is also a stripping bare, was for Duchamp the most important part of the *Glass*, and the first segment to be constructed. It takes the form of a nebula: a flesh-coloured *Milky Way* that surrounds the three *Draft Pistons*, with the *Pendu Femelle* and the *Ring* from which she hangs as its appendage. For Duchamp, it was "the image of a motorcar driving up a hill in 1st gear". The vibrations that run through it stem from the mounting desire of the Bride.

"In this blossoming, the Bride reveals herself nude in two appearances: the first, that of the stripping by the bachelors, the second that voluntary-imaginative one of the Bride. On the coupling of these two appearances of pure virginity – on their collision depends the whole blossoming, the upper part and crown of the picture."

"The bride accepts this stripping by the bachelors, because it provides the love gasoline to the sparks of this electrical stripping; moreover, it furthers her complete nudity by adding to the 1st focus of sparks (electrical stripping) the 2nd focus of sparks of the desire-magneto.[2]"

The notes published in the *Green Box* were often made in a hurry, and sometimes contradict one another. They bring together many different intentions and descriptions, proving that Duchamp sometimes hesitated about the form his work should take. As a result, it is impossible to use them to track down a single unifying motivation that would underlie and explain the work as a whole.

The result of Duchamp's efforts over a period of eight years was an object that acted as a condensation of time itself, time both chronological and mental – the time before the work, the time during which the *Glass* was made, and the past-*Glass*, throughout which most of Duchamp's projects were derivations from and extensions of his *magnum opus*.

"To this day", wrote Breton, "no work of art seems to me to have so equitably divided responsibility between the rational and the irrational, as does the *Bride Stripped Bare*. Everything about this work... down to its impeccably dialectical conclusions guarantees it a dominant position among the significant achievements of the twentieth century.[3]"

1 Note from the *Green Box*.
2 *Ibid*.
3 André Breton, "Phare de la Mariée", *op. cit*.

Duchamp's adventures on stage and screen

From June 1921 to January 1922, Duchamp was in Paris. There he spent time with Aragon, Philippe Soupault, Benjamin Péret, Eluard and Desnos, and with Breton, who wrote enthusiastically about him in the October 1922 issue of the review *Littératures*. "*Lits et ratures*" (beds and crossings out) was Duchamp's comment, though *Littératures* published some of his own jokes, using the signature of Rrose Sélavy. Despite his friendly relations with the Dadaists, he took no part in the events they organized, just as he would later avoid being drawn into the activities of the Surrealists. He produced a new readymade, *The Brawl at Austerlitz*: this was a variant on *Fresh Widow*, another miniature window, but this time with transparent panes. He also anticipated the vogue for "body art" by fifty years when he had a comet shaved into his hair by Marius de Zayas.

The year 1922 was not Duchamp's most prolific year as an "artist". He was now playing chess professionally. He took part in many tournaments, where he would play and often win against international masters, returning loaded down with cups and prizes. "Hateful Harer" was Breton's comment – Harer being the Ethiopian province where Rimbaud had abandoned poetry for arms-dealing. Duchamp too appeared to have given up his vocation. Yet despite this harsh judgement, Breton was still the staunchest promoter there was of the "Duchamp myth", and he made sure that the Surrealist group never censured Duchamp for all the liberties he took. Duchamp, for his part, remained as incomprehensible and as unpredictable as ever. He could be wilfully silent, when he was not fashioning cool elliptical witticisms. He seemed detached from everything, except women, whom he preferred rich, unattached and with plenty of free time on their hands. When asked, he said he was not sure whether he would return to "art". He left the discon-

Man Ray
Marcel Duchamp
1921.
Haircut by
Marius de Zayas.

Duchamp installing a reproduction
of *The Large Glass* at the Moderna
Museet in Stockholm in 1961.

OPPOSITE
Marcel Duchamp
***The Bride Stripped Bare
by her Bachelors, Even***
Details of the lower part of
The Large Glass, showing the
Chocolate Grinder, the *Capillary
Tubes*, the *Sieves*, the *Oculist
Charts*, etc.

PAGE 140
Duchamp seen through *The Large
Glass* at the Philadelphia Museum
of Art in 1950.

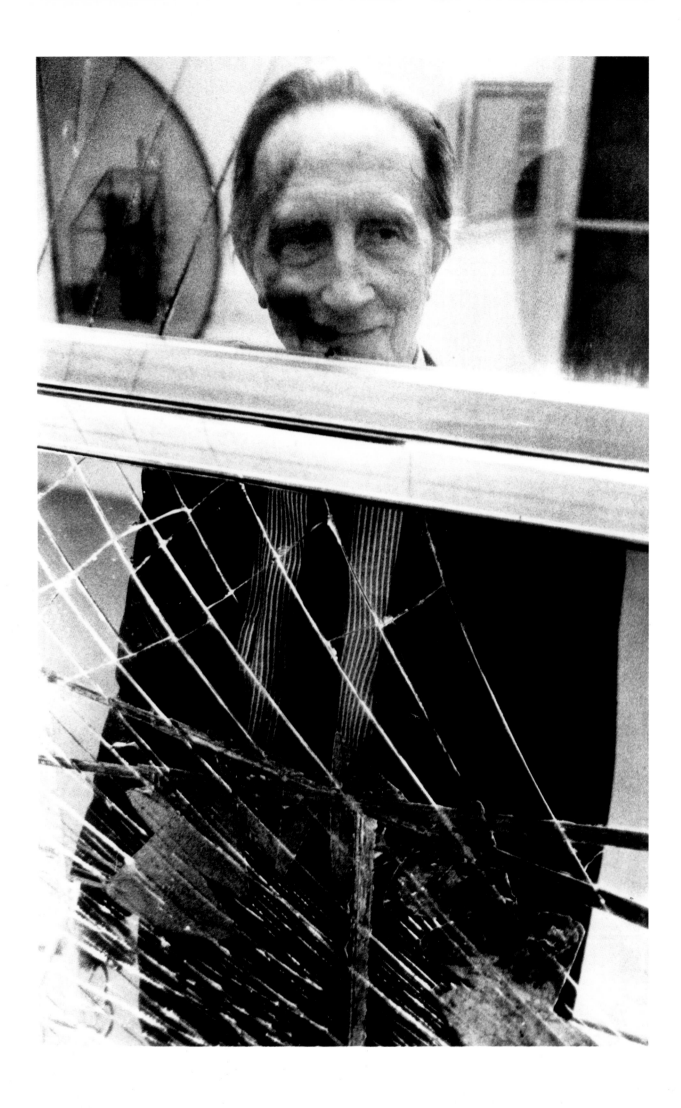

PAGE 141

Sylvie Blocher

Disappointed, the Bride Got Dressed Again

1991, steel, neon, synthetic fabric, 166 x 22 cm
(65 3/8 x 8 5 /8 in), stainless steel housing,
34.5 x 23 x 35.5 cm (13 1/2 x 9 x 14 in).

The Collection of the Musée national d'art moderne, Paris.

Sylvie Blocher's work offers a commentary on
Duchamp's *The Bride Stripped Bare…* in the form of a
"stereoscopic" view which generates a narrative space.

ABOVE

Erwin Blumenfeld's photograph of
The Large Glass made the cover of
American *Vogue*, July 1945.

OPPOSITE

Marcel Duchamp photographed
by Richard Hamilton for the
Peterburg Press poster advertizing
the *Oculist Charts*.

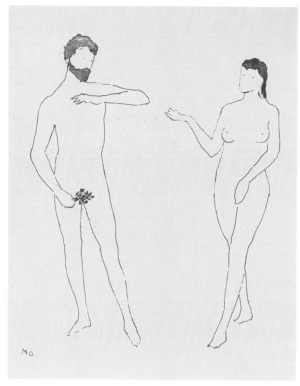

ABOVE

Marcel Duchamp and Bronia
Perlmutter as Adam and Eve
in *Ciné-sketch* by Francis Picabia
in 1924.

RIGHT

Marcel Duchamp
Selected Details
after Cranach
1967, etching,
50.5 x 32.5 cm
(19 7/8 x 12 3/4 in).
Private collection, Paris.

certing and enigmatic *Bride Stripped Bare* to fend for herself in his studio in the
Lincoln Arcade Building, where his acquaintances would occasionally visit her.
He had become, and would remain, the only twentieth-century artist to have
produced a work that was in perfect symbiosis with the life of its creator. The
Bride was as inscrutable as her maker, and her future as uncertain as his.

In 1926, while Marcel was in France, Katherine Dreier agreed to loan *The
Large Glass* to an exhibition that was being organized by the Société
Anonyme, Inc. at the Brooklyn Museum in New York. The work was badly
packed, and when it returned it was broken in several places. By a curious co-
incidence, the cracks in the glass followed the lines defined by the *Network of
Stoppages*. Since the *Glass* was not unpacked immediately on its return, the
damage was only discovered several years later. Duchamp refused to let this
mishap upset him, and made the necessary repairs in May 1936 during one of
his stays in New York. He approached the job with his customary detachment.
"It's much better with the cracks, a hundred times better. That is the fate of
things", he later said. It is now difficult to imagine *The Large Glass* intact.

In December 1923, Duchamp took up residence at the hôtel Istria in the rue
Campagne-Première. The hotel was a sort of commune, frequented by artists
and models from Montparnasse who used it to conduct their experiments in
free love. Duchamp, who always had time on his hands, occupied his hours of
"non-activity" by appearing in René Clair's film, *Entr'acte,* in which he plays
chess with Man Ray on a rooftop while being sprayed with water from a hose.
The film, as its title suggests, was meant to be shown during the interval of a
ballet on which Picabia had collaborated with Erik Satie, *Relâche (Night Off)*.

This "double bill" was staged by the Swedish Ballet during their residency at the Théâtre des Champs-Elysées in November-December 1924.

On New Year's Eve, which was the last night of the production, Duchamp appeared on stage in a *Ciné-sketch* devised by Picabia. In this, he played the role of Adam, naked save for a false beard. Eve was played by the beautiful Bronia Perlmutter, also in the nude. Her performance had a considerable impact on René Clair, who married her shortly afterwards.

During the summer of 1923, Duchamp returned to puzzling over optical problems. He made seven *Disks Bearing Spirals* in ink and pencil, which he cut out in irregular shapes and mounted on a sheet of paper, and the *Disks Inscribed with Puns*. These subsequently figured in the film *Anemic Cinema*, which Duchamp made with Man Ray and Marc Allégret in 1925-1926. He later said: "What amused me most in the cinema was the optical dimension. Instead of making a machine that revolves [*tourne*], as I had in New York, I said to myself: why not shoot [*tourner*] a film? It would be much easier… it was a more practical way of achieving the optical results I wanted.[1]"

1 *Ingénieur du temps perdu, op. cit.*

Marcel Duchamp and Man Ray playing chess on a rooftop in René Clair's 1924 film *Entr'acte*.

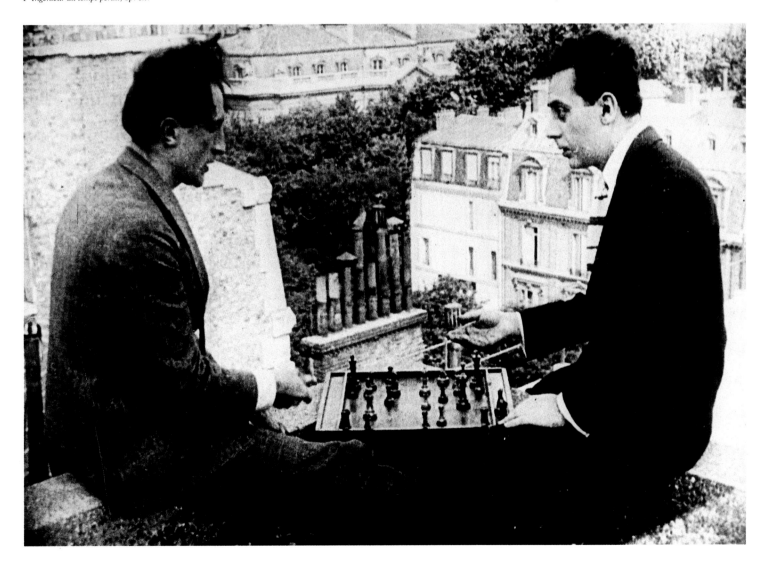

Marcel Duchamp
Rotoreliefs (Optical Disks)
1935, six cardboard disks printed
with colour designs on both sides,
diameter 20 cm (7 7/8 in).
Private collection, Paris.

OPPOSITE
Marcel Duchamp
Rotorelief known as *Corollas*
1935, cellophane label presented
on a black cardboard disc.
Private collection, Paris.

The disks were followed by the *Rotary Demisphere*, a machine for producing spiral effects, which was mounted on a metal base and worked by a motor. It was financed, rather implausibly, by a man who seemed ill-equipped to understand and appreciate it: the couturier, patron and collector of the arts, Jacques Doucet. It was Breton's idea that he should pay Duchamp to make it. Doucet at that time was using Breton as a kind of informal agent, and had come to rely on his advice and intelligence. Breton was also responsible for persuading Doucet to buy Duchamp's *Glider* of 1913-1915.

To support himself, Duchamp began to organize art auctions, and soon proved to be a very shrewd businessman. A dandy he might be, but his contempt for material considerations had not left him completely indifferent to money. He had to make frequent trips back and forth to New York, and in 1926 took an apartment there at 11, Larrey Street. It was there he commissioned a carpenter to make his famous *Door*, which was designed so that it could, contrary to the French dictum, be open and closed at the same time.

The 1938 Surrealist exhibition

On 9 June, Duchamp rather absent-mindedly married a rich heiress to whom Picabia had introduced him, Lydie Sarrazin-Levassor, at the Protestant Church at the Étoile. The marriage lasted only six months. His bride has left us an entertaining memoir of their brief life together[1].

The years immediately preceding the war were a time of cowardice and betrayal in France. Fearing the worst, Duchamp got ready to leave again. "Everything important I've done will fit into a small suitcase", he said. And it was true that he had done little since returning to France.

1 Lydie Sarrazin-Levassor, "Le récit de Lydie", in *Rrosopopées*, XIIᵉ année, March 1989.

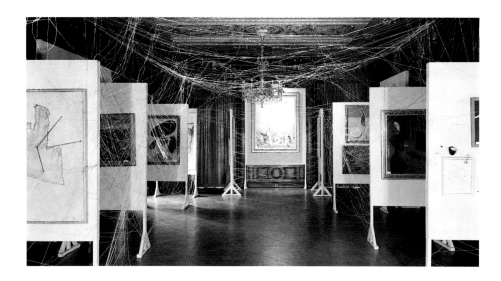

The "First Papers of Surrealism"
exhibition held in New York
in 1942.

The *Box in a Valise* was conceived as a Collected Edition: in its original form, it comprised sixty-eight (later expanded to eighty-three) photographs or miniature reproductions of Duchamp's works. These were placed in a cardboard box, and the box was placed inside a suitcase. Assembling this collection was fiddly and time-consuming work, and took Duchamp several years. The *Box* was finally completed in New York in 1941. Like the *Green Box*, it was produced in a limited edition of three hundred copies, of which twenty were a de luxe version.

Duchamp remained in New York throughout the war. He was no longer a "missionary for insolence". He had mellowed into a quiet, discreet gentleman, who seemed unconcerned by the great events that were tearing the world apart. However, he was still capable of provoking the occasional scandal. When Breton organized an exhibition called "First Papers of Surrealism", in aid of the children of French prisoners of war, Duchamp's contribution was to hang an inextricable cat's-cradle across the rooms in which the show was held, so that the visitors who wanted to look at the works were obliged to perform feats of gymnastic contorsion in order to reach them. He submitted a portrait of George Washington for the front cover of *Vogue*, but the editors turned it down, suspecting that the red patches on the bandage wrapped around the great man's head might represent blood. He also managed to provoke the ire of women's institutes by designing a shop window to mark the publication of Breton's *Arcane 17* in which a headless female dummy was displayed with a tap implanted in her thigh.

In 1941, the collection of the Société Anonyme, Inc. was given to the Yale University Art Gallery. In all the thirty-two notices he wrote for the catalogue, Duchamp deliberately adopted a banal purely descriptive style, even though he loathed some of the artists he discussed, and knew nothing of the work of some of the others. The result is a uniform flatness, occasionally leavened by perverse ambiguities, and a complete lack of critical perspective. When these texts, which had been written in English, were translated into French, Duchamp was widely criticized. His answer: "I had perceived the vanity of censoriousness".

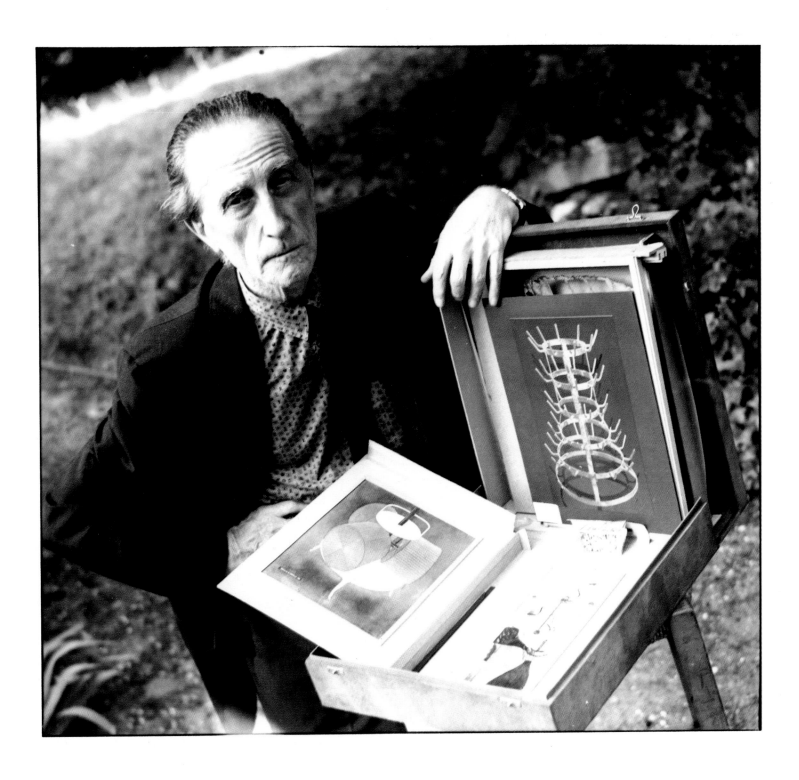

Marcel Duchamp with his *Box in a Valise*.

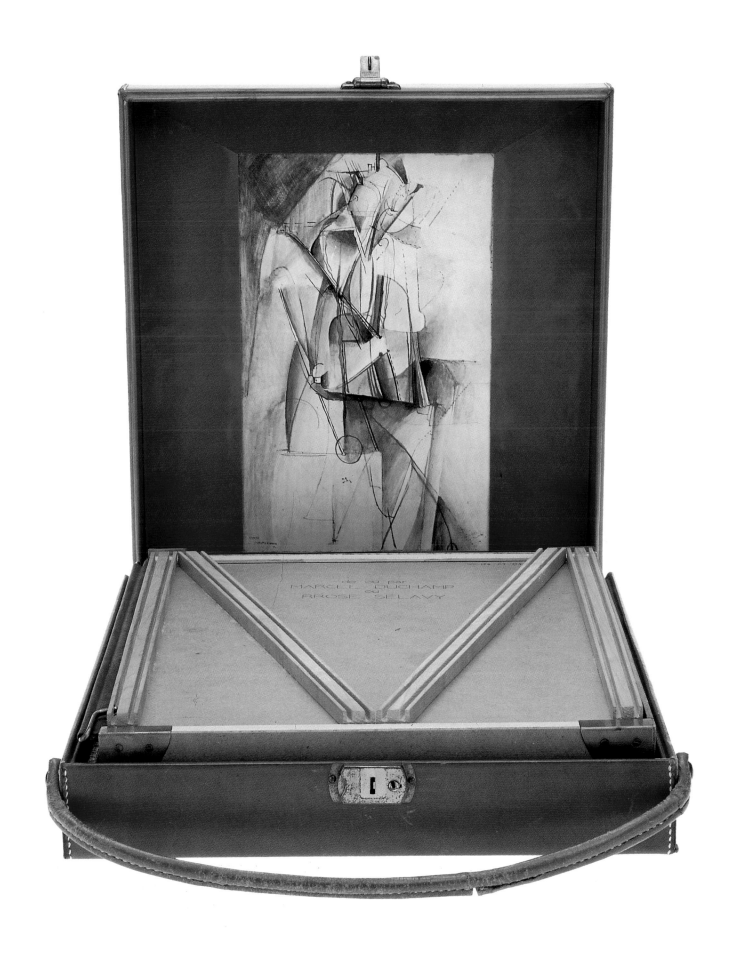

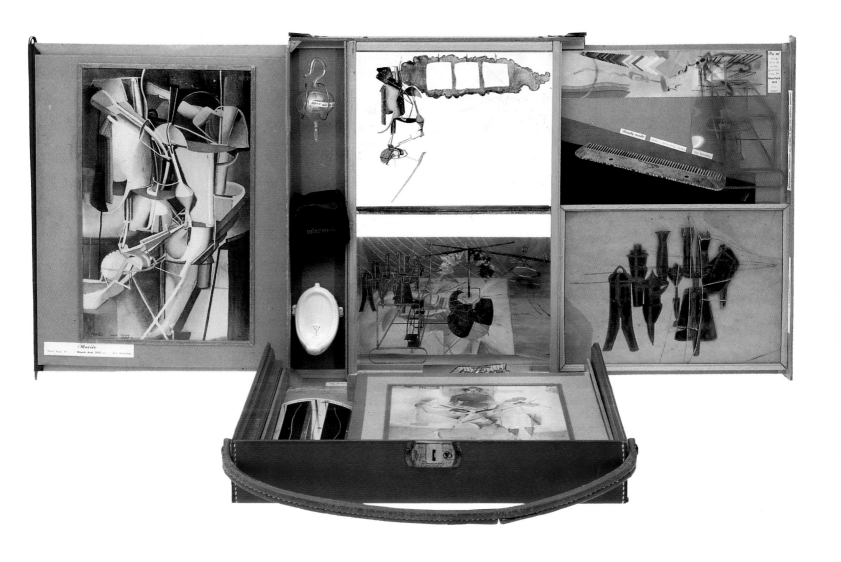

OPPOSITE AND ABOVE

Marcel Duchamp

Box in a Valise

1943, leather-covered cardboard box O/XX
containing the original of *The Virgin*.

The Louise and Walter Arensberg Collection,
Philadelphia Museum of Art.

FOLLOWING PAGES

Marcel Duchamp

Box in a Valise

1936-1941, leather-covered cardboard box con-
taining between 68 and 83 (depending
on the edition) miniature replicas, photographs
and colour reproductions of works by Duchamp,
40.7 x 38.1 x 10.2 cm (16 x 15 x 4 in).

Musée national d'art moderne, Paris.

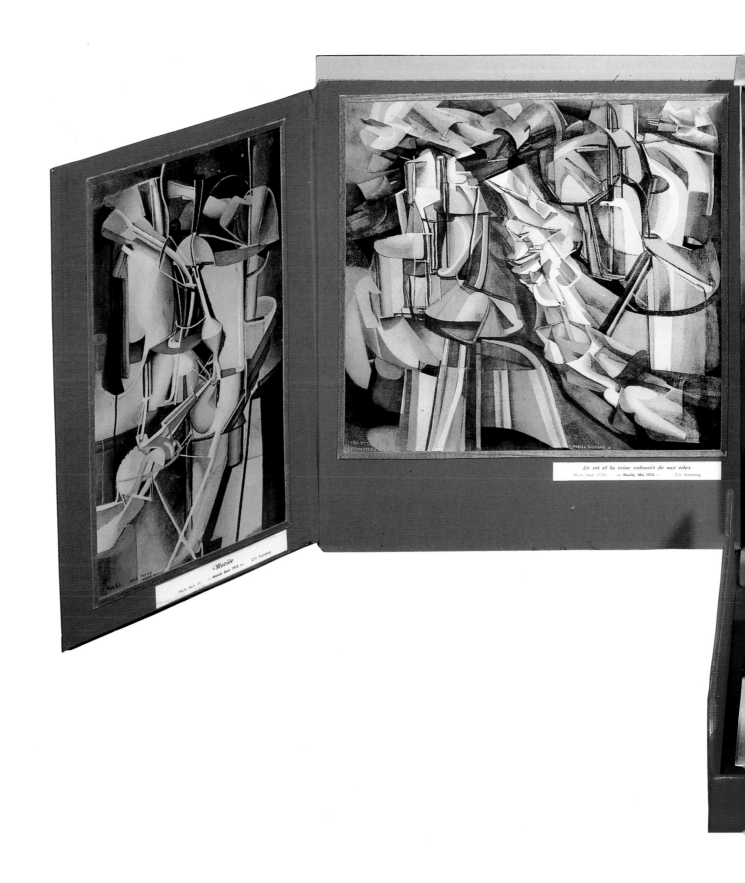

Mariée Coll. Arensberg

(Huile, haut. 1^m. — Munich Aout 1912 —

Le roi et la reine entourés de nus vites

(Huile, haut. 1^m30) — Neuilly, Mai 1912 — Coll. Arensberg

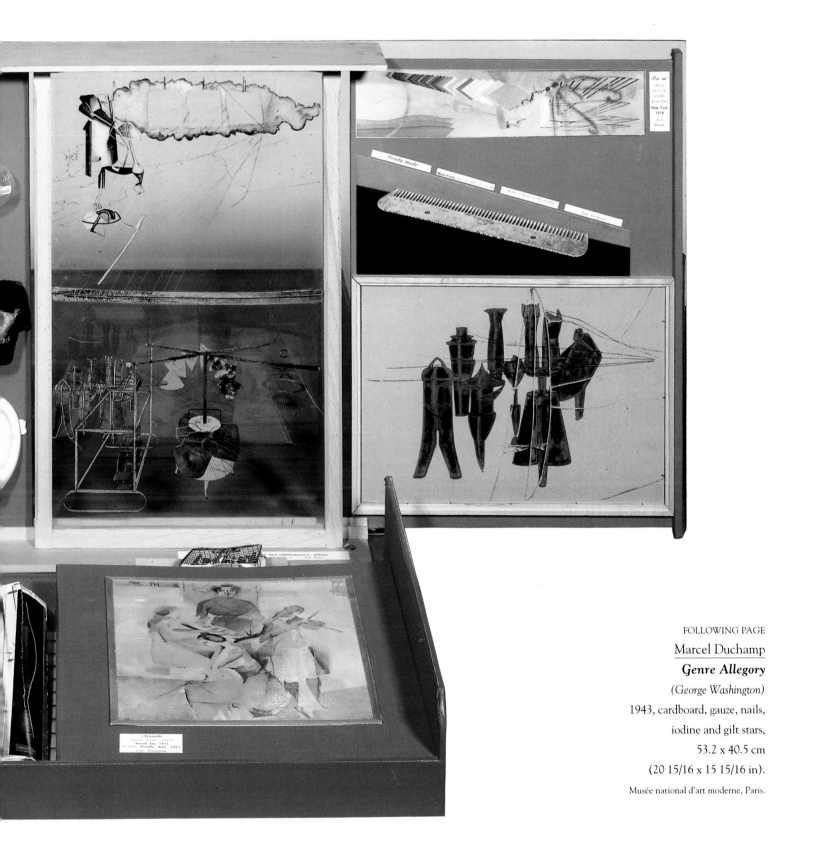

FOLLOWING PAGE
Marcel Duchamp
Genre Allegory
(*George Washington*)
1943, cardboard, gauze, nails,
iodine and gilt stars,
53.2 x 40.5 cm
(20 15/16 x 15 15/16 in).
Musée national d'art moderne, Paris.

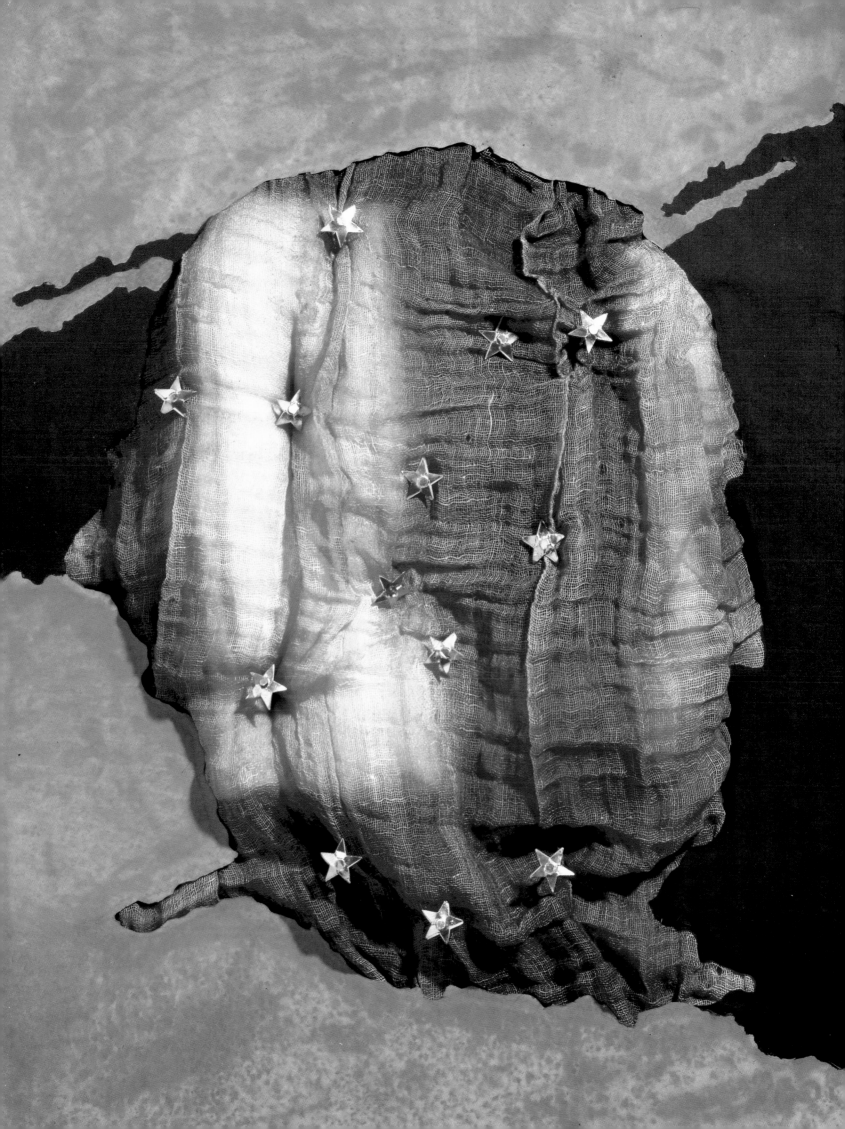

5 - Birth
of a myth

PRIERE DE TOUCHER

ABOVE AND OPPOSITE

Marcel Duchamp

Please Touch

1947, foam rubber breast
on black velvet background,
mounted on cardboard, cover
for the catalogue of the
exhibition *Surrealism in 1947*.
23.5 x 20.5 cm (9 1/4 x 8 1/16 in).
Private collection, Paris.

PREVIOUS PAGES

Man Ray

Dust Farm

1920.

Musée national d'art moderne, Paris.

This photo shows dust that had
collected on *The Large Glass* when
it was left lying flat for several
months in the New York studio.

Duchamp lived out the war in America, where it could cause him least inconvenience. Once it was over, he returned to France, though there was no one waiting for him there but his family. One good piece of news was that Villon had achieved fame at last – albeit, at the age of seventy. Duchamp stayed four months in Paris, from autumn 1946 to January 1947. Shortly before he returned to New York, Breton invited him to take part in the exhibition *Surrealism in 1947* that was to be held at the galerie Maeght in July. On Duchamp's advice, Breton invited the American architect Kiesler to come to Paris to oversee the installation of the show. It was Kiesler's job too to make sure that the instructions Duchamp had left behind were carried out.

For the exhibition, Duchamp had designed a "Rain room", where rain fell on a billiard table standing on a floor of artificial turf, a Labyrinth, and a "room of Superstitions", which took the form of a cave with a huge white sheet hung across it. In all these rooms, he was seeking to give visible form to his theory of the "infra-thin" – the borderline of what was perceptible to the human senses. He also designed the cover for the catalogue – a foam rubber breast with a pink nipple mounted on a black velvet background. Underneath were written the words: "Please touch".

Back in New York, Duchamp embarked on the first preparatory studies for his next major project, *Given…* He was to work on it in complete secrecy for more than twenty years. At the same time, he applied for American citizenship.

In the USA or Paris, lionized or ignored, Duchamp remained true to himself, never allowing himself to be constrained. His silences were as disturbing as his aphoristic and deflating wit. He never seemed to have the problems others encountered with money, housing, work or emotion. In his own words: "There are no problems, there are only solutions." When his friend Picabia died in

Marcel Duchamp
Wedge of Chastity
January 1954, galvanized plaster
and dental plastic,
5.6 x 8.5 x 4.2 cm
(2 3/16 x 3 3/8 x 1 5/8 in).
Private collection, Paris.

Paris on 30 November 1953, Duchamp sent a telegram reading simply: "Dear Francis, See you soon." He remained extraordinarily active. To those around him, it seemed that he would vanish and reappear at will. However, even he could not avoid the publicity surrounding the public opening of the Arensberg Collection at the Philadelphia Museum of Art in October 1954. Duchamp is one of very few artists whose œuvre now belongs almost entirely to a single museum. The opening was followed shortly afterwards by another significant, but less-well publicized event: at sixty-seven years of age, Duchamp married Alexina ("Teeny") Sattler, the ex-wife of the dealer Pierre Matisse. "I took a woman who, because of her age, was unable to have a child", he said later. Nevertheless, he was clearly delighted to have inherited a family in the shape of Teeny's children and grandchildren from her previous marriage.

As a wedding present, he gave his wife *Wedge of Chastity*. There had always been a strong erotic undercurrent in his work, and from 1950 on, this began to take concrete form in a series of objects in galvanized plaster: *Not a Shoe*, *Female Fig-Leaf* and most directly *Objet-Dard*, a pun on the erect male organ as both penetrating dart *(dard)* and art object *(d'art)*.

"I believe firmly in eroticism, because it is something really widespread in the world, something that people understand", Duchamp said. "It takes the place, if you like, of what certain literary schools refer to as symbolism or romanticism... It's a way of bringing to light things which are constantly hidden.[1]"

1 *Ingénieur du temps perdu, op. cit.*

Marcel Duchamp
Female Fig-Leaf
1950, galvanized plaster,
9 x 14 x 12.5 cm
(3 9/16 x 5 1/2 x 4 15/16 in).
Private collection, Paris.

Marcel Duchamp
Objet-Dard
1951, plaster with incrusted lead,
7.5 x 20.1 x 6 cm (2 15/16 x 7 15/16 x 2 3/8 in).
Private collection, Paris.

OPPOSITE, ABOVE
Andy Warhol
Ten Liz
1963, oil and lacquer on canvas,
silk-screen print,
201 x 564.5 cm (79 1/8 x 222 1/4 in).
Musée national d'art moderne, Paris.

OPPOSITE, BELOW
Andy Warhol
Black and White Retrospective
1979, acrylic and lacquer on canvas,
silk-screen print,
125 x 155 cm (49 1/4 x 61 in).
Courtesy of the Jérôme de Noirmont Gallery, Paris.

Old master, young disciples

In November 1954, Duchamp and Teeny spent three months in Paris. Duchamp was still more or less unknown in France, and his visit went virtually unnoticed. This anonymity does not seem to have bothered him. He was used to leading a clandestine existence in the French capital. When he did show some of his "things" there, the strongest reaction they provoked was amusement. However, in New York, his fame was about to undergo a resurgence, thanks to Neo-Dada and the emergence of the commonplace object as a form of expression. As a result, Duchamp would soon find himself acclaimed as the precursor of what was perhaps the greatest artistic revolution of the second half of the century.

As early as 1954-1955, Rauschenberg, Jasper Johns and Allan Kaprow had begun to turn their backs on the art of the previous generation. They allowed the object back into their works, and in some cases granted it an unprecedented degree of autonomy. The megalomaniac reign of the artist as demiurge and the lyric gestures of abstract expressionism now belonged to the past. Pop art opened up representation to the imagery of mass culture, promoting work that incorporated everyday items and could be reproduced in multiple copies. This was a revolution whose consequences were felt throughout the world. Pop brought art back into contact with reality. Kinetic and op(-tical) art sought to integrate movement and light, exploiting the physiology of the eye to new effect. But Duchamp was unimpressed by what he saw. Although his *Bicycle Wheel*, his *Rotoreliefs* and his optical experiments had pointed the way to kinetic art, he found the work of his young disciples repetitive and monotonous. In his own words, it did not seem to "offer much scope for future development".

Meanwhile, two schools separated by the Atlantic, Neo-Dada in the USA and New Realism in France, sought to express the realities of the contemporary world: the massmedia, industrialization, the consumer society and their attendant urban folklore. Their strategy was explicitly indebted to Duchamp's example. The readymade and the artistic election of the object formed the

PREVIOUS PAGES
James Rosenquist
President Elect
1960-1961, oil on three
chipboard sheets,
213.4 x 365 cm (84 x 143 3/4 in).
Musée national d'art moderne, Paris.

RIGHT
Marcel Duchamp and Eve Babitz
posing for the photographer
Julian Wasser during the Pasadena
Museum of Art retrospective
in 1963.

OPPOSITE
The Duchamp family tomb in the
Cimetière monumental, Rouen.

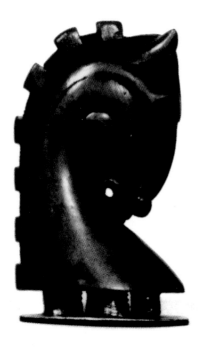

Knight from the set of chess pieces
carved by Duchamp in Buenos Aires.

basis for this new philosophy of the visual, conceived as an extension of modern technological humanism. Duchamp viewed all these developments, and the fame they conferred on him, with his habitual indifference – though he never refused the glory or income that they brought him.

"I play the role of prototype, a role I am delighted with", he said. "But it doesn't go any further than that… I have a life which doesn't depend on what people say about me, or the way in which they perceive me. I owe nothing to anyone, and no one owes anything to me.[1]"

Snapshots in old age

Duchamp was now a public figure. He was no longer simply a myth, he had become a star. He was expected to appear in public, to exhibit himself as well as his work, to give speeches and interviews. He was there to be exploited. He accepted this, enduring every opinion and every situation, no matter how extreme or contradictory, with his inimitable courtesy, yet distancing himself as ever, always contriving to remain remote from what was going on around him. He put up with the "histrionic behaviour" of his admirers which he had mocked so mercilessly in the past, only allowing himself to remark that "One shouldn't allow oneself to get too carried away." He play-acted and performed his party tricks before an ever-admiring circle of devotees. Willy-nilly, he had become a guru; fortunately, his sense of humour survived intact.

During this period he produced a few readymades, including the astonishing *Couple of Laundress' Aprons* – one of which is male, the other female. The ironic eroticism of this work was intended for the de luxe edition catalogue of the *Eros* exhibition at Daniel Cordier's Gallery. His wit could be exceedingly

1 "Marcel Duchamp: Je suis un défroqué", interview with Pierre Cabanne, *Art-Loisirs*, 25 May 1966.

cruel; the rectified readymade that he contributed to a benefit sale for Benjamin Péret was a servant's striped waistcoat. His friend Pierre de Massot, who had, similarly, fallen on hard times, received a drawing of a urinal ornamented with a scabrous anagram.

Exhibition followed exhibition, each an inevitable triumph. Marcel and Teeny advanced serenely towards old age, moving easily back and forth between society gatherings and official functions. In June 1966, the Tate Gallery became the first European museum to host a retrospective of Duchamp's work. Duchamp himself judged the show "excellent": "When your memory is refreshed, you can see more clearly. The chronological sequence is clearer… Everything brought back memories… Everything was simply stripped bare, but gently, smoothly, without regrets.[1]"

France was dragging its heels. Rouen held an exhibition entitled: "The Duchamps". Marcel shared a show with his brother Raymond at the Musée national d'art moderne in Paris in 1967. Marcel's work was still deemed too outrageous to exhibit without the 'cover' provided by Duchamp-Villon's more conventional œuvre. Duchamp himself would appear discreetly at openings, always aloof even in the midst of a crowd. He had an aristocratic sense of distance. Only once did he seem to betray some slight sign of emotion, when a marble plaque was unveiled on the house at 73, rue Jeanne-d'Arc in Rouen, which read: "Here lived, from 1905 to 1925, a family of Norman artists…" Of that family, Marcel was now the sole survivor.

Duchamp had shocked many of his admirers when he agreed to allow replicas of his readymades to be made for an exhibition in Stockholm in 1961. Shortly afterwards, he travelled to Sweden in person to oversee the making of a copy of *The Large Glass* by Ulf Linde. Duchamp had authorized this reproduction, which differed from the original only in that it was signed on the reverse: "Certified accurate, Marcel Duchamp, Stockholm 1961". (This is the standard French formula for endorsing a duplicate.) He repeated his gesture when he approved a second replica of *The Large Glass*, as well as several replica readymades, by the British Pop artist, Richard Hamilton. These pieces helped swell the catalogue of the Tate Gallery retrospective, which went by the

1 *Ingénieur du temps perdu, op. cit.*

First performance of *Walkaround Time*
by Merce Cunningham in Buffalo,
1968. The sets, by Jasper Johns,
are based on Duchamp's *Large Glass*.

title: "The Almost Complete Works of Marcel Duchamp". Duchamp later said that this proceeding had not "greatly rejoiced" him. He added: "As for distinguishing the true from the false, the imitation from the copy, these are technical questions of astounding vacuity."

For orthodox Duchampians, however, the worst was still to come. So far, the copies had simply "stood in for" the Philadelphia originals. The artist had obtained no financial benefit. But when the Milanese art dealer Arturo Schwarz proposed a commercial edition, Duchamp was only too happy to accept. Schwarz produced fourteen series of readymades, each in a limited edition of eight numbered copies (as well as two series reserved for the artist and his agent). Duchamp found himself violently attacked for this decision, but he shrugged off the anger and sadness of his followers, as was his wont. He was accustomed to confounding other people's expectations, and saw no reason to maintain either the "unique" status of his readymades or, for that matter, his reputed indifference to financial gain. Indeed, he was delighted to make some money. The readymade as windfall; this was the ultimate betrayal – or the ultimate subversion.

Snapshots in old age: Mr and Mrs Duchamp lunching with Man Ray and his wife Juliet during a trip to Spain. Marcel Duchamp luxuriating in the shade of an awning he had made for their terrace at Cadaqués; Marcel on a bench in

Washington Square in coat and hat, a cigar in his mouth, sitting behind an empty chess board; playing chess with a naked woman in front of *The Large Glass* during the Pasadena exhibition; and taking part in *Reunion*, a musical performance organized by John Cage in Toronto, in which Duchamp and Cage, with Teeny beside them, played chess on an electronic board that picked up and amplified the different sounds made by the pieces.

On 10 March 1968, Duchamp appeared dressed in black to take his bow between Merce Cunningham and Carolyn Brown at the end of the world premiere of *Walkaround Time* at the Arts Festival of the State University College in Buffalo. The set for the piece, designed by Jasper Johns, was based on *The Large Glass*. Then, after a long journey through Switzerland and Italy, and their habitual summer holiday in Cadaquès, Teeny and Marcel returned to Paris in the autumn of that year. On 2nd October, after dining with friends (amongst them, Man Ray) in their apartment in the rue Parmentier in Neuilly, Duchamp died suddenly of an embolism. His ashes were laid to rest in the family vault in the Cimetière monumental at Rouen. He had composed his own epitaph: "Besides, it is always other people who die."

The Revelation of *Given...*

The Supreme Subversive of 20th-century art had led an outwardly ordinary life. Even his death was undemonstrative and peaceful. His acts had always been simple ones, though their consequences were often far-reaching. From the moment Duchamp had begun baptizing objects into the religion of art, art had ceased to be an aesthetic activity. It had become an ethical project.

The bare entries for his birth and death make no mention of the countless championships he won as a chessplayer, nor of his long stays in New York where the importance of his work and moral example was first recognized (he was made an American citizen in 1955). They say nothing of his years of toil preparing *The Large Glass*, of his indifference to the opinions of others, nor of the many discreet love affairs that preceded the haven of his marriage and the fame of his last years. By then, the artist was already a myth in the making.

Perhaps Duchamp's most profound ideas and intentions are to be found among the scraps of paper, aphorisms, word games, notes and diagrams that he collected into his various *Boxes*[1]. They go some way to explaining how his "things" came into being, outside the citadel of painting and regardless of the prevailing trends of contemporary art. They illustrate the plenitude of his enigmatic and ludic "art", and of the affirmative irony (or meta-irony) which was the thread that ran through everything he did. It was an irony that distanced him from ideology and society alike. The Duchamp legend was built on the quicksand of his mischievous, calculated ambiguity.

Duchamp was a connoisseur of disruption. His last will and testament was a work of erotic aggression and mysterious serenity. It was constructed over a period of twenty years in a New York studio in the utmost secrecy. When it was

1 Published in English as *The Essential Writings of Marcel Duchamp*, edited by Michel Sanouillet and Elmer Peterson, London, 1975.

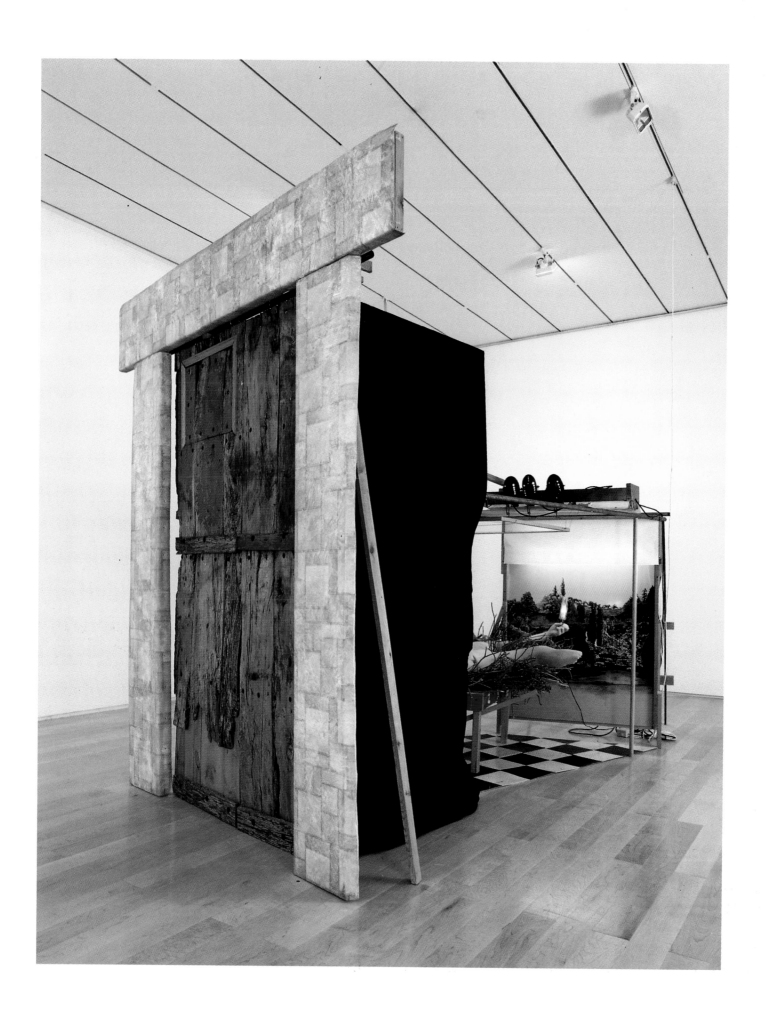

Marcel Duchamp
Preparatory Study for the Figure
in Given: 1. The Waterfall,
2. The Illuminating Gas
C. 1950, gouache on perforated Plexiglas,
91.3 x 55.9 cm (36 x 22 in).
Private collection, Paris.

OPPOSITE

Richard Baquié
Untitled. Given: 1. The Waterfall,
2. The Illuminating Gas
1991, life-size reconstruction of Duchamp's
work, showing how the image, which in
the original installation is visible only
through the two peepholes in the door,
is actually constructed.
The Collection of the Musée d'art contemporain
de Lyon.

unveiled, it comprehensively refuted the oft-repeated claim that towards the
end of his life he had more or less stopped working. It is called _Given: 1. The
Waterfall, 2. The Illuminating Gas_. On Duchamp's death, only his wife, his son-
in-law Paul Matisse and the executor of his will, William C. Copley, were
aware of its existence. It was revealed at the Philadelphia Museum, nine
months after his death, to general astonishment.

The first idea for this work can be found in the _Green Box_ of 1934, among the
documents, notes, plans and drawings of the years 1912-1915. From them, it is
possible to reconstruct the successive phases of the work's "posthumous" exe-
cution. These phases include the reliefs and sculptures that Duchamp made be-
tween 1942 and 1968, works marked by an obsession with modelling the
naked female body in forms and poses which prefigure those of the nude of

OPPOSITE

Marcel Duchamp

Given: 1. The Waterfall,
2. The Illuminating Gas

1946-1966, Mixed-media assemblage
including an old wooden door, bricks,
velvet, wood, leather stretched over
a metal armature, twigs, aluminium,
glass, Plexiglas, linoleum, cotton,
gas lamp, motor, etc.

242.5 x 177.8 x 124.5 cm
(95 1/2 x 70 x 49 in).

Donation of the Cassandra Foundation,
Philadelphia Museum of Art.

There are two peepholes in the door
(right) through which the scene is
visible (opposite page).

OPPOSITE, ABOVE

Marcel Duchamp

The Bec Auer

1968, engraving,

42.2 x 25 cm (16 5/8 x 9 7/8 in).

Private collection, Paris.

BELOW

Marcel Duchamp

The Bec Auer

1968, engraving,

42.2 x 25 cm (16 5/8 x 9 7/8 in).

Private collection, Paris.

Given... Is this figure the Bride, now torn from the protective cocoon of her immaterial glass, and ambiguously offered up as a prey to the single voyeur-viewer? An old wooden barn door hangs in a brick frame. Two holes made in the door at eye level allow the viewer to spy on an extraordinary scene: the body of a naked woman is laid out on a mat of branches. Her head is hidden, and her thighs are spread wide, revealing her sex – glabrous, tumescent, androgynous. She holds out at arm's-length a bec Auer gas lamp, lit by an electric light. Behind her is a retouched photograph of a landscape (possibly Swiss), bathed in an unreal light. In the photograph is a waterfall operated by a motor. Duchamp left an illustrated "user's guide", in which he explained precisely how this "collapsible approximation", delivered in kit form, should be installed. The resulting work provokes a feeling of unease in the viewer. Are we the spectators of a sadistic crime? A ritual act? A rape? *Given...* is neither painting, sculpture, environment, nor an exercise in mechanics or optics. It offers a synthesis of several recurrent themes in Duchamp's work. The painstaking reconstructions

of perspective in *The Large Glass* are here transposed into three dimensions. What was suggested in the earlier work is here explicitly established as central. As a note from the *Green Box* puts it: "The conditions for the instantaneous state of Rest (or allegorical appearance) of a succession [of a group] of various facts seeming to necessitate each other under certain laws, in order to isolate *the sign of the accordance between*, on the one hand, this state of Rest (capable of all the innumerable eccentricities) and, on the other, a *choice of Possibilities*, authorized by these laws and also determining them."

"For the instantaneous state rest = bring in the term extra-rapid…"

The viewer has to move from one eyehole to the other to see the whole of the scene. The search for an overall view of these fragments disrupts standard patterns of exploration, which are undermined both by this physical obstacle and by the curiosity which this fragmentation exacerbates. The viewer thus finds himself in the same situation as the Bachelor – pursuing an inaccessible prey which he will never be able to possess.

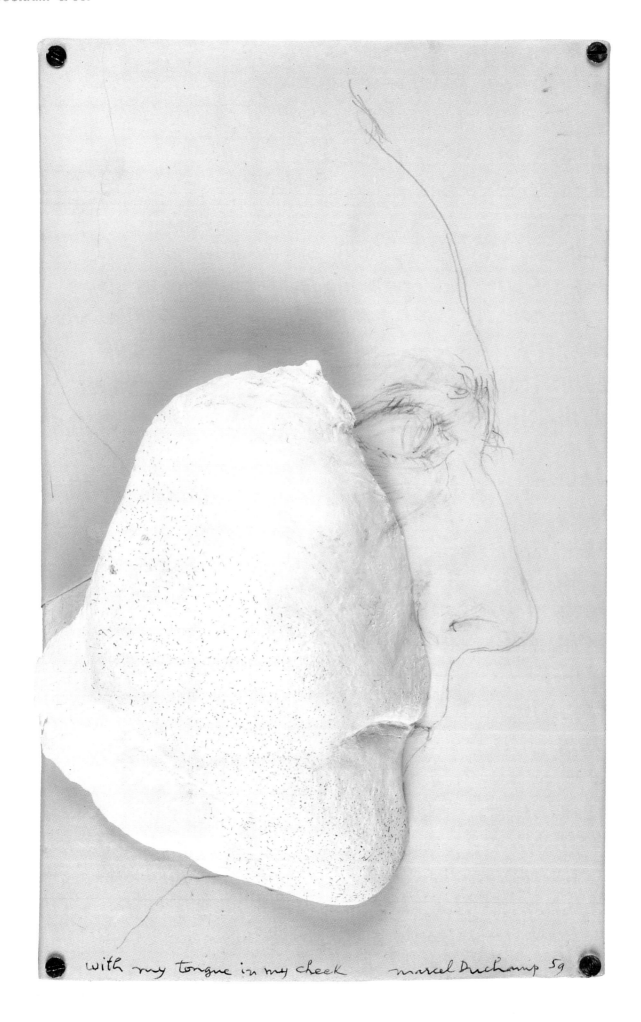

with my tongue in my cheek marcel Duchamp 59

OPPOSITE

Marcel Duchamp	Jasper Johns
With My Tongue in My Cheek	**M.D.**
1959, plaster, pencil and paper,	1974, decoupage, silhouette
mounted on wood,	of Marcel Duchamp,
22 x 15 x 5.1 cm (8 5/8 x 5 7/8 x 2 in).	56.4 x 45.6 cm (22 1/4 x 18 in).
Musée national d'art moderne, Paris.	Courtesy of the Galerie 1900-2000, Paris.

Rauschenberg and the American cult of Duchamp

No sooner was Duchamp dead than his artistic heirs were squabbling over his legacy. No artist has ever had such an extraordinarily disparate succession. For many, Duchamp's posterity was an unmitigated disaster. No corpse was ever picked apart with such a heady mixture of respect and jubilation. Duchamp's lesson was many-layered – there was much to be learned from the spiritual dimension of the readymade and its consequences, the moral stature of the man himself, his paradoxical and remote attitudes, and his deadpan humour. He occupied a unique place in modern culture. He was the archetype of the solitary creator, detached both from others and from the "things" he made. Answerable to no one, he fomented a permanent scandal directed against established aesthetic values. Late in life, he even took on the aura of an ironic patriarch, and would often say: "I owe nothing to anyone, and no one owes anything to me" – though it was obvious he did not believe it.

He elected America at an early age, and by her had countless children and grandchildren. Well before he died, his transatlantic offspring were already exploring his estate and dividing it up between them, though in Europe, and more especially in France, he was either unknown, or dismissed as a belated Dadaist. In 1948-1950, John Cage had already passed on his enthusiasm for Duchamp to his friends at the Black Mountain College in North Carolina, amongst whom was Richard Rauschenberg. It was Rauschenberg's *26 Statements about Marcel Duchamp* that founded the Duchamp cult in the USA – a faith that soon united the Abstract Expressionists, from Motherwell to Pollock, despite their many differences. Duchamp had encouraged Motherwell in 1951, suggesting he put together an anthology of *The Dada Painters and Poets*, and helping him bring the project to fruition. Duchamp was also responsible for hanging Pollock's famous six-metre long *Mural*, when it was shown in Peggy Guggenheim's New York Gallery. Matta, for his part, had met Duchamp in 1938, and was one of the first to grasp the importance of the mechanical forms used in *The Large Glass*. He described himself as "a fetishist of Marcel Duchamp's work". He bought the *Green Box* on installment plan, and in 1942 made a "suite after Duchamp", a series of canvases inspired by objects and themes from Duchamp's work. Two years later, he produced an explicit homage called *The Bachelors, Twenty Years After*, in which he elaborated in an extraordinary, explosive style on the fusion of the organic and the cosmic to be found in *The Bride Stripped Bare*. It was Matta who thus provided the "passage", in Duchamp's sense of a transition from one psychological state to another, between the heirs of Surrealism, the young Americans, and Duchamp himself. In his *Combine Paintings* of 1958, Rauschenberg drew on both Schwitters' collages of discarded and recycled materials and Duchamp's readymades. These works kept the sociological dimension of art alive in the context of Abstract Expressionism, which was still dominated by the wearing gestural physicality of action painting. Rauschenberg's borrowings from the mythology of contemporary technology opened the door to Jasper Johns and the invention of Pop art. Johns, too, owes much to Duchamp. His flat paintings, his targets, his American flags, with their letters and numbers sketched in "by hand", may all

be signs of the survival of a retinal aesthetic. But his painted bronzes, cans of Ballantine's beer and coffee tins full of brushes are something new. They are sculptures disguised as everyday objects, not everyday objects taken out of context and baptized into the realm of art. Where Duchamp sought to demonstrate the arbitrary nature of art and the importance of chance, Johns seems to be concerned chiefly with the gap which separates life from art, art from reality.

One of Johns's experiments was to make a mould from one of Duchamp's final works, the *Female Fig-Leaf,* heat the bronze and then press it against a canvas for the object to inscribe its form there. In this work, the negative of a negative does not give a positive. Johns's appropriation of Duchamp's work is indirect. In his hands, the presence of the object is *de-natured* in its fundamental identity.

Robert Rauschenberg
Monogram
1955-1959, assemblage, oil and
collaged objects on canvas,
163 x 160.5 x 95 cm
(64 1/8 x 63 1/4 x 37 3/8 in).
Moderna Museet, Stockholm.

Jackson Pollock

Mural

1943, oil on canvas,

243.2 x 603.2 cm (95 3/4 x 237 1/2 in).

The University of Iowa Museum of Art.

Pollock's six-metre long *Mural* was painted
for Peggy Guggenheim's apartment.
When it was shown at her Art of This
Century Gallery in New York, Duchamp
helped Peggy with the installation.

Roberto Matta

The Bachelors Twenty Years After

1943, oil on canvas,

96.3 x 127 cm (38 x 50 in).

Private collection.

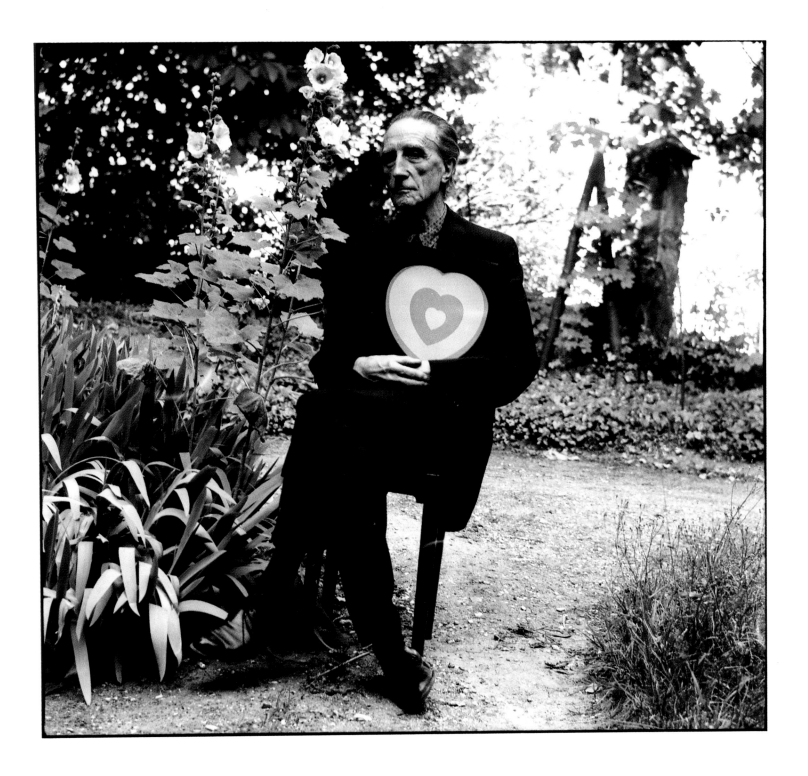

Marcel Duchamp holding a collage of
two paper hearts which he made for the
cover of the *Cahiers d'Art*. A life-size
colour reproduction of this work was
included in *Box in a Valise*.

OPPOSITE

Jim Dine

The Southern Cross no. 2

1995, acrylic and thick pastel on canvas,
122.2 x 92.1 cm (48 1/8 x 36 1/4 in).

Courtesy of Didier Imbert Fine Art & Pace Wildenstein.

Jim Dine

Putney Winter Heart no. 3 (Garbage Can)

1971-1972, assemblage with fabric and metal on oil
on canvas, 183 x 183 cm (72 x 72 in).

Musée national d'art moderne, Paris.

LEFT

Claes Oldenburg bringing materials
for the environment *The Street,*
created in front of the Judson Gallery,
New York, in 1960.

BELOW

Jim Dine rehearsing for the *Car Crash*
happening in 1960.

Warhol, too, was inspired by Duchamp's ethics of indifference, when he deliberately devised his silkscreen prints as works which required neither talent nor skill. Another major figure in Pop art, Rosenquist, painted his objects in isolation on enormous canvases, violently elevating them to a monumental status which destroys their original identity. Jim Dine, like Claes Oldenburg, Rauschenberg and the sculptor George Segal, adopted the practice of using ordinary everyday objects – in Dine's case, tools from a local hardware store and second-hand clothes. Jim Dine and Oldenburg were also among the first artists to experiment with what the poet Allan Kaprow called "happenings" – freely invented (and often violent) theatrical episodes which aimed to "create archetypal situations out of elements that have neither form nor structure". Duchamp was a great fan of happenings. They were one of the rare occasions on which I saw him lose all trace of his usual detachment and serenity.

Andy Warhol

Electric Chair

1966, acrylic and laqueur on canvas,

silk-screen print,

137.2 x 185.3 cm (54 x 73 in).

Musée national d'art moderne, Paris.

The New Realists: adventures with objects

First, there was the Dada trio of Duchamp (readymades), Schwitters (Merz-bild) and Picabia (mechanistic drawings). Then, forty years later, there was the Neo-Dada trio of Cage, Rauschenberg and Kaprow. Where Duchamp had engaged in covert operations, his successors planned their coups in full view of the art establishment. Together they brought about the most significant aesthetic revolution of the second half of the century and, in the process, reestablished America at the forefront of artistic innovation following the decline of Abstract Expressionism. For these young Turks, Duchamp's example was a powerful stimulus. Through their reaction to his work, the historical leaders of Neo-Dada, Rauschenberg and Jasper Johns, were able to tap into energies that had lain pent-up not only in the United States, but also in Europe. Exhibiting alongside the Parisian New Realists in New York, they inspired their European colleagues to go out and rediscover modern nature. The object, thus restored, was able to cross the Atlantic as easily as Duchamp had done on his many trips, his cigar box invariably tucked under one arm.

The New Realism manifesto was written by the critic Pierre Restany on 16 April 1960, and signed by Yves Klein, Dufrêne, Arman, Hains, Tinguely, Villeglé, Spoerri, Martial Raysse, César, Rotella, Christo, and Niki de Saint-Phalle. Their vision of the world was directly inspired by Dada. In their work, the example of Duchamp's readymades took on a new significance and a new relevance. Reacting to the homage they had paid him, Duchamp's only comment was: "I take this quite simply, attach no particular importance to it, and draw no conclusions from it."

Christo wrapped the object, Spoerri glued it to a surface, César compressed it. Tinguely, the prodigal son of Calder and the direct heir of Duchamp and Roussel, invented his *Métamatics*, painting machines which operated in an automic world of potentially infinite metamorphoses. Through them, he created a new approach to reality as radical as that which had come into being with the readymades. Duchamp recognized this when he saw Tinguely's work at the Iris Clert Gallery, and was still talking about his discovery when he got back to New York. The two men soon became firm friends.

Arman, for his part, specialized in collecting objects, which he could then break down or cut up. His ludic pleasure and his critical determination derive from his awareness of the object's aggressive, invasive presence in our society. Arman also spent a lot of time with Duchamp in New York. He enjoyed the older man's deadpan humour and abrupt manner, and they would often meet to "push wood" (i.e. play chess).

Duchamp's readymades had become the morphological units of a new artistic language. In Arman's work, they acquired both a quantitative syntax and a poetic dimension. The articulation of Arman's expressive repertoire derived in a perfectly coherent way from the processes that had engendered its elements. In this way he was able to transcend the pure industrial fetishism to which Duchamp's legacy was so often reduced.

PAGE 186

Jasper Johns

Flag on Orange Field

1957, encaustic on canvas,

167 x 124 cm

(65 3/4 x 48 3/4 in).

Museum Ludwig, Cologne.

PREVIOUS PAGE

Christo

Packaging

1959, canvas and rope,

20 x 30 x 20 cm

(7 7/8 x 11 3/4 x 7 7/8 in).

Musée Cantini, Marseille.

RIGHT

Raymond Hains

The New Realists

1960-1990, stencil painting on
wood, based on the typography
of the cover for the catalogue
of the exhibition "Arman,
Hains, Dufrêne, Yves le
monochrome, Villeglé,
Tinguely" at the Apollinaire
Gallery, Milan in May 1960,

245 x 354 cm

(96 1/2 x 139 3/8 in).

Musée national d'art moderne, Paris.

OPPOSITE

César

Ricard

1962, car compressed under
the artist's supervision,

153 x 73 x 65 cm

(60 1/4 x 28 3/4 x 25 1/2 in).

Musée national d'art moderne, Paris.

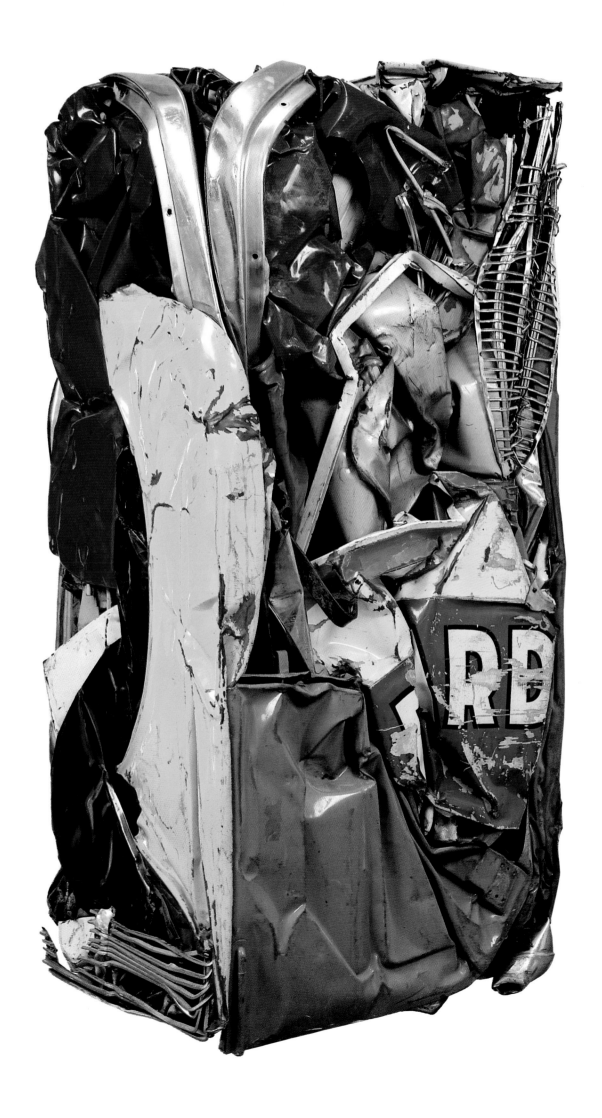

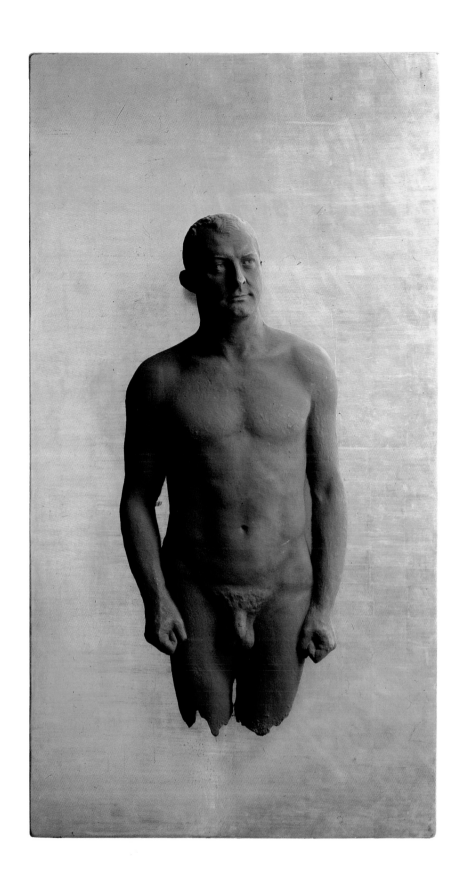

Yves Klein

Relief-Portrait "Arman"

1962, sculpture, painted bronze after a plaster
cast, mounted on gilt plywood,
175 x 95 x 26 cm (68 7/8 x 37 3/8 x 10 1/4 in).

Musée national d'art moderne, Paris.

OPPOSITE, ABOVE

Duchamp in front of one of
Tinguely's *Métamatics* (painting machines)
at the Iris Clert Gallery.

Jean Tinguely

Métamatic no. 1

1959, metal, paper, felt-tip pens, motor,
96 x 85 x 44 cm (37 3/4 x 33 1/2 x 17 1/4 in).

Musée national d'art moderne, Paris.

Arman

Chopin's Waterloo (Anger)

1962, pieces of a piano fixed to wood panels,

186 x 302 x 48 cm (73 1/4 x 118 7/8 x 18 7/8 in).

Musée national d'art moderne, Paris.

OPPOSITE

Arman

Home Sweet Home

1960, collection of gas masks,

160 x 140.5 x 20.3 cm (63 x 55 1/4 x 8 in).

Musée national d'art moderne, Paris.

Joseph Beuys
Homogenous Infiltration
for Grand Piano
1966, piano covered
with felt and fabric,
100 x 152 x 240 cm
(39 3/8 x 59 7/8 x 94 1/2 in).
Musée national d'art moderne, Paris.

The readymade belongs to everyone

In February-March 1988, the Museum Ludwig in Cologne presented an exhibition under the title "Duchamp and the Avant-Garde since 1950". It opened with a work by Gerhard Richter, *Emma – Nude on a Staircase*, which was a direct allusion to the two *Nudes Descending a Staircase* of 1911-1912. Richter's canvas was at once a homage to the master, and a refusal to follow him in his critique of retinal painting. The time had come for the received myth to be revised. For the post-Duchampians, Duchamp himself was no longer above criticism; nor was his work necessarily held to constitute a point of no return for Western art. Twenty-four years earlier, Joseph Beuys had already declared that in his opinion, Duchamp had failed to face up to the consequences of his readymades; he had been satisfied with producing a shock-effect, from which he had then retreated into an "overvalued" silence and chess. For Beuys, "Duchamp the artist was a good starting point." Buren went even further, in his ironic reference to Duchamp as "a drudge producing antiquated objects, including a completely unserviceable urinal that has been used by everyone". Major exhibitions devoted to the work of Picasso and, above all, Matisse, whose influence was to prove crucial on both sides of the Atlantic, encouraged a general return to retinal painting, after a period during which its role had been decried or simply denied. Duchamp no longer appeared generous; instead he was a castrating Father. The "infra-thin" within which he had operated was rapidly becoming invisible. It fell to the second generation of his spiritual heirs to reassess his legacy as an iconoclastic subversive recuperated by "history".

George Brecht was one of these revisionists, and he carried forward his intellectual critique of the "Duchamp paradigm" in his work as a member of Fluxus. Exhibiting a group of chairs in a gallery, he explained: "The difference between a chair by Duchamp and one of my chairs might be that Duchamp's chair is on a pedestal, while my chair must be used. With my chairs, it is quite explicit; you *can* sit down."

The use and ontological status of the object now formed two indivisible aspects of a single, unavoidable question, to which Duchamp had left no answer. Yet that question would never have been asked had it not been for the challenge thrown out by Duchamp's works, both as form and as content. It is easy to lose sight of this point; the revolution that they had triggered was in large measure accomplished, and their context abolished. His disciples, and even some of his interpreters, often seem to have forgotten this.

The contradictions, celebrations and negations of Duchamp's supremely ironic corpus remain. The readymade belongs to everyone. Sanejouand adapted the concept in his *Charge-Objects* (a pun on *charge*, which might mean either "load", "charge" or "caricature"). These pieces are jokes at the expense of painting, produced by appropriating ordinary materials and assembling them in a way that both reveals and defamiliarizes the space in which they are displayed. At much the same time, 1963-1964, Jean-Pierre Raynaud was creating *Psycho-Objects*, meditations on the intersection of physical reality and psychic resonance.

Joseph Beuys
Plight
(Critical State)
1985, installation with felt,
43 elements, grand piano,
blackboard, thermometer,
310 x 890 x 813 cm
(122 x 350 3/8 x 320 in).
Musée national d'art moderne, Paris.

FOLLOWING PAGE
Jean-Pierre Raynaud
Psycho-Objects 3 Pots 3
1964, painted hardboard, photo,
Plexiglas, wooden shelves, flower
pots, lacquered metal,
185 x 124 x 23.5 cm
(72 3/4 x 48 3/4 x 9 1/4 in).
Musée national d'art moderne, Paris.

LEFT
George Brecht
Three Arrangements
1962-1973, installation with shelf, coatstand,
coat, painted chair, wool.
Musée national d'art moderne, Paris.

Duchamp left his objects as he found them. Raynaud alters his, assembling them, colouring them with white and red lacquers, placing them in different situations and suggesting various different uses for them. In this way, their spatial aura becomes an organic extension of the object itself. Choice, appropriation and relocation form part of Raynaud's refusal to distance himself from its object. His work stems from a vital necessity, and his aesthetic and spiritual concerns are quite alien to those of the guru of Dada. Duchamp's successors use objects to show how the object can become a work of art. Thus Bertrand Lavier uses industrial readymades as his raw materials, piling them one on top of the other, reframing them, covering them with thick layers of paint. The titles of his work reflect the directness of his approach: *Brandt on Fichet, Brandt on Haffner, Ikéa on Zanussi, Argens on Decaux.* Lavier describes himself as a painter, and like Raynaud he wants his works to be seen as art objects, not objects. Yet despite that, his place is in the vast "no-art's-land" opened up by Duchamp. Lavier allows the elements he works with to keep their original identity and function. His use of colour is crude and unreflective. The objects he constructs serve to create a focus for spatial tension and, in this way, extend the idea of the assisted readymade, by playing simultaneously on both its analytical and ironic potential.

RIGHT
Bertrand Lavier
Bendix
1994, refrigerator door, wood and plastic,
135 x 58 x 28 cm (53 1/8 x 22 3/4 x 11 in).
Courtesy of the galerie Durand-Dessert, Paris.

Jean-Michel Sanejouand

Charge-Object

1965, object with rubber and wooden
box covered with stapled orange canvas,
75.5 x 64.3 x 34.5 cm
(29 3/4 x 25 1/4 x 13 1/2 in).

Musée national d'art moderne, Paris.

PREVIOUS PAGES

Ange Leccia

I Want What I Want

1989, arrangement, two motorcycles
and four Cibachromes.

Courtesy of the galerie Montenay-Giroux, Paris.

OPPOSITE

Richard Baquié

***In the Past He Often Used to
Take the Train so as to Disguise
His Anxiety as Tiredness***

1984, assemblage including metal nozzle,
train window, ventilator,
185 x 320 x 93 cm
(72 3/4 x 126 x 36 1/2 in).

Musée national d'art moderne, Paris.

Does art have a future?

As the influence of the Duchamp cult reached its peak in the 1980s, the readymade was transformed into a museum piece. Once enshrined in this new role, it cast a perverse light on all the other objects that were already stored and displayed in this way. It deprived them of their uniqueness, turning each of them into a fragment in some virtual series. In the words of Marc Le Bot: "Since museums began to accept any old thing, provided it had been signed by someone considered to be an artist, the essential reality of everything in a museum was reduced to the simple function of being there, as just any old thing in a collection of any old things".

Thus the recuperation of Duchamp's act by the museums was simply a secondary effect of the murder of the Father which they carried out with great tact and serenity, not to say deference. Duchamp only discovered that he had been hoist with his own petard after the event, by which time he had already been converted into a hero and appropriated by the massmedia. Today's junk-terrorists lack Duchamp's subversive instincts; they venerate their model, and invoke his name to endorse the perpetuation of avant-garde procedures. Ange Leccia, for instance, stages confrontations between objects – televisions, motorbikes, even heavy plant – arranged "in silent poses of hope, attention, meditation, availability to others, or receptiveness, as if in dialogue". For Richard Baquié, "The work of Marcel Duchamp represents a limit for contemporary creativity." To define his own relation to this œuvre, Baquié used the "Instructions" for *Given...* to construct "the non-visible parts of the work" (p. 170). In his words: "I wanted to demystify the only piece that he himself had not been able to re-make." In this, his approach resembles that of Sherrie Levine, who has taken the mythical *Fountain* as the starting point for an exploration of questions of sameness and resemblance. Not only does she give her bronze moulded replicas of the banal original a magnificent gold finish (page 110), but she also removes the signature "R. Mutt", thus undermining (in a way Duchamp himself would have appreciated) the very notion of 'author'-ity.

Robert Gober, for his part, has made a series of wax sculptures imitating, and often deforming, the organs of the human body, as well as readymades based on everyday objects. Both these kinds of work are intended to denature the object on which they are modelled, reducing the original itself to a mere simulacrum (page 112). John Armleder, on the other hand, has developed the concept of the *Waistcoats* Duchamp made in New York in 1958. He turns his own suits into fetishes by reproducing them in multiple copies and placing them in a context where they seem to be lying in wait for someone to come along and wear them.

In 1991, the young artist Sylvie Blocher created and exhibited a work in steel, neon, synthetic fabric and wood, which was intended as a response to Duchamp's *Bride*. She called it *Disappointed, the Bride Gets Dressed Again...* (page 141). In this piece, she makes use of a technique dear to Duchamp, the stereoscopic view, to produce a perspective narrative scene. The transparent glass of the original is replaced by an empty space, a space of expectation, where the Bride appears in a form almost identical to the pyramid-figure which Duchamp drew for the 1918-1919 rectified readymade *Hand Stereo-*

scopy. Alone, and draped in a veil whose vertical pleats are lit from within, she is a lily-like apparition surrounded by an apparatus of rectangular and circular pedestals. In front of her is a prompt box, which suggests that speech may at any moment erupt out of the silence.

Blocher, like Duchamp, proposes two different narrative options. The viewer has to choose between travel and clairvoyance. From imaginary places and remarks arises a drama involving Bride, plinths and prompt box. Like the viewer's gaze, the Bachelors are suspended on the verge of a mirage within which the ceremony of her stripping bare is always in preparation, and perpetually deferred.

John Cage once said: "Everything we can see – that is, every object, plus the fact that we are looking at it – is a Duchamp." He added: "If you say that something is not a Duchamp, you only have to turn it round, and it is one." Duchamp would have enjoyed Cage's joke. But this joke also bears witness to the range of Duchamp's influence, which extends throughout the "arts" – painting, sculpture, found objects, photography, installations and, more recently, video, computer art and new imaging technologies (in the work of

Jean Sabrier
Down With Age
1944, sculpture object,
37 x 18 cm (14 1/2 x 7 in).
Private collection, Paris.

OPPOSITE
John M. Armleder
Untitled
1986, installation with acrylic on tray
and armchair.
Musée d'art et d'industrie, Saint-Étienne.

RIGHT
Marcel Duchamp at the exhibition:
"Raymond Duchamp-Villon –
Marcel Duchamp", Paris, 1967.

Jean Suquet, Jean Sabrier and Shigeko Kubota). Duchamp has also found countless disciples among the theoreticians and exegetes who have rummaged through his Suitcases, trying to extract a message from the least fragment of his artistic remains. For them, his work is no longer important in itself, but is a pretext for free intellectual speculation.

Octavio Paz summarized this point of view many years ago when he remarked: "The work is the road, and nothing else." The significance of Duchamp's work cannot be reduced to the light it casts on the problem of the object. This reduction is the fallacy behind the Museum of the Object, a pseudo-cultural flea market that was opened in Blois in 1996. The name of Marcel Duchamp may now be reducible to that of a street in the XIIIth arrondissement of Paris; the readymade is not reducible to a collectors' category.

For Duchamp, painting was not an action but a way of life. His artistic heirs have endlessly reiterated what was no more than a young man's assertion of identity. Duchamp himself was able to combine an exceptionally acute vision of the world of things with a detachment from it which varied in intensity between doubt and negation. He observed the twists and turns of his century with an ironic smile, even as he constructed his work as a permanent challenge to its needs and certainties. Whenever I think of him, I see him sitting in his enormous leather armchair in his apartment in Neuilly, his fingers toying with a cigar, and the *Bicycle Wheel* behind him as the emblem of the essential act of his career. And I hear again the words spoken during a round table in America in 1957: "The artist is not the only one who performs an act of creation, for it is the spectator who establishes contact between the work and the outside world, by deciphering and interpreting its underlying distinctiveness, and in this way bringing his own contribution to the creative process. This contribution is more obvious again when posterity reaches its final verdict and rehabilitates forgotten artists."

With Duchamp, nothing is ever finished. He is always the future.

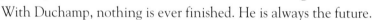

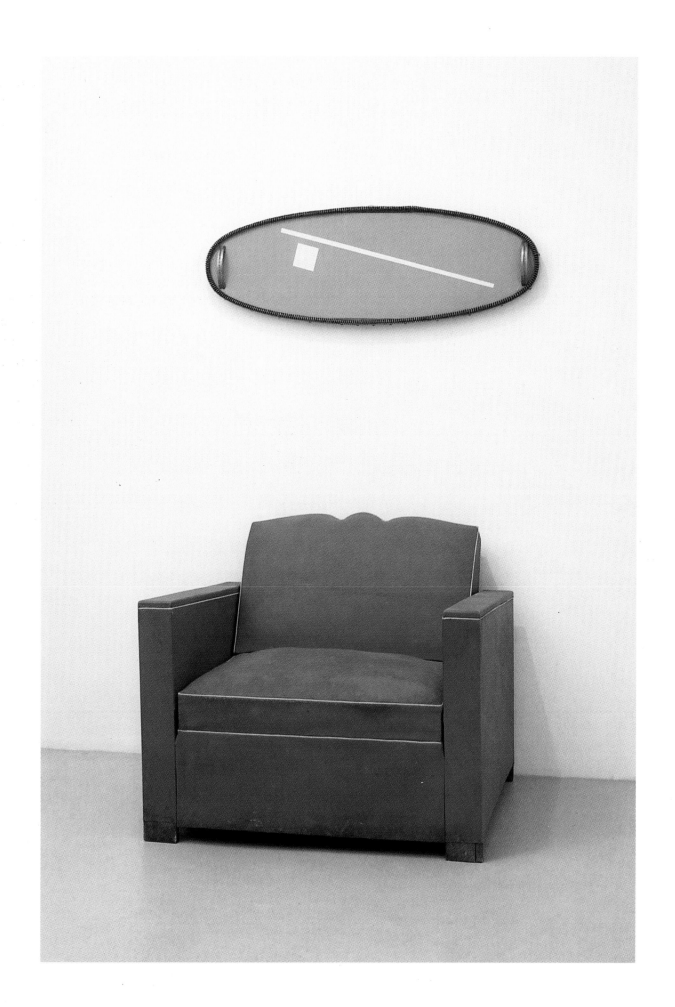

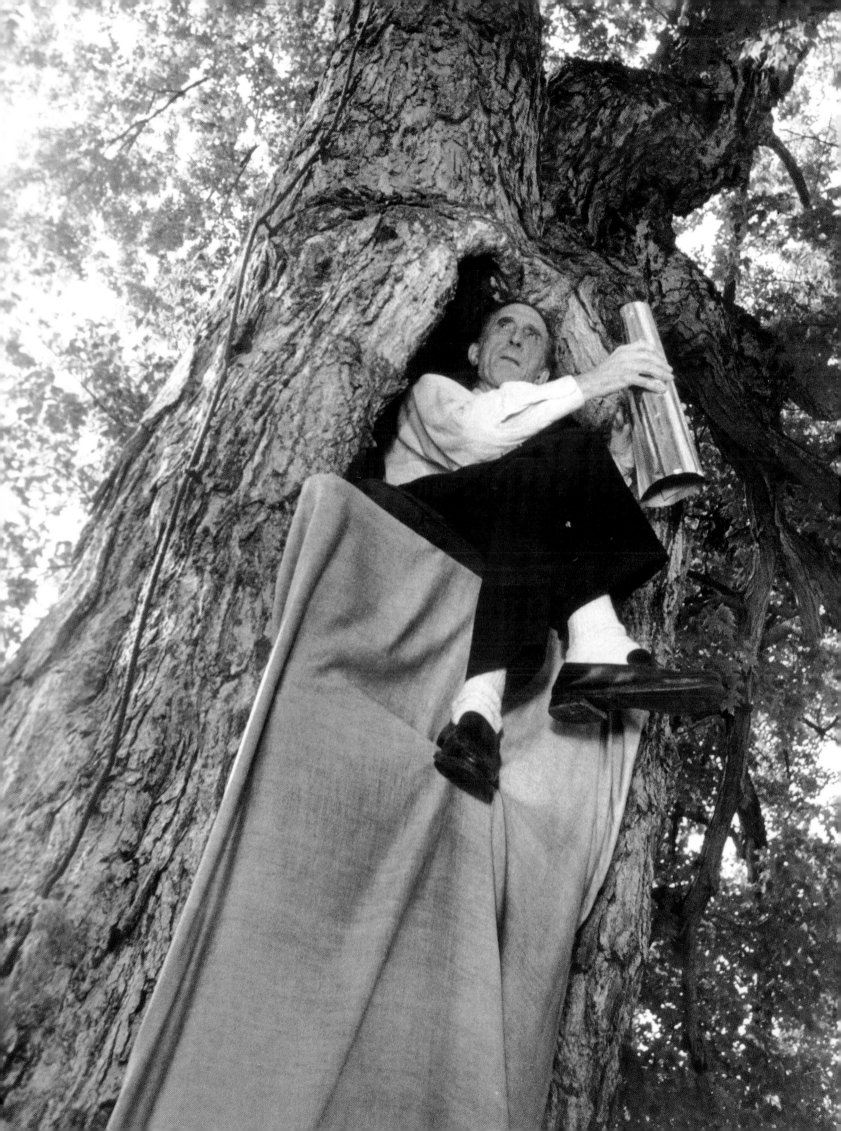

*Opposition and juxtaposed
squares reconciled,*
text by Marcel Duchamp and
V. Halberstadt, 1932, Brussels.

OPPOSITE
Marcel Duchamp photographed
for the film *Dadascopes*
by Hans Richter in 1952.

BIBLIOGRAPHY

ALEXANDRIAN, Sarane, *Marcel Duchamp*, Paris, 1976.
APOLLINAIRE, Guillaume, *The Cubist Painters, Aesthetic
· Meditations*, Paris, 1913; tr. Lionel Abel, New York, 1944.
APOLLINAIRE, Guillaume, *Marcel Duchamp, 1910-1918*, Paris, 1994.
ARAGON, Louis, *La Peinture au défi*, Paris, 1930.

BLESH, Rudi, and JANIS, Harriet, *Collages, Personalities, Concepts,
Techniques*, Philadelphia and New York, 1962.
BONK, Ecke, *The Portable Museum, The making of the Boîte-en-
valise de ou par Marcel Duchamp ou Rrose Sélavy*, Munich,
1989.
BRETON, André, *Les Pas perdus*, 1924, 1969 and 1989.
BRETON, André, *Le Surréalisme et la peinture*, Paris, 1928;
second edition, New York, 1945.
BRETON, André, *Dictionnaire abrégé du surréalisme*, Paris, 1938.
BUFFET-PICABIA, Gabrielle, *Aires abstraites*, Paris, 1957.
BUFFET-PICABIA, Gabrielle, *Rencontres…*, Paris, 1977.

CABANNE, Pierre, *Les Trois Duchamp, Jacques Villon,
Raymond Duchamp-Villon, Marcel Duchamp*,
Neuchâtel, 1975, New York, 1976.

CABANNE, Pierre, *Dialogues with Marcel Duchamp*, Paris, 1967; tr.
Ron Padgett, New York, 1971, preface by Salvador Dalí,
introduction by Robert Motherwell, appreciation by Jasper
Johns; reprinted as *Ingénieur du temps perdu*, Paris, 1977 and
1995.
CAMFIELD, William, *Fountain*, Houston, 1989.
CARROUGES, Michel, *Les Machines célibataires*, Paris, 1954.
CAUMONT, Jacques, GOUGH-COOPER, Jennifer, *Ephemerides on and
about Marcel Duchamp and Rrose Sélavy 1887–1968*, Milan.
CHARBONNIER, Georges, *Entretiens avec Marcel Duchamp,
1960-1961*, 2CDs and book, Paris, 1995.
CLAIR, Jean, *Duchamp et la photographie*, Paris, 1977.
CLAIR, Jean, *Marcel Duchamp ou le Grand Fictif, essai de
mythanalyse du Grand Verre*, Paris, 1976.

DADOUN, Roger, *Duchamp, ce mécano qui se met à nu*, Paris, 1996.
DREIER, Katherine, and MATTA, Roberto, *Duchamp's Glass. An
Analytical Reflection*, Société Anonyme, New York, 1946.
DUVE, Thierry de, *Nomadisme pictural, Marcel Duchamp la peinture
et la modernité*, Paris, 1984.
DUVE, Thierry de, *Résonances du ready-made*, Nîmes, 1989.

GIBSON, Michael, *Duchamp Dada*, Paris, 1991.

GOLDING, John, *Cubism: A History and an Analysis, 1907-1914*, London, New York, 1959; revised edition, Boston, 1968.

GOLDING, John, *Duchamp: The Bride Stripped Bare by her Bachelors, Even*, London, 1972, New York, 1973.

GUGGENHEIM, Peggy, *Art of This Century*, New York, 1946.

HARNONCOURT, Anne d', HOPPS, Walter, *Étants donnés: 1° La chute d'eau, 2° Le gaz d'éclairage… Reflections on a New Work by Marcel Duchamp*, Philadelphia, 1969.

HARNONCOURT, Anne d', HOPPS, Walter, *Manual of Instruction for Given…* (facsimile), Philadelphia, 1987.

HELD, René, *L'Œil du psychanalyste. Surréalisme et surréalité*, Paris, 1973.

HOPPS, Walter, LINDE, Ulf, SCHWARZ, Arturo, *Marcel Duchamp, Ready-mades etc., 1913-1914*, Milan, 1964.

HUGNET, Georges, *Marcel Duchamp*, 1941.

JEAN, Marcel, *Lettres à, Letters to, Briefe an Marcel Jean de, From, von Marcel Duchamp*, Munich, 1987.

LEBEL, Robert, *Sur Marcel Duchamp*, Paris, 1959, New York, 1967, Cologne, 1962 and 1972.

LINDE, Ulf, *Marcel Duchamp*, Stockholm, 1963.

LYOTARD, Jean-François, *Les Transformateurs Duchamp*, Paris, 1977.

MASSOT, Pierre de, *The Wonderful Book: Reflections on Rrose Sélavy*, Paris, 1924.

MASSOT, Pierre de, *Marcel Duchamp. Propos et souvenirs*, Milan, 1965.

MINSK, Janis, *Duchamp*, Cologne, Paris, 1995.

MOTHERWELL, Robert, *The Dada Painters and Poets: an Anthology*, New York, 1951.

MOURE, Gloria, *Duchamp*, Barcelona, Madrid, Cologne, 1984.

PACH, Walter, *The Masters of Modern Art*, New York, 1924.

PARTOUCHE, Marc, *Marcel Duchamp*, Marseille, 1991.

PAZ, Octavio, *Marcel Duchamp, l'apparence mise à nu*, Paris, 1967.

PAZ, Octavio, *Marcel Duchamp*, Mexico, 1968.

PAZ, Octavio, *Marcel Duchamp or the Castle of Purity*, London, New York, 1970.

PAZ, Octavio, *Deux Transparents, Marcel Duchamp et Claude Lévi-Strauss*, Paris, 1970.

RICHTER, Hans, *Dada: Art and Anti-Art*, Cologne, 1964; Eng. tr., London, 1965.

SANOUILLET, Michel, *Marchand du sel. Écrits de Marcel Duchamp*, Paris, 1958; Eng. tr., Oxford, 1973.

SANOUILLET, Michel, *Dada à Paris*, Paris, 1965.

SANOUILLET, Michel and PETERSON, Elmer, *The Essential Writings of Marcel Duchamp*, London, 1975.

SCHWARZ, Arturo, *Marcel Duchamp*, Milan, 1968, Paris, 1969.

SCHWARZ, Arturo, *The Complete Works of Marcel Duchamp with a "Catalogue raisonné", over 750 illustrations including 75 colour plates*, New York, 1970, reprinted, 1995.

SUQUET, Jean, *Le Grand Verre, visite guidée*, Paris, 1992.

SUQUET, Jean, *In vivo, in vitro, Le Grand Verre à Venise*, Paris, 1994.

SUQUET, Jean, *Le Grand Verre rêvé*, Paris, 1991.

SUQUET, Jean, *Miroir de la Mariée* (with correspondance between Marcel Duchamp and the author), Paris, 1973.

SUQUET, Jean, *Le Guéridon et la Virgule*, Paris, 1976.

SUQUET, Jean, *Oubli, sablier intarissable*, Bordeaux, 1996.

TAKIGUCHI, Shuzo, *To and From Rrose Sélavy*, Tokyo, 1968.

TOMKINS, Calvin, *The Bride and the Bachelors: the Heretical Courtship in Modern Art*, New York, 1966.

TOMKINS, Calvin, *Duchamp, a Biography*, 1996.

PHOTOGRAPHIC CREDITS

Agence Explorer, Paris: pp.54 (photo by Willi Peter), 82 (photo by Willi Peter). Agence Giraudon, Paris: pp.51, 52 (right), 55 (above), 63, 180, 186, 187, 191 (below). AKG photos, Paris: pp.114-115, 125. Archives Photo, France,: pp.30 (below, photo by Michel Sima), 119 (photo by Michel Sima), 149 (photo by Michel Sima), 181 (photo by Michel Sima). Archives Terrail: pp.20 (above), 168, 184 (left and right). Bibliothèque Nationale, Paris: p.56. Collection of Arturo Schwarz, Milan: pp. 22, 43, 72, 88 (below). Collection of Jacqueline Monnier, Paris: pp.118 (photo by James Mathews), 171 (photo by F. Catal Roca). Collection of the Musée d'Art Contemporain, Lyon: p.170 (photo by Blaise Adilon). Private collection, Paris: pp.116 (below, photo by F. Tissier), 202 (above, photo by F. Tissier). Courtesy of Didier Imbert Fine Art and Pace Wildenstein: p.182. Courtesy of Jablonka Gallery, Cologne: p.110. Courtesy of Galerie Jérôme de Noirmont, Paris: p.163. Courtesy of Galerie 1900/2000, Paris: p.175. Courtesy of Galerie Montenay-Giroux, Paris: pp.198-199. Courtesy of Galerie Roger Pailhas, Paris-Marseille: p.141. Courtesy of American *Vogue*, copyright 1945 (renewed 1973) by Condé Nast Publications Inc.: p.142. Editions Flammarion, *Le Miroir de la Mariée* by Jean Suquet: p.134. Galerie Nationale du Jeu de Paume, Paris: p.112 (above, photo by J. Dee, and below, photo by D.R.). Museum Ludwig, Cologne: p.61. Kunstmuseum, Basel: p;51. Moderna Museet, Stockholm: p.177. Museum für Moderne Kunst, Frankfurt-am-Main: p.109 (above). Musée National d'Art Moderne, Centre Georges Pompidou, Paris: p.2, 13, 21 (Jacques Villon collection), 29, 30 (above), 31, 36, 38 (photo by P. Migeat), 39 (above and below), 46, 48, 53 (above), 55 (below), 62, 66-67, 76, 77, 79, 84, 87, 89, 90 (photo by P. Migeat), 94 (photo by P. Migeat), 95 (photo by P. Migeat), 102 (above), 106 (left), 109 (below), 126 (below, P. Migeat), 127, 128 (photo by B. Hatale), 135, 143, 147 (photo by P. Migeat), 152-153, 154 (photo by P. Migeat), 156-157, 159 (photo by P. Migeat), 163 (above), 164-165, 174 (photo by J. Faujour), 183, 185, 188 (photo by J. Faujour), 189 (photo by A. Rzepka), 190, 192 (photo by P. Migeat), 193, 194 (photo A. Rzepka), 195 (photo by P. Migeat), 196, 197 (left, photo by P. Migeat), 200 (photo by P. Migeat), 201, 202 (below), 203 (photo by A. Rzepka). Parti Communiste Français, Paris: p.6. Philadelphia Museum of Art: pp.5 (Estate of Marcel Duchamp), 8 (Lent by Mrs Marcel Duchamp), 9 (Gift of the Cassandra Foundation), 10 (Lent by Mrs Marcel Duchamp), 11 (Gift of the Cassandra Foundation), 14 (Lent by Mrs Marcel Duchamp), 24 (The Louise and Walter Arensberg Collection), 26 (The Louise and Walter Arensberg Collection), 27, 32 (The Louise and Walter Arensberg Collection), 35 (The Louise and Walter Arensberg Collection), 37 (The Louise and Walter Arensberg Collection), 40 (left and right, The Louise and Walter Arensberg Collection), 41 (The Louise and Walter Arensberg Collection), 42 (The Louise and Walter Arensberg Collection), 44 (The Louise and Walter Arensberg Collection), 45 (The Louise and Walter Arensberg Collection), 49 (The Louise and Walter Arensberg Collection), 54 (Marcel Duchamp Bequest), 58 (The Louise and Walter Arensberg Collection), 59 (The Louise and Walter Arensberg Collection), 69 (The Louise and Walter Arensberg Collection), 71 (above and below, The Louise and Walter Arensberg Collection), 73 (The Louise and Walter Arensberg Collection), 83 (The Louise and Walter Arensberg Collection), 85 (The Louise and Walter Arensberg Collection), 91 (The Louise and Walter Arensberg Collection), 93 (Estate of Marcel Duchamp), 100 (Lent by Mrs Marcel Duchamp), 101 (Private collection), 104 (Lent by Mrs Marcel Duchamp), 106 (above, The Louise and Walter Arensberg Collection), 107 (The Louise and Walter Arensberg Collection), 117 (Lent by Mrs Marcel Duchamp), 118 (below, lent by Mrs Marcel Duchamp), 120, 121 (The Louise and Walter Arensberg Collection), 122 (The Louise and Walter Arensberg Collection), 126 (above, The Louise and Walter Arensberg Collection), 130-131 (Private collection), 133 (Bequest of Katherine S. Dreier), 138 (Estate of Marcel Duchamp), 139 (Bequest of Katherine S. Dreier), 140 (Estate of Marcel Duchamp, photo by Lynn Rosenthal), 148 (Duchamp Archives), 150 (The Louise and Walter Arensberg Collection), 151, 172 (The Louise and Walter Arensberg Collection), 173 (left, The Louise and Walter Arensberg Collection), 191 (above, Lent by Mrs Marcel Duchamp, photo by Lynn Rosenthal), 204 (Lent by Mrs Marcel Duchamp). Réunion des Musées nationaux, Paris: p.197 (right). Estate of Mrs Marcel Duchamp: pp.16-17, 19, 20 (below), 23 (photo by J. Faujour), 25, 33 (photo by J. Faujour), 34, 47 (above, below, photos by J. Faujour), 60, 74, 75 (photo by Edward Steichen), 81 (photo by J. Faujour), 92, 98-99 (copyright 1963 Julian Wasser), 102 (below, photo by Beatrice Wood), 103 (photo by J. Faujour), 111 (photo by J. Faujour), 116 (above, photo by J. Faujour, and below), 123, 144 (left and right), 145, 146 (photo by J. Faujour), 158 (photo by J. Faujour), 160 (photo by J. Faujour), 161 (photo by J. Faujour), 162 (photo by J. Faujour), 166 (copyright 1963 Julian Wasser), 173 (right), 205 (photo by J. Faujour). Photographie A. Donval, Paris: pp.20 (above), 167. Statens Konstmuseer, Stockholm: p.12. Tate Gallery, London: p.52 (left). The Museum of Modern Art, New York: p.88 (above, Abby Aldrich Rockefeller Fund and Gift of Mrs William Sisler). The Museum of Modern Art, San Francisco: p.28. The University of Iowa Museum of Modern Art: pp.178-179 (Gift of Peggy Guggenheim 1959.6). Whitney Museum of American Art, New York: p.113 (50th Anniversary Gift of Mr and Mrs Victor W. Ganz, photo by Jerry L. Thompson, N.Y.).

ACKNOWLEDGEMENTS
Éditions Pierre Terrail would like to thank the staff of the Musée national d'art moderne for their help, and in particular Mrs CHARTON, Mr SCHULMANN and Mrs VINCENT.
Éditions Pierre Terrail also wish to express their thanks to Mrs Jacqueline MATISSE MONNIER and Mrs HOCHART for their continuous and unfailing assistance throughout the preparation of this book.